Cultural Reflections of

This project studies the patterns in which the Medusa myth shapes, constructs, and transforms new meanings of women today, correlating portrayals in ancient Greek myth, nineteenth-century Symbolist painting, and new, controversial, visions of women in contemporary art.

The myth of the Medusa has long been the ultimate symbol of woman as monster. With her roots in classical mythology, Medusa has appeared time and again throughout history and culture. Hedgecock presents an interdisciplinary and broad historical "cultural reflections" of the modern Medusa, including the work of Maria Callas, Nan Goldin, the Symbolist painters and twentieth-century poets.

This timely and necessary work will be key reading for students and researchers specializing in mythology or gender studies across a variety of fields, touching on interdisciplinary research in feminist theory, art history and theory, cultural studies, and psychology.

Jennifer Hedgecock is Professor of English at Saddleback College and teaches Shakespeare's plays, early British literature, and world literature. She has also taught at the University of California, Irvine and Michigan State University. Her publications include *The Sexual Threat and Danger of the Femme Fatale in Victorian Literature* (2008) and "William Blake and The Road to Hell: Demystifying the Cultural Iconoclasm of the Hells Angels," in *Rethinking Madness: Interdisciplinary and Multicultural Reflections* (2019).

Interdisciplinary Research in Gender

www.routledge.com/Interdisciplinary-Research-in-Gender/book-series/IRG

Cultural Reflections of Medusa

The Shadow in the Glass

Jennifer Hedgecock

Routledge
Taylor & Francis Group

LONDON AND NEW YORK

First published 2020
by Routledge
2 Park Square, Milton Park, Abingdon, Oxon OX14 4RN

and by Routledge
52 Vanderbilt Avenue, New York, NY 10017

Routledge is an imprint of the Taylor & Francis Group, an informa business

First issued in paperback 2021

© 2020 Jennifer Hedgecock

British Library Cataloguing-in-Publication Data
A catalogue record for this book is available from the British Library

Library of Congress Cataloging-in-Publication Data
A catalog record has been requested for this book

ISBN: 978-0-367-18347-9 (hbk)
ISBN: 978-1-03-208295-0 (pbk)
ISBN: 978-0-429-06096-0 (ebk)

Typeset in Bembo
by Newgen Publishing UK

Contents

Introduction

The shadow in the glass

Medusa of the Snakes
They used your name
to frighten us,
But you
don't frighten me ...
No more this lie
No more this fear.
You belong to us again.
We call your name
to aid us.
and you
Greet us anew.
Medusa! Medusa! Medusa!
 (Forfreedom 72)

When I started writing the first draft of my book about Medusa, my friend, Kim, asked me about the subject. After I explained that it was a study of cultural and artistic representations of Medusa, I was not surprised that her immediate reaction was one of fear and repulsion, invoking stereotypes of the serpent-haired woman. Following that conversation a week later, my friend confided that she had nightmares about Medusa, of a snake escaping from the Gorgon's hissing hair and making its way to her pillow. When I explained to my friend that Poseidon, the sea god, rapes Medusa followed by Athena's curse that transforms Medusa's beautiful hair into serpents and makes her face so frightening that men turn to stone by looking at her, my friend showed more sympathy than fright toward the Gorgon woman typecast as the mythical monster. By that time I was working on a more contemporary interpretation of the Medusean myth influenced by some of the major social movements reported in the news over the past few years, starting with sexual assault charges against Harvey Weinstein, sexual harassment accusations against a plethora of iconic men, the viral MeToo Movement, and later formal allegations of sexual assault and sexual harassment made by former doctoral student Nimrod Reitman against his advisor, feminist scholar Avital Ronell. Though I struggled with popular,

conventionalized yet inaccurate notions about the Gorgon woman expressed earlier by my friend, these twenty-first century upheavals concerning the abuse of corporate and academic power leading to the sexual exploitation of women and men helped form a new perspective of Medusa. In our current cultural climate where men and women are unabashedly speaking out on a global level against sexual harassment, I believe that revisiting the Medusa myth leads contemporary society out of these personifications representing the Gorgon as a victim of womanhood or as a predatory monster. Instead she symbolizes victims of abuse seeking justice and protecting themselves. In fact, the role Medusa plays today largely surpasses this view of the silent victim reimagined into a predatory stereotype. Medusa still transfixes our attention, haunts the imagination, but she represents to us something far different compared to other historical interpretations. Though that very image of the terrifying Gorgon has sustained itself throughout history and contemporary culture, for many other women she evolves into a symbol of strength, and for me, a woman encouraging independence among other repressed women. In this progression of women speaking up in public and telling the truth in courtrooms and televised press interviews, it is figuratively Medusa coaxing men and women of sexual assault to be freed from the trappings of the silent victim, by whispering, "don't be afraid."

When I consider contemporary ways in which women have attempted to gain power, share power, or at least refuse to be a victim to it, I am reminded of the story told by Emily Erwin Culpepper, Professor of religion. While writing her dissertation at night, Culpepper answered the door to a man who she believed was the friend of her neighbor. However, the stranger standing outside forced himself into her home with the intention of sexually assaulting her. Immediately, Culpepper's reaction turned into physical rage, so intense that it scared off her assailant. When she caught a glimpse of her contorted face in the mirror, she did not recognize herself, thus naming her reflection as that "Gorgon spirit." It was her Medusa face that scared away a dangerous threat and saved her in an emergency. Culpepper recognizes the "Gorgon / Medusa image" as "one face of [women's] rage," an expression that all women are capable of demonstrating (qtd. in Garber and Vickers 239). When I read her story, Culpepper's words invigorated me, viscerally leaving me with the feeling that I was right there with her, fighting off a stranger who dared to trespass, to violate, and to demoralize. But what disturbed me was how Culpepper felt after her attacker was gone. It is an emotion familiar to many women in spite of saying no, standing up for themselves, or fighting back, and that is the feeling of guilt and shame.

According to a study conducted by Caroline Kelleher and Sinead McGilloway, researchers in the Department of Psychology at the National University of Ireland Maynooth, the feeling of guilt comes from a high degree of self-blame among victims of sexual violence. In *The Politics of Rape*, feminist sociologist Diana E. H. Russell studied the reaction among a number of rape victims who overall expressed guilt and responsibility rather than seeking revenge (265). In other words, these victims believe that the crime committed against them is

something that they could have prevented. Because the assault did happen, the victim believes it is his or her fault. In some cases the victim even tries to justify why this act of violence was carried out against them. Typically, victims also feel like they are not entitled to support or special services but instead should suffer alone and hide their secret. Being secretive is often caused by the stigma that goes along with rape since society often blames female victims. Such condemnation leads a rape victim into a cycle of guilt from which there is little escape when she believes that she has done something wrong. The victim even assumes that she has some kind of control over her situation. Shame leads to guilt, caused by a victim's belief about the way in which society perceives her. Physical and sexual violence cause a woman to feel defenseless, and when she cannot fight back, she turns to self-hatred. ——> Wayne's medusa dies the opposite

Culpepper admitted that she blamed herself for letting the man into her home. For other women who do report sexual assault, they often hold themselves responsible for being attacked. Though the attacker ran away before physically harming Culpepper, that feeling of guilt at the hint or aggression of physical violence is inevitable, left with the question: What could I have done differently? Even women who escape such an attack accuse themselves of "not thinking" or putting themselves in a dangerous situation. Having had a family member who was 14 years old when she was raped, I have observed that the cycle of shame runs so deep, that it can self-destruct into drugs and alcohol, a remedy powerful enough to end a person's life. But I hate using words like "victim" or "rape casualty" to describe women who suffer these outcomes. I especially dislike the idea of identifying my family member as a victim, another casualty of rape, a statistic. Instead, her story is one that echoes and melds together with the voices of other ghosts, women who quietly suffer a similar fate, of women who may have gone on with their lives as if it were a dream, or a nightmare from which they awaken, and start the new day ahead. There might be a much better word in place of "casualty" or "victim" to define a woman or man defenseless against sexual assault or harassment. These terms are redundant and allude to the powerlessness of someone who has endured physical violence. The meaning of these words repeat the violent act committed against them. Such terminology also threatens a person's identity, even destroying it. But then again destruction brings attention to the weaknesses of old identities, and this recognition can lead to something positive, forcing one to make a clean break from the old self that can no longer function or work productively. The old path heading towards a dead end must welcome something life-affirming. This requires creating a new identity that more readily can adjust to changes that we experience and to a future that will be different from the one we expected. Women who have experienced trauma cannot help themselves within the tight restrictions of an old selfhood. The attempt to do so ignores the reality of their situation. A more evolved selfhood relies on new resources and skills that are not restricted to surviving a traumatic experience, but rather strive for self-acceptance. To transform and to adapt are the new demands that one must face. It also means that a new, emerging identity will be less conformist to the rules of convention.

A genuinely changing selfhood is at odds with patriarchal stereotypes. Women in this case must cross that threshold out of the darkness of silence and into the light of speech. A woman cannot be defined by the crime committed against her. This action shatters the simple worldview of a "victim" or "casualty" of sexual violence when a woman uses her voice, her own Medusa face, by conjuring up her Gorgon spirit. Though Medusa's anger has often been interpreted as destructive—namely by her deadly gaze— this is a narrow perspective. Her name has an alternative meaning that translates into fertility and renewal, an emblematic figure of mother earth.

Reading about Culpepper's experience caused me to wonder about women and their face that they use in certain situations. Here's the problem that I see: today it is very common that women take self-defense classes, they run marathons, they hike, they race down rough terrain on mountain bikes, they snowboard, and they surf. They compete in Iron Man events, participate in triathlons. For months I took kickboxing, not only to gain upper body strength, but to feel good, to experience relief from the rest of the world, to yell, kick, and punch. But those athletic lifestyle activities pursued by women do not change the world in which we live. Women are still taught, encouraged, and rewarded for being submissive and accommodating. This training in obedience is a lifelong conditioning where women are expected to put their guard down, or to just put up with it all; it ultimately keeps women from learning how to defend themselves against physical attacks, or reprimands, denunciations meant to limit women's power. On the contrary, that raw edge, that self-assertiveness, the yell, the ferocity of a woman's spirit can be identified with that snake-haired Gorgon woman, that other Self that is in fact staring back at women as an ally looking after them.

Our culture has often defined women as being secretive and manipulative when they are confronted with danger, their face and body easily objectified. But contemporary cultural feminists observe that society has forced women into this situation. Over time, what I observe is that women are responding by finding constructive means to overcome repression and even abuse, by building a strong female community. That sense of female community has become more important than ever. In her lecture dating back to 1970, feminist activist, Ann Herschfang (a.k.a. Ann Forfreedom), declares that "women as a group have never made it, but individual women have seemed to make it, especially in the United States, the richest country in the world" ("Making It and Not Making It," Episode 3). In a lecture on June 14, 1970, Forfreedom proposed that marriage is one of the means by which a woman can make it, but from a postmodern perspective, this example of achieving power is too conventionalized, an outdated belief where power and identity can only be achieved by a woman's dependence on another man. An alternative to marriage, according to Forfreedom, is women "making it" as a mistress, instead of a wife, but still relying on a man of power or wealth to achieve this position. Then there are women of power who teach other women how to be exploited by men. While Forfreedom discussed these issues at least four decades ago, a lot

has changed for women. But it has only been in the past few years that sexual harassment occurring in industries where such scandals are usually kept quiet, forced exploited women in powerful positions to start organizing themselves in a global effort to stop sexual violence. Women are coming together as a unified front which seems to be a possibility affecting the way women respond in relation to their own power. But I am skeptical that it will last, and I certainly do not believe that this unified voice speaks for lower income or minority women otherwise marginalized from white, middle-class, college-educated women. This recent effort is not to deny recognition of women from the past who have made the same sacrifices to generate better rights for women. It has certainly led to lawmaking changes such as the 2018–2019 ban on nondisclosure agreements in Washington, Massachusetts, Tennessee, Maryland, and Vermont. Senator Diana DiZoglio who proposed the amendment in Massachusetts, stated that banning nondisclosure agreements "sends a clear message to our communities that we are not nor will we be in the business of silencing victims or covering up misdeeds under any circumstance using public funds."

Primarily in the workforce, sexual harassment is still secretive, and shameful behavior among sexual predators is oftentimes silenced in the form of money or some other enticement such as job promotions. Given the status of new non-disclosure laws, this appears to be changing. While, previously, women facing challenging situations felt pressured to give in to sexual advances, or try to ignore them, they are now confronting the situation by seeking justice, emerging from the rubble of the past. The #MeToo movement does prove that women must learn to rely on each other and fight on each other's behalf. The Medusa figure manifests as this unified symbol of strength, a revisionist image signifying this shift that shouts out loud rather than turning against one's self, paralyzed in silence. Here I want to clarify how I am using the term "revision," which is not to revise her story or change what she is. When I think of Medusa, I consider how much the ideas attached to her have evolved. These ideas have largely been expressed in art and poetry over the centuries from the time Homer writes about "the terrible monstrous, Gorgon head, a thing of awe and terror" in *The Iliad* (113), compared to May Sarton who identifies with Medusa: "I turn your face around! It is my face" (line 25). My use of the term "revise" is not to amend, to correct, or to alter the Gorgon woman. Instead it is to show how the story develops over the centuries, to reexamine Medusa, to rethink. In *Nan Goldin The Mirror Medusa*, Martine Delvaux confirms that Medusa is "reborn" into a Lilith, Eve, and Salome (13). She is creative, independent, free spirited, and dangerous. She is a goddess, a queen, a fearsome warrior. As we progress further into the twenty-first century, the Gorgon spirit is crucial to this new perspective of female autonomy, a thriving force of possibility for women as they continue moving forward in the twenty-first century.

Though today women still experience the indignation of patriarchal oppression on a socio-economic level, they also continue to be confronted with physical violence. Yet the mythical visage of Medusa is emblematic of women summoning their Gorgon spirit against a dangerous threat. Instead of being put

in such a position, exhaustively staving off a threat, women have more time for their own quiet contemplation and applying themselves to their own work. This was the central issue addressed by Culpepper, that her work on her doctoral dissertation is violently and dismissively interrupted by her attacker. One's private domain is especially meant to be used for contemplative work. Pursuing academic work has previously been regarded as entering into male-dominated territory, by carving out time and seeking out undisturbed property, a room of one's own, to think and to write. For decades now women are declaring the right to their own private room to do exactly the same. Culpepper's attack while working suggests that women still do not have a right to their own property where serious, thoughtful work can be carried out. In *A Room of One's Own*, Virginia Woolf implicitly demonstrates that achieving personal space constitutes a woman, in this case, as a political subject. For Woolf, private property gives women the right to wield their own power. This claim resonates with all women focusing on serious work that leads to a passage into previously male-controlled disciplines. Among women, private property is a celebrated space where a woman can concentrate and become lost in her own creative energy, to enjoy her freedom and to think without interruption.

I argue that the Gorgon spirit is defined by an attitude of independence, self-assertion and empowerment. Given Culpepper's example, a woman does not have to be a victim, but can retaliate by the strength of her own fury. Men may be repelled by Medusa, but women are not frightened by her. They can look at Medusa without turning to stone because she guards a woman's power and encourages them to have no fear of their own power. Today, that Gorgon spirit represents women seeking a new vision of themselves while meeting social and economic demands in the twenty-first century that require them to earn an education, compete in the workforce, or raise children in single-parent homes.

In "Rage Begins at Home," literary scholar Mary Ann Caws explains that there is a difference between rage and anger among women: "Rage is general, as I see it, and is in that way quite unlike anger—specific or motivated by something—which can, upon occasion, be calmed by some specific solution, beyond what one can state or feel or see" (65). Rage, in other words, has more to do with the oppressive circumstances in which women have had to live, and therefore base their reaction to it. Women may not be able to change the boundaries that cause oppression. But if they work together as a female community, perceptions of women's actions within the narrow parameters of public and private space can change the way powerful women are socially judged. For example, in contemporary culture we do not perceive Medusa similarly to the way in which Sir John Harrington of the late sixteenth century allegorically portrays the Gorgon as "sinne and vice, a thing base and earthly" (67). From the very beginning, Medusa is judged as demonic and evil because she does not want to marry. Renaissance mythographer Natale Conti names Medusa as a warning against pleasure, that her beauty is a "damnable thing" and that she is "dedicated to pleasure" and therefore "useless in all honorable things" (62).

In comparison to this sixteenth-century evaluation of Medusa, today women have a right to choose not to marry, and it is inhumane to ostracize a woman for being raped.

Yet there is a double standard that exists within our culture upon closer examination of these two issues of women choosing not to marry and of women who are sexually assaulted. In the twenty-first century, women are assured that they have liberties similar to men and a voice to express these rights to independence and self-protection. But this freedom comes with limitations. In other words, it forces us to reexamine these very judgments of women that derive from ancient Greece and the Renaissance, and identify how they figuratively operate as a stigma against women even today. For example, women who choose not to marry are judged, and a woman risks feeling marginalized from her own community of family and friends if she has been raped. Unmarried and childless women indirectly destabilize cherished traditions that define women in association with motherhood. Typically in a pitying tone, married women with children will ask older single women about their choices, an inquiry that figuratively questions their womanhood. I assert that our culture still fears women who do not fit into a proper feminine stereotype as wife and mother. These stereotypes persist even though their specific origin might be archaic, dating back centuries ago. Marriage is still an expectation that our culture has of women and can be overbearing. Mixed reactions to rape victims are most obviously oppressive. But both these situations lead to women's internalized mood of alienation. Oppressive circumstances from the ancient past may have evolved over time, but remain tacitly in place by rewarding women who conform to the proper, socially acceptable feminine image. To be more specific, women can have power as long as they disguise it or perform public roles identified as a benefactress that appropriately alludes to a mother figure.

Women attempting to break from this stereotype are just now determining a positive way in which they can create new identities for themselves. Younger women are more determined to pursue an education and a career before considering marriage and children. I do not want this to be confused with undermining motherhood or married life. This is not the intention of my point. But not all women choose this more traditional path, and yet they seemed to be lambasted for it. Here it is necessary to explain the difference between a woman's anger and rage. Though rage is internalized, it can be used by women toward constructive measures. Caws suggests that in our culture there is a belief that one can get in touch with her anger, alluding to the possibility of controlling it or manipulating it. But rage, separate from anger, is something that demands it cannot be controlled; it lives inside a person and can be cathartically released in creative, expressive ways, whether that it is in art or writing or the introspective pursuit of a woman's personal ambitions, which reminded me of Virginia Woolf. But according to Woolf, in modern, capitalist Western societies, women require the means of money and private property to embark upon these pursuits, which allows some women this privilege, but not all women. The twenty-first century still demands that we look at ways in which women

of different social classes and educational backgrounds can liberate themselves from repressive forces.

Anger can ironically liberate women from social restrictions, but only when anger serves some psychological relief that does not cause them to isolate in self-victimization, stunted by wounds from the past. French feminist Hélène Cixous suggests that women must find creative expression that develops into a community of female writers and artists. Caws further makes a distinction between rage and anger. Wounds that fester have no emotional release. Women must engage in some form of artistic expression, personal and private contemplation, or community work to direct their anger. The Medusean myth, as it is applied to women in this case, provides a creative resource that can be realized within a female community. Anger can be the very thing that clears the path for something new, a new beginning. A new cultural and revisionist myth of Medusa, the invocation of the Gorgon spirit by writers and artists, insists upon force and fury to lead women out of conventional definitions within oppressive parameters of public and private space. Rage can be applied as an objective and productive method by which an injury or injustice is set right. But this relies on more than one individual. It must be a response that involves other women. When the border finally collapses between the "inside" and "outside," such as private and public realms, necessary change is called for, which occurs by exposing the conventionally defined feminine as inaccurately characterizing women, that they are more than just mothers and wives, but can aspire to be many things. The work achieved within that private realm among women can transition into public space.

My friends' original belief about the petrifying Medusa, along with the attitudes of men and women familiar with the Gorgon, is primarily rooted in patriarchal convention because Medusa is understood only in context with the hero Perseus who is victorious over the Gorgon. Over time in Western culture, a woman's power is often in relation to the power of men, or as Forfreedom explains, a woman's power is the result of her dependence on influential and wealthy men. While over recent years women have succeeded in achieving their own source of economic and social power without depending on men, a woman of position and of power is negated, stereotyped as terrifying, threatening, or in short, labeled "the bitch." Though men and women still shirk from thinking about Medusa, the passé image is relied upon to undermine powerful women who refuse to honor the sharp boundaries between private and public life. Married women that Forfreedom discusses in her lecture from the 1970s operate from a more ambiguous position within the power structure, within the safe, prescribed borders of the home. Powerful women today have left the private world of silence and entered the public world of speech. By asserting themselves and transgressing this periphery between private and public space, our culture claims that such women are aggressive or mannish, which is meant to negate their femininity. Women who undermine the model between these two separate worlds are castigated by unflattering words and descriptions of their actions that are difficult, if not impossible, to escape. This reproach is meant to cause women to be afraid of their own power.

In Greek myth, Medusa does not exactly seek a public role before Athena curses her, but she certainly does not want the same prescribed, conventional life as other Greek women, and instead desires independence, a privilege allowed only to men of wealth and social position. The curse indirectly warns other young women of that time, and the oppressive patriarchal centuries that followed, against desiring the same independence as men. Freedom of movement from one sphere to the other is only allowed to men, and moving from home into the temple for worship is to move freely within these realms. Easily it can be argued that rape in Athena's temple is not the only reason why Medusa is cursed, but it is moreover for her rebellion against these cherished Greek traditions that force men and women into their proper place within the power structure. To develop this argument about Medusa as a representation of women in the twenty-first century, this project studies various interpretations of Medusa namely in Symbolist art at the end of the nineteenth century and photography and art by Nan Goldin and Liz Craft in the twentieth and twenty-first centuries where Medusa is the central protagonist. Chapter 1 introduces Vincenzo Bellini's Druid priestess, Norma, whose leadership, sacrifices, and personal conflicts exemplify characteristics that relate to the mythical Medusa. This chapter further explains the inspiration for this project and summarizes the historical and cultural transitions of Medusa, from ancient myth to contemporary culture.

Chapter 2 of this project goes into the chronological timeline of Greek myth about Medusa by Homer, Hesiod, Pindar, and Ovid to identify the subtle developments that are made throughout the storytelling of the Gorgon archetype from one generation to the next. In addition, this chapter studies the origins of Medusa in the eighth to seventh century BCE as a talismanic mask produced by hand-crafted carvings or drawings on vases, shields, and plates, even on the front doors of homes. In these examples, Medusa is a symbol used to ward off evil. Her sexual identity is ambiguous, and there is no narrative attached to this image, based only on rituals. British anthropologist, Jane Ellen Harrison, explains in *Prolegomena to the Study of Greek Religion* that the talismanic mask in early ancient Greece is based on rituals, but the myths first introduced by Homer in *The Iliad* provide an explanation of these rituals, hence Perseus slaying the Gorgon and therefore giving an explanation of the threat she poses and of her demise. While the sexually ambiguous Medusa head is still produced throughout early ancient Greece at this time, a body is now attached to the head, transforming the cultural representation of Medusa, from frightening monster to a beautiful woman cursed by Athena. The first myth of Medusa depicted by Homer is followed by Greek poets Hesiod and Pindar, and Roman poet Ovid. In paintings, sculpture and poetry where Medusa is a central figure, we see how culture has continued to be obsessed with her.

Chapter 3 concentrates on Romantic philosophy and Symbolist art from the mid- to late nineteenth century. Symbolist paintings portray Medusa as a femme fatale, a seductive and sexually charged woman. This image is ubiquitous and many poets such as Percy Shelley and Charles Baudelaire, and painters Delville, von Stuck, Böcklin, and Munch seem to be obsessed with the Gorgon monster, projecting a tender or sometimes disdainful fascination for Medusa. In

Romantic poetry by Shelley and Baudelaire, these poets present a new aesthetic where corrupted beauty is idealized. But it is time to introduce a more contemporary understanding and realization of Medusa, whose rage women artists not only identify with, but use to reinvent her myth in poetry and art, thus reinventing themselves. Medusa is a symbol from which women can discover their own source of power, their own true self.

Chapters 4 through 6 focus on the artistic interpretations of Symbolist painters Jean Delville, Franz von Stuck, and Edvard Munch. In order to more clearly understand how Medusa evolves in art as both a literary and artistic muse, it is necessary to provide the background and philosophical influences of artists who paint her image and repeat certain tropes that represent the fin de siècle. She is the sad, exiled woman, dark and threatening. Beginning with Homer in the eighth century BCE, Medusa transforms from "a grotesquely unfeminine beast, complete with bulging eyes, protruding tongue, and even the odd beard" (Currie 170) into a beautiful woman. These physical manifestations of the Gorgon are slowly introduced and depicted by 450 BCE in paintings on vases, plates, and other sculptures in ancient Greece; she transforms from a hideous head described by Homer into a beguiling gorgonian when Pindar writes about her. Obviously this is too limited a characterization of Medusa, especially in artistic interpretations. Writing a revisionist myth of Medusa begins with interpretations throughout myth, poetry, literature, philosophy, and art. By the nineteenth century, Symbolist painters Arnold Böcklin, Franz von Stuck, Jean Delville, and Edvard Munch feature her as a central figure throughout their work. The Medusean woman characterizes the spirit and social changes of that period.

Chapter 4 provides a detailed study of the sketching by Jean Delville, *The Idol of Perversity*, which is also named *The Bride of Satan*, or *Parsifal*. While the image in the portrait bears a significant resemblance to Medusa, it also conjures up several myths about the femme fatale, a motif that I argue is somewhat mistakenly attached to Medusa. Primarily, this chapter defines the femme fatale as a female agent who initiates a novice, usually male, to transgress morally prescribed boundaries. She often distracts him from his intended path. The term "initiator" alludes to the role performed by the femme fatale, usually portrayed as destructive. She is a conduit in between that liminal space of experience and innocence, good and evil. I argue in this chapter that such an initiation from neophyte to expert, perfection to fallibility, good and bad is absolutely necessary to truly test the initiate. The initiator is a combination of light and dark signifying the various boundaries that the hero must face in order to be tested, to demonstrate his strength, and to gain knowledge. But to argue that Medusa is relegated to the initiator role would be flawed. She is both the initiate and the initiator of worldly experience where one triumphs and fails, pursues the dark path, and, by the end, ascends to a spiritual realm. She is inexperienced when she serves as a temple maiden, worshipping Athena, and though she is victimized by Poseidon and doubly by Athena, she prevails by creating a secret life for herself in exile. To make this argument, I explain Schopenhauer's theory on human suffering and happiness in "The Road to Salvation." This philosophy explains how the

initiate can be sidetracked by pleasure and happiness, which is all an illusion since the expectation of joy is far greater than its reality. Pleasure disguises itself in the promise of something else. But is always temporal. The initiator only gains wisdom about the world through the tribulations that he or she must face, and the suffering that often goes along with it. But the sacrifice is necessary in order to discover deeper meaning in life, to be purified once again, and to be "led back from the path of error of the will-to-live" (Schopenhauer 636).

In Chapter 5, Medusean images in paintings by Franz von Stuck, a careful analysis of the biblical Eve in *Sin*, constructs strong similarities to the modern interpretation of Medusa. This chapter also questions the degree to which the spectator can experience liberation from conscious reality when he enters into the symbolic realm of art. Snakes and women come to take on a number of different meanings, which are common motifs in Stuck's art. In Chapter 6, I move from a thematic perspective on the snake and female image to a study of the personal relationships that the artist has with women. While Munch may have fallen in love a number of times in the early part of his career, his romantic life led to unfortunate disappointment and suffering. Metaphorically, the effect that women have on Munch's life emerge into feminine archetypes in his art, often where he characterizes women as Medusean tropes. It is important to understand the historical context of his romantic affairs in order to comprehend this new meaning and interpretation of Medusa into art based on human relationships between men and women. This study transitions into Chapter 7 and Chapter 8, an analysis of photography by Nan Goldin and art by Liz Craft where Medusa features as the main protagonist to understand the way women transform Medusa into a new feminist myth. This shift between male artists and their projection of Medusa during the fin de siècle compared to twentieth-century art by women shows how the trope of Medusa culturally transforms and echoes the spirit of the age in which she resurfaces into the faces and stories of the modern woman. Through the work of female artists, such as Goldin and Craft, contemporary women identify more with Medusa's rage which is deeply internalized but can be used within a number of positive connotations beginning with women creating their own communities and producing their own art where their voices are finally heard. The snake-haired woman is emblematic of this shift to understand how women's rage serves as a creative and cathartic feature that leads to independent lives by turning the rage outward to more productive pursuits rather than turning it inward against one's self. Women's new vision of themselves through the trope of the cultur-ally redefined Gorgon spirit shapes itself into the very translation of Medusa's name: protector against one's enemies. That enemy can mean a number of different things, even a woman who perceives herself as a threat; the image eradicates self-blame and self-hatred. This study of Greek and Roman myth, of nineteenth-century male artists' paintings compared to female artists' work of the twentieth- and twenty-first-century, produces a new cultural lens of Medusa, leading women to seek an authentic life that allows them to reinvent themselves.

Bibliography

Caws, Mary Ann. "Rage Begins at Home." *Massachusetts Review*, 34(1), Spring, 1993, pp. 65–75. www.jstor.org/stable/25090401

Conti, Natale, and DiMatteo, Anthony. *Natale Conti's Mythologies: A Select Translation.* Garland, 1994.

Culpepper, Emily Erwin. "Ancient Gorgons: A Face for Contemporary Women's Rage." *The Medusa Reader*, eds. Marjorie Garber and Nancy J. Vickers. Taylor & Francis Group, 2003.

Currie, Charlotte. "Transforming Medusa." *Almatea Revista de Mitocritica*, 3, May 2011, pp. 169–181. www.ucm.es/info/amaltea/revista.html.

DiZoglio, Diana. "Massachusetts Senate Bans Use of Nondisclosure Agreements for Senate Employees." *Mass Live*. 1 February 2019. www.masslive.com/news/2019/01/massachusetts-senate-bans-use-of-nondisclosure-agreements-for-senate-employees.html.

Forfreedom, Ann. "Making It and Not Making It." University of Southern California, Lecture. 19. https://archive.org/details/pacifica_radio_archives-BB4475.03.

Forfreedom, Ann. "Medusa." *The Book of the Goddess.* Crossroad/Herder and Herder, 1980.

Harrison, Jane Ellen. *Prolegomena to the Study of Greek Religion.* 3rd ed. Meridian Books, 1908.

Kelleher, Caroline, and McGilloway, Sinéad. "'Nobody Ever Chooses This …': A Qualitative Study of Service Providers Working in the Sexual Violence Sector—Key Issues and Challenges." *Health and Social Care in the Community*, 17(3), May 2009, pp. 295–303. doi:10.1111/j.1365-2524.2008.00834.x.

Russell, Diana E. H. *The Politics of Rape: The Victim's Perspective.* Stein and Day, 1976.

Woolf, Virginia. *A Room of One's Own.* Leonard and Virginia Woolf at the Hogarth Press, 1929.

Part I
The myth

1 The modern Medusa

"Casta Diva (Chaste Goddess)"
Who casts silver upon these sacred plants
Turn your beautiful face upon us
Without shadows and without veils
Yes, without shadows and without veils
Temper, O Goddess
You must temper burning hearts
Strengthen again the bold zeal
Strew o'er the earth, ah, that peace
Strew o'er the earth that peace
Which you make reign in heaven.
(Vincenzo Bellini)

In Act I of Vincenzo Bellini's *Norma*, the Druid priestess prays to the moon goddess, who is an instrument of power and a blessing of light that reveals truth, soothes pain, and strengthens character. Norma sings "Casta Diva," praying for peace, declaring that now is not the time for war against the Romans. Her declaration is also meant to protect the life of Pollione, her lover, the Roman proconsul, for whom she broke her vow of chastity and bore two children. But in the following scene, Pollione confesses that he no longer loves Norma. Instead he has fallen for Adalgisa. When Norma discovers this news, she wants to murder her own children to punish Pollione. But she cannot carry out her revenge because she loves her children too much. While considering such a brutally violent act, the moon's silver light is cast upon sacred plants alluding to the afterwards, the effect of Norma's stony gaze on all living things. In this context the moon, itself, has a dual purpose. While it is perceived as feminine, and therefore passive, the receiver of the sun's light, the moon, also affects the emotions and is believed to influence events on earth. Norma's spirits darken when she thinks of murdering her own children to strike revenge against Pollione. Because her love for her children supersedes her desire for revenge, she offers them to Adalgisa. But Pollione can only keep the children under the condition that he return to Norma. When he refuses, Norma is enraged, urging

war against the Romans. Oroveso demands a human sacrifice to the gods which will lead the Druids to victory. Pollione is captured, and Oroveso declares that he will be their sacrifice. But still unwilling to part with Pollione, Norma stalls the ceremony and speaks to Pollione in private, promising him freedom as long as he gives up Adalgisa. When he refuses, Norma finally relents, offering herself as a sacrifice and confessing her sins to her father. Overcome with disbelief, Pollione falls in love with Norma again and joins her in the pyre.

Norma protects Pollione against his enemies because she cannot help loving him, even though Pollione desires someone else. She is full of rage and wants revenge. But when it comes down to acting on her passionate emotions, she resists, incapable of harming anyone. She recoils and instead saves the life of the man she loves, though he tells her he cannot reciprocate her affection. Love can only be found in death, and ecstasy seems to always be followed by despair. There is a constant transaction that must prove love exists, a transaction, a dramatic exchange by sacrifice, when two lovers voluntarily embrace each other in death, which means that Pollione can love her again but only when Norma is willing to die for him on the altar. Throughout the opera, Norma makes many threats spurred by anger, betrayal, and jealousy. But she does not have the capacity to act on any of these warnings.

Beginning early in her career, opera singer Maria Callas performed the role of Norma more times than any other living soprano, and she later admitted that it was emotionally and vocally draining. The piece demands perfect pitch, clear and clean chords. However, what appealed to Callas about the lead role were these very dramatic demands, a woman internalizing her rage though she must appear calm among her followers, who are savage and ruthless. Norma attempts to avoid war with the Romans while ruling a most treacherous group who do not realize that she has broken her vows and is no longer that chaste diva, having borne two children by Pollione, her Roman lover. When Callas first performed the role on November 30, 1948, critics celebrated her "vocal color" as unusual (Kesting 34). She was rich and subtle, outshining most sopranos attempting to execute this same part. As a result, Maria Callas made Norma her own. But there is a price that goes along with such notoriety, an expectation that never seems to be quite settled, and that is the incongruity of a woman appearing tough on the outside, yet inwardly sensitive and vulnerable. It seems to be the very thing that so often leads to a crucial misunderstanding about women. Callas was very suitable for the role of Norma, not only for her vocal expression, but for the common unseen threads that bind certain women together. Whether it be Callas, whose private life became as equally notorious as the character she played, the tempestuous, self-sacrificing Druid priestess, Norma, or the central study of this project, the beautiful yet monstrous, chaste yet defiled Medusa, these tormented women are hard to place in common patriarchal archetypes that otherwise limit them to being either good or bad. Maria Callas is a struggling young woman transformed by the media into a diva that creates a public perception beyond Callas' control. To understand the complexities of Callas, or of any other contemporary woman for that matter, is to

know that there are many retellings and interpretations of a woman's story, and to start with, there are many different definitions and explanations of Medusa. This exotic and mythical creature has been all sorts of things: beautiful victim, femme fatale, frightening monster. The reader, however, is denied a reliable truth. More or less, Medusa becomes a mirror of other women's experience and stories.

In retrospect, it is possible that like the moon goddess to whom Norma prays, Medusa tempers anguished hearts, and even more appropriately the broken hearts of lost women identifying with her melancholy, an image that late nineteenth-century Symbolist painters attempt to convey in images of her. Ancient beliefs identify the moon with Medusa. For example, Clement of Alexandria "says Orpheus called the moon 'Gorgonios' because of the face inscribed on its surface" (Stafford 9). The later Greeks, according to Konrad Levezow, declare that the Gorgon head personifies the moon (25). In addition, Wilhelm Heinrich Roscher claims that Athena is the moon goddess (123). So if Medusa represents the moon, and Athena is the moon goddess, together the women are manifestations of nature. They are the divine feminine joined to one another. Athena's aegis symbolizes storm clouds, linking the two women to thunderstorms, who let loose floods and tempests when the earth is separated from the moon. But in another reading Medusa is mother earth, her snake hair attesting to this personification, representing also temptation that actually brings forth new life. She is specifically representative of the feminine. Awakening a woman's passion to prevail, to boost her eagerness for life, Medusa is of the earth and the moon, symbolic of fertility, a life-force. She is a physical and mystic entity. The moon goddess, Athena, reigns in the heavens. Medusa reigns here on earth, creating her own unique community, that while it does not last, is forever immortalized by storytelling and various interpretations of that mortal woman, that warrior, that once chaste diva.

When we consider artistic images of Medusa from Symbolist painters Arnold Böcklin, Franz von Stuck, Edvard Munch, and Jean Delville, Medusa is always alone; she appears burdened by her curse, with an expression of deep melancholy sometimes combined with fear. Her eyes might be dramatized as large and opaque or simply vacant, but regardless she draws our attention in artistic interpretations of her, as we study or connect to some kind of feeling for, or of Medusa. There is a certain hidden beauty that the artist attempts to reveal, and a profound sadness that she is lost. Sometimes Symbolist painters emphasize Medusa's head, a woman without a body after Perseus slays her, the eyes gazing at us, not in an attempt to turn onlookers to stone, but to evoke empathy from the viewer. Medusa is beguiling even in her changed form, unlike ancient Greek sixth century BCE paintings of Medusa on terra-cotta vases or cups depicting a full-frontal face with bulging eyes, a large simian nose, a mouth with bared teeth, protruding tongue, two pairs of tusks, and a full beard (*Stand*). In comparison, Böcklin's portrait, "Medusa's Head" (1878), portrays a young woman whose perfect symmetrical features express shock and sorrow, the snakes atop her head appearing to be a heavy burden, more dead than alive, Medusa succumbing to

her own death in grey pallor, her half-closed blue eyes yearning and reflective. Franz von Stuck creates a more haunting impression: her skin is porcelain, her eyes a hypnotic, glowing yellow, making it impossible for the spectator to look away. Medusa's countenance paralyzes the spectator while she too seems transfixed by the onlooker as if she sees something of her own face among those who are watching. The emotions that these artists convey in the Medusa figure are complex. Her beautiful face emerges from a dark background of coarser textures in grays or browns. Still the artist conjures up a resemblance of what she once was before the curse. The snakes curl or slither across her forehead, seemingly indifferent from the very face we see.

At one time, she had been that "Chaste Goddess," virginal and naive, pure and innocent, poets recalling her forgotten past, and artists combining her beauty and ugliness together in an expression of sadness. But Medusa was a mortal, and it was not until after Homer wrote *The Iliad* in the eighth century BCE that other narratives emerge, depicting her as a goddess or monster of all sorts of things. We seem almost obsessed with her, as if re-creating her image, designing our own Medusa, reflecting our own beliefs, can in some way help us to recover Medusa from the past. These Symbolist artists inscribe and interpret old myths, that identify more with the patriarchal definitions of women. This obsession among Symbolist painters with the Medusa figure lead to a reconsideration of her myth. They emphasize the seductive, dangerous nature of the cursed woman. The curse becomes very central to the way in which she is portrayed particularly by Symbolist painters, to show that she is now a knowledgeable and experienced woman who becomes a figurative threshold figure to the hero whose virtue must be tested. In the late nineteenth century, the roles of women are changing from the patriarchal dichotomy of the fallen woman or chaste woman (Angel of the House, as it was frequently put in the mid-nineteenth century) to women struggling for more autonomy. I argue that Symbolist painters express both fear and a fascination with these fluctuating identities of women. It is therefore important to understand how Medusa becomes emblematic of women's political and social rebellion as she is portrayed in Symbolist art.

I was inspired to write about Medusa when I attended the Spring 2013 *Ange Du Bizarre* Exhibition at the D'Orsay Museum in Paris featuring the theme of Dark Romanticism. Based on *The Romantic Agony* (1930) by Italian writer and art historian, Mario Praz, the exhibit explored eighteenth-century through twentieth-century artistic creations that revive myths, exploit enigmatic landscapes, confront man—his terrors and contradictions—and reveal the strangeness of everyday life. These works not only made visible the sexual idiosyncrasies of artists and writers, tormented by their obsessions, but also reflected sensual fantasies, both disturbing and cruel, shared by a universal human population, especially in the late nineteenth century. Noticeably at this exhibit was the reaction among artists to a stifling hypocrisy of bourgeois moral and artistic conventions. Noticeably at this exhibit, the Symbolist

painters, beginning with Böcklin, tried to get at the deep mysteries of life, clearly avoiding scientific analysis or an imitation of external forms, and repeatedly drawing upon inspiration from the Medusa figure. A commentary of this part of the exhibition keenly observes that "Satan and other princes of evil" are now more prominently embodied by the image of Medusa, "teeming with snakes" while she luridly gazes at the spectator. Traditional beliefs about Medusa who "petrifies those who cross eyes with her" are in fact subtly modified by these artists in their work. In these portraits, the spectator does not fear staring at her, but rather it is hard to pull one's gaze away from her. She is an odd paradox of beauty combined with horror, though these paintings reveal more of her splendor and less of her frightfulness. Artists von Stuck, Böcklin, Delville, and Munch paint her as a romantic figure that builds a new aesthetic model, fascinated by the taboo of looking at Medusa.

By being a romantic figure, the image of Medusa signifies a poetical paradise that is lost, seeking divine contemplation in her seclusion at Athena's temple, then suddenly cast out, and turned into a ravaged and cursed woman banished to the arid North African desert. In his comparison, Diodorus Siculus explains in *The Gorgons and the Amazons* how these women fought valiantly but were inevitably defeated by Hercules, a loss suggesting that women should not be leaders of large armies and nations. Her courage and leadership is seldom discussed. Instead Symbolist artists paint Medusa in the romantic style, which hints at the wanderings of the imagination that the artist does not always translate well into actual life. The romantic figure is sensual, and these paintings of Medusa attempt to gratify the sensibilities of the spectator with an inner unity at work here. The Medusa figure cultivates the ideal presence, a waking dream, a virtual state of mind, a higher reality, which directly conflicts with reality. Shelley, in his poem "On the Medusa of Leonardo Da Vinci," recalls: "'Tis the tempestuous loveliness of terror" (line 33). To be both lovely and terrifying at the same time makes Medusa fascinating to see, triggering both anticipation and titillation that comes with being frightened by a beautiful woman. Gazing at her is irresistible. But she is also a conservative symbol of revolutionary violence. The Medusa head articulates the political dilemma coupled with a complicated aesthetic one: how does the spectator identify with her, without speaking for her, the oppressed? It's actually impossible. That would suggest that any individual can represent the oppressed without having shared their experience, yet the truth of the matter is that they are silencing the voice of the oppressed by claiming that they are in a position to speak on their behalf. This would mean that anyone can flippantly use the Medusa symbol for their own cause, though it may not be representative of its intended purpose, to stand for those who are denied agency, to speak for themselves. The victimized woman in Shelley's poem requires a careful balance. In other words, to represent the oppressed by the figure of a female victim (Medusa) poses problems. This is to be read in light of fixed gender politics. Medusa as a symbol reveals that the gendered ground upon which political conflicts and aesthetic desires are articulated is

itself at stake in Shelley's work: "And from its head as from one body grow" (line 17). According to Barbara Judson in "The Politics of Medusa: Shelley's Physiognomy of Revolution":

> During the 1790s the Medusa functioned fetishistically: as a horrific image of castration, she emblematized the establishment's fear of losing its political and social privileges to the fury of women and the unpropertied classes demanding enfranchisement; but, at the same time, by virtue of the condensation and displacement intrinsic to symbolization, her snaky tresses extrude an apotropaic effect-constellating the male organ's petrifaction upon encountering this image-a stiffening that reassured the masculine establishment of its undiminished authority.
>
> (135)

Judson suggests that Medusa is an object of sexual desire that ironically threatens men's masculinity. Because she has been artistically represented as seductive, the femme fatale, a Salome figure, she compels the male gaze, but she renders man immobile, unable to act, and more so, she undermines their power over the existing political and social state of affairs. On a more social level, women are struggling and resist against male power. They wish to have the same social privileges equal to men, but this will throw off the status quo. But two images are fused together, and that is the threat of the Medusa, and her power to protect one from their enemies. Instead men can use her power to protect themselves, and that is by demonizing the threat posed by women. Her "snaky hair" comes to represent the power of the phallus. The stiffening of the phallus guarantees male subjectivity in response to danger, though at first, the fear of looking and identifying with figuratively castrated penises jeopardizes male authority, as Freud explains the reaction to Medusa's serpentine locks.

In "'What a World We Make the Oppressor and the Oppressed': George Cruikshank, Percy Shelley, and the Gendering of Revolution in 1819," Ashley J. Cross explains that Shelley's poem reveals a different revolutionary significance of Medusa. She comes to define what a revolution transforms into, beginning with an aesthetic ideal, transitioning into potential, and then eventual terror. Emblematically, the Medusa image warns about the wreckage of reform movements that result in violence over a struggle for power. The role in which the feminine operates is to consolidate power with all parties which is symbolized by the Medusean knot. On the contrary, Linda Shires clarifies that during late eighteenth century, the affiliation between radicalism and sensibility led conservatives to demonize both male and female revolutionaries "as disfigured by passion into beasts, furies, offal," who share beliefs that at the time were very pivotal (Judson 137).

By portraying Medusa, artists struggle with this paradox of a lovely woman transformed into a terrifying creature. Medusa's oppressor, Athena, represents the new order of the gods from the heavens and is put into a position where she must take action against the Gorgon who originates from the previous

rulers, the sea gods. But Athena's action must be aligned with patriarchal authority that punishes rebellious women. While her punishment is signified by Medusa's physical change, this transformation is unsettling as if writing about her or painting Medusa can make sense of a tragic and complex outcome. Furthermore, the patriarchal, canonical myth of Medusa relies on a dichotomy of women (good and bad, pure and fallen, lovely and terrifying). As David Leeming in *Medusa in the Mirror of Time* puts it, this "makes no sense" (97)—that a beautiful woman can be suddenly transfigured into a horrifying monster; he implicitly questions the reliability of the myth. The myth implicitly suggests that if a woman loses her physical beauty that she is of no value. Her value is determined by being gazed upon by other men. On the other hand, Praz notes that "pleasure and pain are combined in one single impression" (26), a fusion reflected by the Medusa image. Two polarities that mix together as a single unity result in the "ideal presence." Though it may seem unrealistic, Medusa is a desirable object for the very reason that her figure causes the spectator to be frozen by his prurient looking as if he is caught, like a peeping tom. The purpose for looking in this case is the hedonistic pleasure gratified by the very image he sees. From the poet's perspective, by gazing at Medusa, the linear structure of time must be considered by understanding how time fits harmoniously together. Within a Romantic framework, a linear flow is also an illusion, discontinuous of any time-ordered structure. Early German Romantic philosopher Novalis uses the term "Flame" as an image of transition between two separate worlds (95). Linear time is created in properties of memory. But the flame denotes both time and timelessness. Medusa represents both these worlds by her physical characteristics in Symbolist paintings. The viewer shudders at the face of the severed head, the snakes writhing about her face, the rigidity of death. But rising from this terror is contaminated beauty that tells the story of a woman whose punishment leads to endless interpretations. A revisionist myth of the Medusa figure generates new modes of thinking by imagining new relationships between old ideas about the Gorgon, old images, or breaking up old ideas and old images united by tradition, and to reunite them in a differently ordered fashion. Eventually this structure will divide until new links, equivocal and fragile, are formed. Medusa is a timeless image that can be reinterpreted, reconstructed, and reimagined throughout the centuries in which she captures the imagination. Praz points out that for the Romantics, "beauty is enhanced by the very elements that deny it" (27). Poisonous snakes, the dreaded Medusa head, the paralyzing gaze that produces horror are also combined with a sadder, more painful intensity that is relished by the Romantics. The ideology that structures each new generation leads that culture to arrive at its own conclusions about the representation of the Medusa head depending on popular beliefs that are in direct conflict with old ideas.

The Romantics of the early nineteenth century define beauty where pleasure and pain are combined as one experience. For example, Percy Shelley's primal and ekphrastic description of Medusa embraces all the elements in the portrait which should cause horror. Yet the terror in the eye of the Medusa,

the snakes for her tresses, Medusa's severed head are contrarily the very objects that create a new sense of beauty for the Romantics. Shelley explains: "Yet it is less the horror than the grace / Which turns the gazer's spirit into stone" (line 9–10). The poem combined with Da Vinci's painting create a meta-narrative by suggesting that the male spectator sympathizes and identifies with Medusa as a victim. Yet reading Shelley's poem compared to looking at the painting, also creates two different experiences. First, though it is not mentioned by Shelley, from where we look at Da Vinci's painting, we are standing from the position and perspective of the hero, Perseus. Second, while we may not physically turn to stone, Medusa, in this case, is the gazer and it is our spirit that turns to stone. By reading the poem, it might seem that we are locking eyes with Medusa, whereas when we look at Da Vinci's painting, we are beholding the head, while her gaze stares straight up, away from us. There is something more modest and far less threatening, more tragic, and less frightening in Da Vinci's painting combined with Shelley's poem. They come to idealize this aspect of beauty. It is a beauty that Mario Praz names as contaminated, finding beauty in that which has been corrupted. Beauty is enhanced by the very features that seem to deny it (Praz 27). The more sad, pitiful, and painful the object of beauty, the greater intensity the feeling of something refined and thrilling.

For Edgar Allan Poe, it was the death of a beautiful woman that he comes to find charged with an intense, indescribable feeling, ethereal, "the most poetical topic in the world." But it is necessary for this kind of beauty to evoke compassion for women whose features have been corrupted by horrifying events. These artists, poets and writers suggest that such an imperfect and murky past increases her value, driving our compulsion to look at her. However, I also argue that if horror becomes in fact a single most source of delight, then it is not compassion that men are feeling. Novalis explains, "It is strange that the true source of cruelty should be desire." Pain is an integral part of desire that can transform into empathy and sensitivity. To desire something that is truly beautiful would suggest that the object of beauty will always be out of our reach, coveted without fulfillment or satisfaction. This is where its power resides. Why is it painful to desire? Desire itself cannot stand alone in order to understand the source of its pain. In other words, the object of desire must also evoke compassion. A study of Symbolist painters who rely on images of the Medusa to show the connection between desire and fear help the viewer understand that desire alone is lacking. We must understand how desire poses limitations and must transform into something more fulfilling.

Shelley concludes that pleasure is inseparable from pain, that desire and suffering are intimately connected: "Our sweetest songs are those that tell of saddest thought" (line 90). Beauty constructs a dream world of fantasy. The beautiful woman gazes into a mirror like Lady of Shallot contemplating her reflection and the world as it seems. The lovely yet lonely damsel conceals the less happy aspects of her tale because it is too much an authentic reflection of reality that obscures the fantasy of the woman. Yet it is a woman's tale that makes her more human. By reinventing a woman's history into a dream world

her image infuses erotic feeling rather than compassion or spiritual ecstasy. The truth about her life is replaced by sexual imagery, recreated into a tale of excess, and we are reminded of so many sad cases such as cult figures like Marilyn Monroe distorted into an object of fanciful illusion. The truth of her humanity denies that fantasy, but instead reflects a woman in the mirror whose private history will never be understood by public perception. The image of the Medusa constructs a sad narrative caused by the pleasure of looking at her, which should be inseparable from the suffering that she has endured. But instead the intrusively curious onlooker only seeks her mystery that is attached to eroticism. Medusa's gaze is compelling; we cannot look away in spite of the danger of looking directly at her; Medusa's beauty has the power to stop mortal men in their tracks. Yet from a different perspective of Medusa, even before she is cursed, to be objectified as a beautiful woman alludes to sadness, having no control over how she is perceived. So what does rape have to do with desire? Rape does not fulfill desire because it will never result in possessing the woman whose body is violated. She remains out of reach—and it is only further coupled by pain, eventually leading to social exploitation of her pain. Medusa's beauty surpasses all other women, which also becomes a curse. To be celebrated for one's beauty is not an advantage. Poets and artists show that traces of her beauty remain after she is cursed. But she is forbidden in yet a different way, now more literally than ever. Rape contaminates and corrupts conventional standards of beauty usually portrayed as unadulterated and innocent, as if the aesthetic itself has been violated. But for the Romantics, it evokes a melancholy landscape. A supreme beauty is a beauty accursed, and inseparable from sadness. Beauty and Death are looked upon as sisters by the Romantics. Unless it is filled with an air of corruption, the Romantics profess that beauty otherwise is insipid and does not inspire careful contemplation. Thematically, Medusa represents tormented, contaminated beauty. After being raped and cursed, Medusa elicits a more profound and mysterious meaning of beauty.

The Romantics more specifically perceive Medusa as "a pose of sensibility" (Praz 38). They espouse the figure of Medusa to reconstruct a new mythic-poetic territory. Like many late nineteenth-century Symbolist artists, Shelley in particular explores the threat and mystery embodied in the mythological figure of Medusa. But more importantly, artists and poets seem more compelled to find something remote and distant that relates to the inside, even disclosing a hidden layer within themselves that they wish to expose, and they attempt to achieve such self-reflection through different constructed images of Medusa. Therefore, the difference in early to late nineteenth-century thought does more than simply intellectualize Medusa, or stereotype her as a symbol of male anxiety. Instead the image of Medusa "translates wanderings of the imagination into actual life" (Praz 38). Forms of the grotesque, that dark territory, provide material for such whimseys of the imagination. The "dark" is that which is cast out—bodily, feminine, natural or primitive. Impulses of the imagination are led by disembodied reason, or *dark enlighten-ment*. It is argued from this romantic perception that fatality, evil, and death are

manifested by female beauty which is corrupted or flawed, such as Medusa (tragically monstrous). Presumably, if there is something distant within the poet or the artist in which he searches to discover, his aim is to find it and then to explore its meaning as a way of understanding and knowing himself better. The Romantics and Symbolist artists come to identify fear and anxiety that they wish to overcome themselves in the Medusean figure. These artists depict Medusa as a dark, feminine force that dominates and penetrates the male spectator as these elements of identification become diffused, entangled, and trapped in the poet's and artist's consciousness, which can be ascertained in their work. The repetition of these objects and features, the color and tone in paintings or poetry, can still intensify rather than demystify, the ubiquitous fear and vulnerability that carries over from the artist to the spectator. So rather than name her as a muse, a force used to inspire the artist, this work demonstrates how poets and artists, by comparing different works, can also reveal that Medusa is specifically a subject of her own experience, not just the marginalized or feared "other." To be more specific, Medusa is more than a source inspiring or terrorizing the artist or poet, though the product of their work might ultimately mark such an effect on their audience. The threshold of the abyss that she marks is a reflection of our own interiorized fears with which we struggle against, and she permits the spectator to enter into the unknown. To see her as only a muse is to return back to the old antiquated belief that the artist / poet faces a destructive muse, by blaming her for the neurotic or anxious condition from which he suffers. Such blame is projected onto the external world, something from outside the artist. This describes a limited perspective that does not allow for the artist to create anything new about Medusa.

Discussing Medusa as a signifier of terror repeats the same old patriarchal story that begins in ancient Greece with Homer. Even in *The Iliad* where the Gorgoneion is first introduced, she is an underworld bogey, and Homer is evasive about what Medusa is supposed to be. It is only clear that she is an awful monster, and the head is to be feared. Even her gender is elusive. Is she man, woman, beast, or a synthesis of both? While the ancient Greek lens is patriarchal, no one can imagine seeing Medusa without being afraid. Yet this is also an ancient culture that believes the head is a protective good luck charm. Trying to decipher Homer's meaning, or whether he ever knew an actual monster like Medusa, is a quandary without any definite answer. Immanuel Kant professes that we cannot know anything in and of itself, and if something cannot be objectified, then it cannot exist. But the Romantics counter Kant's argument with empathy by breaking down the subject / object polarity; they obliterate this dichotomy to show that everyone is made a subject; we are subject to the object's influence on us. Therefore, when I look at Medusa, I discover me, and therefore, I can see her. By discovering Medusa, I discover me. She is looking back at me, while I gaze at her. Medusa shocks our moral sensibility. Why? What does the image see in us that we cannot see in ourselves? Are we remade into her subjectivity?

Through the lens of contemporary art, photographer Nan Goldin captures private, intimate moments of her female subjects that explore universal concerns. The subject / object polarity in Goldin's work can at least be revised to show how an objectified woman is remade into a subject. The photographs cause the spectator to feel the transience of life, while desperately wanting it to slow down. The vastness of everyday life is irretrievable, a moment, a memory, a relationship, a person—gone. In particular, Goldin's photographs mourn the loss of a moment; we capture that point in time as it disappears. In that moment of loss, the subject (the spectator) feels like she belongs to that object. Aching for the memory, we attach it to people and therefore feel the loss of those people. The best examples of this are more clearly illustrated through the lens of an artist that is articulating more authentic expressions of herself and how it is conveyed by her subjects. The spectator looks at an image, a photograph, taken during a certain period of time, a recorded moment, that conveys a specific mood projected by that person. But that moment is lost as soon as the shutter clicks, though we can observe the original recording. Emotions that come to mind enable that image to register with us, whether it is, for us, a lost part of our past, a lost lover, or a lost part of ourselves.

Medusa is literally paralyzed in time over and over again, by artists and writers alike. Poets and artists are constantly reforming and transforming Medusa's beauty to express their own projection of the world in which they live. Beauty is martyrdom when a woman sacrifices herself for a greater cause when deformed and suffering female beauty profoundly affects genuine feeling, and in death, especially of a young woman, transforms her defects into her merits. When Medusa dies, her blood becomes life-affirming, giving birth to Pegasus, the winged stallion, pure white in color, ascending to heaven after his birth. He is symbolic of wisdom and associated with poetry in the nineteenth century. He also means lightening. The birth of Pegasus suggests that there is more goodness to Medusa, and innocence is finally reborn. But in life when jealousy between two women leads to competition, it becomes a handicap to all involved. Apollodorus certainly notes this conflict between Athena and Medusa that "the Gorgon was fain to match herself with the goddess even in beauty" (34).

While the trope of the Medusa figure originates in ancient Greek myth, beginning with *The Iliad* by Homer, this figure evolves into new nineteenth-century artistic forms and meaning. Medusa more traditionally represents the victim / predator dichotomy, and in Symbolist art, she is a medium used to force the spectator to confront his own obsessions. Though critic Helena Goscilo, in "Vision, Vanitas, and Veritas: The Mirror in Art" claims that these late nineteenth-century male artists "focused less on reflectivity than on the phallic" (283), this is inaccurate. It is important to note that at this time in the nineteenth century, Freud had not yet established the symbolic link between the Medusa head and the castration complex. In fact, Freud had not even published any material on the phallic. *Three Essays on the Theory of Sexuality*, where Sigmund Freud analyzes child sexuality and the phallic stage, was not published until

1905, and he did not write the essay "Medusa's Head" until 1922, published posthumously. Knowledge of the phallic stage or psychosexual experience was unknown at this point when Böcklin produced the painting, *Medusa's Head*, in 1878, and von Stuck painted *Head of Medusa* in 1892. But Goscilo does make more valid claims that Medusa is an "inspirational" source "for later generations of male artists" and that "feminist scholarship ... [undermines] the misogynistic cliché of the lethal female gaze" (283). The myth of Medusa, in general, becomes a central obsession among these painters who find delight in her poisonous beauty. But there is no evidence that these art figures of Medusa figuratively epitomize Freud's phallic stage. Artists fascinated by this form of beauty conceive of nature as a cruel strength, a destructive and perverse force because her power is secret and beyond their control. It can also be argued that these artists attempt to reactivate the Judeo-Christian myth of the Fall. Frequent social problems of prostitution, venereal disease, and plagues in modern cities characterize the fin de siècle that fuel the imagination leading to personifications of the Fall embodied by powerful, mythical female characters. The dangerous, seductive woman is symbolized in the image of Eve, of all women blamed for being a bad influence, or cursed for unruly behavior that goes beyond the control of patriarchy, deadly Salome, or duplicitous Lilith.

Symbolist painters' philosophical creativity is also formed by determinism, the pessimism of Schopenhauer who explains in *The World as Will and Representation* that art awakens a desire that has been concealed by the unconscious mind (406). These artists agree with Schopenhauer that such an awakening allows one to identify and understand the true nature of things. Therefore, an artistic objective "is the expression of the true nature of life and of existence" (406). A work of art, according to Schopenhauer, answers the question: "What is life?" The central objective in nature is to manage human impulses. Though Symbolist painters have expressed in their work that women use their feminine beauty to seduce men, leading to men's great fear of being duped by feminine beauty, of being de-masculinized, and eventually defeated by death, they also represent Medusa as a figurative mother earth. Her secrets can be discovered through the unconscious which generates something new in how the artist identifies with Medusa. These artists put themselves on center stage in this drama, daring to plunge with delight and suffering into the terrible abyss, the secrets of nature, in this case, represented by images of Eve, Medusa, women who rebel against conventional patriarchal boundaries.

Though Symbolist painters attempt to combine elements of beauty with terror, such as the snake-haired woman, it is important to note that in order to achieve this effect, they draw upon patriarchal conventions. The central female figure, while mysterious and often forbidden, must still be perceived as a victim and limited to male power, which ultimately results in too limited a repertoire. Munch and Stuck in particular make new attempts at "interpreting" the Medusa story in their art, but it is not a retelling of her story. For Munch, she serves as a motif telling his story, at so deeply a personal level, that at times he did not like

to show his work publicly. But for any artist retelling or transforming Medusa's myth, it also requires transcending the old victim / predator paradigm that defines women. If the paintings were to tell a new story from Medusa's perspective, then the motifs in Symbolist art could no longer rely on a male patriarchal fantasy; it would mean that these interpretations of ancient Greek and Roman myths of Medusa no longer stand as an adequate foundation in modern contemporary times. This paradox between object / subject in the study of Medusa makes a slight shift during the nineteenth century in Symbolist art when Stuck, Munch, and Delville suggest that Medusa is not so much to be feared, but to render the viewer awestruck. On the one hand, to be paralyzed by the sublime beauty of Medusa can be interpreted as reckless and destructive. Deciphering the mystery of the feminine requires men to transgress safe boundaries even though they realize that they are vulnerable to this seductive force of the feminine. This leads to questions about where that seductive force is specifically located and to recognize where Medusa's power really resides. At this point, her force cannot be exclusively determined by male definitions dating back to ancient Greece and Rome. In nineteenth-century full-figure images, Medusa is often nude, compelling the spectator's attention. She controls the male gaze. But portraits of only her head signify her death. Defeated by Perseus, she is tragic and sorrowful. In the paintings of Medusa's head her softened beauty suggests that there is more pain in leaving this world than there is by living in it. The Medusa figure proliferates during this time, echoing this obsession "to know." Male artists are more obsessed with the dangerous woman who sparks intrigue and mystery, a fascinating beauty, though she is turned ugly *by her experience*. The course of events from fragmented narratives about Medusa lead to several questions about her. Her story is extremely vague in the study of ancient Greek and Roman myth. In fact, a large gap is left open during the course of her life events. For example, what exactly happened to her from the time she is raped up until the time Perseus beheads her? Furthermore, we only know Medusa from a male perspective, and there are so many parts of her story left open to either interpretation or retelling, which modern narrations attempt to do.

So here I argue that artists can only make new interpretations about Medusa, but the retelling of her story is more accurately made by the literary images told from the perspective of female poets, and by narrative portraits constructed by female artists. There is a distinction between interpreting the Medusa myth and retelling her myth, or revising it. Goscilo makes this distinction by explaining that:

> four decades of feminist scholarship have undermined the misogynistic cliché of the lethal feminine gaze and discredited the long-standing equation of the Gorgon with the deadly principle of arbitrary evil, in the process exposing the psychological and political advantages within patriarchy of such a demonizing perspective.
>
> (283)

First, Medusa does not denote "evil." There is no evidence in ancient Greek or Roman literature that she ever did anything wrong. In fact, Hesiod appears most sympathetic when he notes that Medusa "suffered grievously" (Book II, 278). The patriarchal claim that Medusa is evil due to the consequence of Athena's curse is misogynistic, and as Goscilo argues, it leads to "political advantages" for men. Such advantages suggest that a woman is always wrong, even if a crime is committed against her; her story will never be taken seriously because whenever her story is made public, it will always be distorted from a patriarchal perspective that suggests the woman was asking for it. Patriarchy, even today, still constructs our social consciousness of the truth. Furthermore, there is a psychological advantage by stereotyping Medusa as "evil." It suggests that women who have power or pose as a threat against men are bad, and can fit only within the margins of society, but never within the mainstream.

It is not until the twentieth century that female poets May Sarton, Margaret Atwood, and Ann Stanford begin to tell a different story about Medusa, filling in the space between the time Medusa is raped up until she is beheaded by Perseus. Their poetry humanizes Medusa and eradicates these beliefs that the feminine gaze is lethal, that Medusa is evil, an instrument of Hades as she is portrayed by Homer in *The Odyssey*, as the Underworld's guardian / monster (XI, 633–635). Rather, these female poets show that Medusa's story of rape and powerlessness is familiar to other women of all generations, from youth to old age. But while Medusa shares that ravaged place with the reader, she also symbolizes emotional and intellectual curiosity. She does not renounce where she has been; she is not ashamed of her past. She is both darkness and the other side of darkness, light and healing.

In a sequence of poems based on Susanna Moodie's *Roughing It in the Bush*, Margaret Atwood generates a modification of the mythical Medusa archetype. Unlike the Medusa in Symbolist paintings, in Atwood's poetry, Medusa is no longer an object. Rather the poet's source of inspiration comes from rocks themselves, the very thing Medusa creates out of living creatures. Rocks come to stand for human experiences, containers for human sentiments. In "Medusa in Canada," Annis Pratt explains that "by holding pebbles in their hands the human speakers acquire a fresh, polished diction, a poetical dialectic of equal interchange between human and stone being, the synthesis being a 'flight of words'" (90). Human emotions and traits are expressed by rocks held together in a synchronistic pattern by the poet. In Atwood's poems, such a metamorphosis is not limited to rocks; human experience is also expressed by trees, totem poles. Moreover, it's not the rock that represents human experiences, but human experiences represent rocks in a number of different rock types. Medusa is easier to understand in the context of attitudes toward nature. In nature, she does not have to represent human form, or conjure up pastoral romantic notions, or signify existential beliefs. In other words, there must be a harmonious relationship that develops in narratives pertaining to Medusa. She can no longer be represented as an artist's muse, a victim in which the artist / poet can identify, a fascinating yet threatening woman, a representation of failed relationships, all

of which are examples of Medusa depicted in Symbolist Painting, or Romantic poetry by Shelley.

Poet May Sarton takes a far different approach compared to that of Atwood. In "The Muse as Medusa," Sarton does show us how female identity is shaped by means of refuting legends about Medusa, and therefore subverting the paradigm of "Other." In this reading of Medusa, one can liberate herself from oppressive patriarchal stereotypes about women when Medusa becomes an exclusive source of inspiration for women. For the female artist, the Muse is Medusa turned backwards. The true artist therefore looks within herself, and she starts by removing that unyielding force in order to see, to look, to gaze upon herself as if for the first time. By removing or moving past that rigid force within herself, a woman learns how to live independently from oppressive clichés. We therefore end up using that force rather than letting it turn us to stone. Medusa is not outside of us, but rather she is an answer to us, an expression of what we might be or become in our more liberated form. Sarton tries to illustrate this expression for the reader. But this begins with an identification, that the poet can look Medusa straight in the eye. She must not be afraid of what she sees, and when the poet / female artist looks to herself, she must no longer look in horror. In order for a woman artist to see herself, and the world differently, by using Medusa as a Muse, she must no longer view herself through a patriarchal lens.

Unlike the more esoteric approaches to Medusa taken by Atwood and Sarton, Ann Stanford constructs a literal image of Medusa that retells her story from a rape victim's point of view. In "Medusa," Stanford describes the anger of a violated woman, which becomes an emotional and physical manifestation of trauma caused by sexual assault that goes unpunished. The reader comes to understand the psychological destruction resulting from violent rape through the first-person narrative of Medusa. While mental health concerns can diminish self-confidence, Medusa transforms into a headstrong warrior figure, her mental state expressed by her rage. Furthermore, Medusa is also writing her own story through Ann Stanford's words; it is her voice. She refuses to be the silent woman—the invisible woman. Atwood, Sarton, and Stanford break down the treatment of women as objects that are inscribed by patriarchal convention. The voice of Medusa, particularly in Sarton's poetry, envisions the Gorgon as a feminist narrator who mocks the degraded view of women in the original Greek and Roman texts, by giving a more gentle understanding of Medusa's plight.

Twentieth- and twenty-first-century artists, Nan Goldin and Liz Craft, explore the unfathomable abyss of current obsessions, fears, and secret desires communicated frequently in late twentieth and twenty-first-century popular culture. These artistic expressions, in which women are the dominant theme, lodge new translations of Medusa. Goldin reveals two sides of the woman—the one we see on the outside, and the one hidden on the inside, the internalized self, which becomes a physical projection in her photography: the female subject is the woman lurking behind the mirror, arousing a sense of wonder, fear,

dread, melancholy. The mirror becomes an important mechanism that reveals an image reflected back. Goldin's lens on her camera becomes that metaphorical mirror capturing what we fail to see in person, the two sides of every woman. The physical woman is a paradox of the image captured by the lens, almost as if the female subject in the picture has figuratively turned to stone, and we, the spectator, are viewing her for the first time as she really is. Medusa eludes such binary definitions of good and bad, and the camera is an instrument, a mirror that allows the viewer to understand how new meanings emerge, shape, and transform identities of women today. Nan Goldin visually archives contemporary fears, obsessions, and desires, by capturing the underground drug culture of the early 1980s, and tragedies caused by the AIDS virus, fears propagated in the early stages of medical discoveries. Cookie Mueller is a central figure in Goldin's work, and Goldin recorded Mueller's life experiences on film between 1978 and November 1988 when Mueller succumbed to the AIDS virus. Mueller's rebellion and unconventional fearlessness epitomize a contemporary Medusean myth that escapes binary signified codes.

Contemporary twenty-first-century artist, Liz Craft, deals with stimulation of the brain activated when observing the behavior of others. Craft sculpts newspaper mâché effigies of women that remind the viewer of our fascination with looking and observing, that we for a minute disappear, turning stony, lost in the gaze of the other person. Unlike the so-called objectification that often comes with looking, we are in silent observation of our surroundings and other people, which can powerfully subdue our egoistic agenda; we finally step aside, to watch and learn from our environment and the people who are active within it. The idea of watching, observing, and being observed evoke a number of emotions, quite compelling to me. Craft's work engages with this experience of looking and being looked at, the feeling that we are no longer there, the unconscious experience of being in between this world (our world) and that one (belonging to the other). The dubious nature of women, of her culture, of her power, or disempowerment, is provoked by these sculptures, evoking the fear of age, loss of beauty, the crippling effects of post-modernism that still objectifies women for their weight, color of their hair, their ethnicity, the pressure to look youthful, the compulsion to look like a standard convention of beauty.

It is the female artist who does not struggle so much with the Medusa myth as do nineteenth-century Symbolist painters, though they are the first artists who attempt to transcend the common dichotomy of good and bad when it comes to the Gorgon woman. Instead the female artists knew Medusa. She understands her two sides, to look in the mirror and identify the shadow self that remains hidden from public view. The female artist demonstrates that all women can settle into her Medusa self, which leads to a keener awareness of her power, where she is liberated from any form of self-loathing or self-consciousness. She ties together all her life experience into the very center of her "self."

Bibliography

Ange du Bizarre Exhibition. D'Orsay, June 6, 2013.

Apollodorus. *The Library of Greek Mythology.* Trans. by Keith Aldrich. Coronado Press, 1975.

Cross, Ashley J. "'What a World We Make the Oppressor and the Oppressed': George Cruikshank, Percy Shelley, and the Gendering of Revolution in 1819." *ELH,* 71(1), 2004, pp. 167–207. www.jstor.org/stable/30029926.

Freud, Sigmund. "Medusa's Head," *Collected Papers,* Vol. 5, ed. James Strachey. Basic Books, 1959, pp. 105–106.

Freud, Sigmund, and Strachey, James. *Three Essays on the Theory of Sexuality.* Basic Books, 1962.

Goscilo, Helena. "The Mirror in Art: Vanitas, Veritas, and Vision." *Studies in 20th and 21st Century Literature,* 34(2), 2010, pp. 282–319. https://doi.org/10.4148/2334-4415.1733.

Homer, and Palmer, George Herbert. *The Odyssey.* Mifflin and Company, 1891.

Judson, Barbara. "The Politics of Medusa: Shelley's Physiognomy of Revolution." *ELH,* 68(1), 2001, pp. 135–154. www.jstor.org/stable/30031961.

Kesting, Jürgen. *Maria Callas.* Quartet Books, 1992.

Leeming, David. *Medusa: In The Mirror of Time.* Reaktion Books, 2013.

Levezow, Konrad. *Uber die Entwicklung des Gorgonen-Ideals in der Poesie und bildenden Kunst des Alten.* Berlin, 1833.

Mahony Stoljar, Margaret. *Novalis: Philosophical Writings.* State University of New York, 1997.

Pratt, Annis. *Dancing with Goddesses: Archetypes, Poetry, and Empowerment.* Indiana University Press, 1994.

Praz, Mario. *The Romantic Agony.* 2nd ed. Oxford University Press, 1990.

Romani, Felice, and Bellini, Vincenzo. BELLINI, V.: Norma [Opera] (Callas, Corelli, Ludwig, Milan La Scala Chorus and Orchestra, Serafin). Naxos Digital Services US Inc., 2014.

Roscher, Wilhelm Heinrich. *Uber Selene und Verwandtes.* Leipzig, 1890.

Schopenhauer, Arthur. *The World as Will and Representation.* Dover Publications, 1966.

Shelley, Percy Bysshe. "On the Medusa of Leonardo Da Vinci: In the Florentine Gallery." Romantic Circles, July 21, 2019, https://romantic-circles.org/editions/shelley/medusa/mforum.html.

Stafford, Barbara. "'Medusa' or the Physiognomy of the Earth: Humbert de Superville's Cosmological Aesthetics." *Journal of the Warburg and Courtauld Institutes,* 35, Warburg Institute, January 1972, pp. 308–338. doi:10.2307/750935.

Stand with a Gorgorneion. Signed by Ergotimos as potter and Kleitias as painter—Terracotta. 570 BCE. Metropolitan Museum of Art, New York, August 3, 2018.

2 The historical and mythical origins of Medusa

Throughout Greek and Roman myth, the story leading up to the curse of Medusa and events that follow, ending in the final death scene where Perseus beheads Medusa, are told in fragments. Not only do readers lack a clear, linear tale of Medusa from beginning to end, but the timeline is missing significant details, which requires patching together her story from ancient Greek and Roman poets. So to have a clearer understanding of Medusa's myth, the reader additionally learns about other Greek gods, goddesses, and fearless mortals whose own struggles and triumphs help develop Medusa's story. Her narrative begins with her noble ancestry, worship in Athena's temple, rape by Poseidon, Athena's curse, exile to the island of Sarpedon near the Aegean coast of Turkey (as portrayed by Aeschylus and Hesiod) or banishment to Libya (according to Dionysius Scytobrachion), and death by Perseus' sword. Needless to say, it is necessary to know the historical origins of Medusa before showing how the feminist revisionist myth-making of the Gorgon transitions from Symbolist to twenty-first-century art. Moreover, understanding the Gorgon's history is critical to recognizing the various interpretations in which she is represented in art and literature over the course of the last few centuries.

Greek poet Homer writes the first myth about Medusa in the eighth century BCE. By that time, she is already deeply embedded within Greek life as a talisman that guards one against their enemies. A study of Greek antiquities dating back to the eighth century BCE displays only the Medusa head as opposed to her body, which provides a greater clue as to what might have been her true origins. In ancient Greece, the Gorgon head is used as a talismanic mask on clothing, vases, bowls, coins, weapons and other objects before and after Homer writes about Medusa in *The Iliad*. So much of her story at this time in Greek history involves head-centered symbols. In early Greek art during the eighth and seventh century BCE, Medusa's head is never in profile, but always facing out in a menacing, clown-like grin. She has tusks, oversized teeth in a row, her eyes bulging outward. Her tongue protrudes in a mocking gesture. Serpents mingle in her hair. There are no human or feminine features in these early art objects displaying the Medusa head, making her gender ambiguous, the mask being neither male nor female. In *The Mirror of Medusa*, Tobin Siebers, Professor of English and Comparative Literature at Columbia University, interprets

Medusa's face from the account of Ovid as stupefying, a disappointing portrayal for the reader because Ovid never describes Medusa, but instead reduces her to a death mask (2–4).

Jane Harrison, member of the Cambridge Ritualists, explains in *Prolegomena to the Study of Greek Religion* that "Medusa is a head and nothing more"; the body was appended later in myth (187). Masked figures keep away various forms of evil. In ancient Greece, according to Harrison, rituals came first, which means that the myth of Medusa, the story that explains the ritual, came last. So the mask, therefore, would precede the myth of Medusa, the myth which gave the rest of Medusa some kind of more permanent human form. By the time the myth of Medusa takes shape, she is no longer just a mask, or a monster used on various objects, but an actual woman whose physical transformation is depicted later in ancient art. But even when the Gorgon is eventually given a body, her physicality is still somewhat ghoulish. One of the earliest full-figured portrayals of Medusa dates back to seventh-century Syracuse on the famous sixth-century pediment on the Temple of Artemis in Corfu. In this representation, the head is incongruous to the body, appearing to be awkwardly attached as if body and head do not match (Temple of Artemis). The body is large and more masculine than feminine; the head is also big and always in a full-frontal pose, never in profile position.

The chronological order of Medusa transforming in art from a demon-like mask to a beautiful woman suggests that she first originates as an apotrope, and then dies in myth soon after a body is attached with a gender assigned to her, and now a story to tell. This process implies that without a human physical body, a woman lacks a story; her body narrates her history and therefore must exist before her tale can begin. If there is only a head, the Gorgon's head, then we are only left with a symbol, and later a ritual, which Harrison contends eventually leads to explanations about the symbol. A ritual in this case means that there must be a sacrifice. A victim is held responsible for a crisis, a social transgression. In order for that transgression to be resolved, the victim must be sacrificed. This involves first cursing the victim and then sanctifying the victim after they are killed. According to Siebers, the victim "creates and cures the crisis" (20). The mask comes to represent this ritual. Medusa is, at first, nothing but "a frightening object" as Siebers puts it. But fitting within a far more didactic purpose, the function of the mask, Harrison explains, is to make "an ugly face at you if you are doing something wrong" (188). Harrison gives examples of these minor offenses such as breaking a promise, coveting one's neighbor, or initiating a fight. Nevertheless, the mask is meant to be troubling so that whatever is wrong, it must be worked out. When someone is performing the act of doing something wrong, and if he is caught in the middle of that wrongdoing, he is paralyzed by guilt. Nothing can hide the crime. That is one analogy to the mask, to be exposed for that peccadillo, which makes the perpetrator of the offense responsible for correcting their crime. Therefore, the purpose of the mask as a religious apparatus in ancient Greece is to resolve conflict. Based upon anthropological studies conducted by Harrison, there is really no

other way of understanding Medusa other than through the lens of religious ritual. Evidence in this case demonstrates that Medusa began, not with a story, but as a symbol, a mask that later evolves into myth-making. Originally, these masks were religious apparatuses used as an instrument of terror by the Greeks, and in fact are still in use today among tribal communities. The Gorgon's power begins after the head is severed. In ancient Greece she is a cult figure, a ritual mask that Harrison confirms is "misunderstood" (187). In other words, she is a cult object, a head, and nothing more.

Leeming reports that in the third millennium BCE, the Sumerian Gilgamesh story demonstrates a remarkable parallel to the later myth of Medusa and Perseus. Gilgamesh and his animal friend Enkidu enter a sacred cedar forest guarded by the demon Humbaba (Leeming 25–26). Having entered this forest without permission, Gilgamesh fights Humbaba, and with the help of the sun god, Shamash, with the power blinding Humbaba, Gilgamesh decapitates the demon. Figuratively, the Egyptian myth portrays Gilgamesh as Perseus and Humbaba as Medusa. This myth is theatrically portrayed in Humbaba masks made of terra-cotta. The bulging eyes, prominent teeth, and distorted features are very much likened to previous depictions of eighth-century Gorgon masks. Similarly, the popular figure Bes, in Egypt, during the twelfth century BCE, like Medusa and Humbaba, is always depicted as a face looking forward, unlike all other Egyptian drawings in which figures appear in the profile position. Only Medusa, Bes, and Humbaba are portrayed with the full-frontal face, staring eyes, protruding tongue, and menacing grin. These three images served the same purpose, placed in households to ward off evil spirits. It is typically throughout the eighth and seventh century BCE that Medusa is largely imagined this way, a very popular, symbolic image. But by the third century BCE, art depictions of Medusa begin to evolve from the androgynous to a more feminine form, a more sexualized body with the head, a beautiful face that accents Medusa's sensuality, and less of her monstrosity.

Greek and Roman myth revises the image of Medusa by emphasizing her femininity. The mask that terrifies the beholder into taking responsibility for their sins and pleading for absolution, transitions into a more refined, feminine form that now expresses a new purpose and a different warning. In the art exhibit "Dangerous Beauty: Medusa in Classical Art," Kiki Karoglou observes that:

> Progressing from the magnificently monstrous to the terrifyingly beautiful, female hybrids represent a conflicting view of femininity, one that is seemingly alluring but with a threating or sinister underside. They are situated in the uncomfortable space between attraction and desire, on the one hand, and repulsion and anxiety on the other. The process of their feminization was a hallmark of the mythical and artistic imagination of the Classical period when Greek artists humanized and beautified the most repugnant and hideous of all, the Gorgon Medusa. Much like Medusa's gaze, the power of their art is transformative and enduring.
>
> (45)

While this aesthetic transformation of Medusa begins in the fifth century BCE, it is important to understand the cultural influence that made this shift between demonizing Medusa to now idolizing her beauty. The Gorgon's physical repugnance in early art depictions of the head serves as a defense against evil. But this metamorphosis from monster to seductress is specifically meant to create and shape Medusa's myth. To be a seductress represents her as a different kind of threat where men find her sexually exciting but are also ashamed to admit it. Artists reveal the male spectator's personal quandary by viewing art that features Medusa, the man who wants to look and stare while Medusa is portrayed as dangerous, the antithesis of cherished convention. Her beauty undermines male power since, and men are repulsed for wanting a woman that represents evil yet triggers their self-defeating impulses. The desiring male subject cannot meet up to the demands of his ideal self when he secretly harbors a fascination for Medusa, the castaway, the bad woman, precipitating his weaknesses. Symbolist artists in particular negotiate this space between Medusa and the male spectator.

In the Medusa exhibition held at The Metropolitan Museum of Art in 2018, this transformation of the Gorgon woman is carefully explored from Greek antiquity to present day. There is also a shift in representations of sphinxes, sirens, and the sea monster Scylla. Later representations of Medusa beginning in the fifth century BCE portray her as a young and beautiful woman. In contrast to ancient Greek art, the multitude of venomous serpents are changed into long, luxuriant hair featured in Symbolist paintings. Furthermore, she is not apotropaic in Symbolist art. But in ancient Greek hand-painted or sculptured portrayals of Medusa, a pair of wings are at her head with two snakes, tied into a knot below her chin that symbolize protection. Greek poets, Homer, Hesiod and Pindar, do not write a description of the "monster" with lolling tongue, and the snakes are not mentioned at all until Roman poet, Ovid, writes about them when Minerva "transformed / The Gorgon's hair to loathsome snakes" (98). Yet in Greek myth, Medusa is the most threatening compared to any of the dangerous female archetypes. One example is in contrast between Skylla and Medusa. The power of the tongue is no match for the eyes in a comparison between the Sirens with the Gorgons. The sirens charm passing ships with their music, maneuvering these men off-course and into unsafe territory with their songs. However, their performance only poses as a temporary delay. The beauty of the Gorgons being extremely powerful and affecting the very vitals of the soul, stun its beholders and makes them speechless so that everyone who sees the Gorgon, turns to stone in wonder. Medusa reigns over those living around Lake Tritonis, while she also went out hunting and led the Libyans into battle according to Diodorus Siculus. When she is encamped with an army against the forces of Perseus, she is assassinated at night. Admiring her beauty even in death, Perseus cuts off her head and carries it away to show the Greeks.

When her image is joined with the Perseus myth in *The Iliad*, Medusa becomes entirely female, and this is where the art and physical image of Medusa begin to take yet another new shape. She now has a body, a head, her clownish face transforms into an ideal image of feminine beauty. Hence, when she is

conquered by men, one who rapes her and one who murders her, she becomes purely feminine. By the first century BCE, the story is not only compelling, but even romantic when Ovid characterizes Medusa as a notoriously dangerous woman, once glorified for her beauty, who presumably suffers in the end; she is both mysterious and tragic. After he defeats her, Perseus must take special care of the Medusa head in order to protect his own power. But nevertheless, Perseus defeats the woman under the pretense of overcoming evil when really he uses the spoils of his victory to serve his own self-fulfilling ambition. It is important here to understand the ways in which the story changes and develops leading up to Perseus. Medusa begins as a mask and transitions into the myth of Perseus. Furthermore, an additional perspective emerges of what that mask can actually do for the beholder of it. It not only protects against one's enemies, but it also protects one against themselves, by serving as a warning against the corruptive nature of power. The shield through which Perseus seeks out Medusa protects him, but also allows him to now look at her without the consequence of turning to stone. However, it also obscures his own rage and anger when he masks "himself with Medusa's fatal countenance" (Siebers 12). This expression of fury leads to fatal petrifaction that helps Perseus defeat his enemies.

Benvenuto Cellini's marvelous statue helps reveal this irony (1545–1554). Perseus stands victoriously, his own hair appearing wild and coiled, tusks on the side of his head, his face pointed downward, sword grasped firmly in his right hand, Medusa's head held high in his left hand, the Gorgon's eyes closed, her childlike features an odd paradox with Gorgon blood flowing from the neck. Cellini's image is one of great beauty, compelling. Perseus is naked, his body strong, youthful, rippled, exuding complete masculinity, but his face appears so much like that of Medusa, paradoxically cherubic, that Perseus and Medusa appear to be one and the same, their faces expressing a calm resolve, neither triumphant nor defeated. Siebers notes that both Perseus and Medusa in Cellini's sculpture display "identical profiles … aquiline noses, deliberate cheekbones, and lowered eyes twin each other, presenting a baffling spectacle for those in need of clear distinctions between the heroic and monstrous" (12). But there are no real distinctions here besides the fact that Medusa is bodiless. Between Perseus and Medusa, what we see here is the loss of any clear difference, that they are both equally encumbered by the same emotions and fallibilities. Perseus holds up the head of Medusa as a weapon, yet he wears the same mask, the lines indistinguishable. Perseus becomes as equally dangerous when he exploits the use of the Medusa mask, populating the earth with serpents formed by her blood, adding to the number of her victims. It eventually becomes obvious that Perseus is an even more palpable threat than Medusa. They both come to mirror each other, the mask mirroring Perseus' actions which become more treacherous and imperious. Siebers argues that Cellini also depicts "the seductive yet fragile feminine body" that is juxtaposed with "the crown of snakes," but both Medusa and Perseus are monstrous because they embody both good and evil, not one over the other (13). The god-like image of Perseus in comparison is polarized by both serenity and death, that conclusively he is still

in reality heroes are monsters

mortal. It reiterates the point that Harrison observes in early Greek ritual and the use of the mask, that in comparison, the Medusa head mirrors what Perseus is doing wrong.

Furthermore, Cellini emphasizes Medusa's head, the bodiless woman so that the spectator's attention is first drawn to her instead of Perseus. The loss of her body also alludes to the very complications of her story, that much of it is lost or left to the interpretation of male Greek and Roman poets. Similar to the earlier masks depicting a genderless image, Medusa's face becomes once again an apotrope that now appears most notably on shields as characterized by Ovid: on the shield of Minerva, the breastplate of Zeus. The earliest playwright Euripides suggests that Athena was first to use Medusa's head on her shield to protect her against enemies in battle. Gorgon from "Gorgo" means terrifying, the stupefying look that terrorizes and subdues all enemies. She is the first gargoyle, it could be argued, appearing on buildings, temples, churches to scare away evil influences. Medusa's head, overall, is a warning used ironically to drive out terror.

Gaia the primordial goddess

Medusa comes from the most ancient family of the gods, Gaian, associated with the earth and sea, in contrast to the Olympian gods, identified with the sky. Gaian leader, Pontus is the source of all creation on earth and had once been lord of the sea, but Zeus lowers him to a leader of sea monsters and promotes Poseidon to the great sea god. According to Hesiod, the Gaians struggle to sustain their power and fight with the Olympian gods. War in heaven between the Gaian family and the new family of Zeus leads to the defeat of the Gaians, reducing them to sea monsters. Prior to war, Zeus breaks away from his family, and he imprisons his own father, the lawless child-eating Cronus. Inevitably this new generation of Olympians replace the ancient gods governing the sea and earth.

Gaia was the goddess of the earth, giving birth to Pontus who mates with his mother and produces the father and mother of Medusa, Phorcys, and Ceto who rule over the sea monsters. Ceto has many offspring, beginning with the "fair cheeked Graiae, sisters grey from their birth" with white hair. In later accounts, they have only one eye and one tooth shared among them (Hesiod lines 270–271). In *Theogony*, Hesiod names only two sisters, the deathless gods Pemphredo and Enyo, while there is in fact a third sister, Deino. Other sea monsters born to Ceto are Thoosa, the mother of Cyclops, blinded by Odysseus; Hesperides, the dragon like monster guarding the apples of the nymphs; and Skylla who swallows sailors. The nature of all the offspring of Ceto and Phorcys are negated by the doom or mischief they cause. When Ceto bears triplets, the Gorgon sisters Sthenno and Euryale, Medusa is the only mortal. Medusa's two sisters live "in the frontier lands towards Night … undying and grew not old" (Hesiod lines 274–277). The two Gorgon sisters have twin heads twined about with the scales of dragons and great tusks like swines, and brazen hands, golden wings by which they flew. They turn to stone anyone who beholds them.

Because she is different from her family's lineage, Medusa demonstrates the possibility of escaping her family's legacy when she attempts to devote her life to worship in Athena's temple. But her ambition is short-lived, and she "suffer[s] a grim fate" (Hesiod line 274). According to Hesiod, Medusa is not raped by Poseidon, but instead lies with "the Dark-haired One in a soft meadow amid spring flowers" (line 280). In this version of the myth, Medusa is willingly lured by Poseidon outside of the temple, and seduced by him. Medusa's father, Phorcys, is the grandson of Gaia. It becomes very ironic that Medusa is the daughter of Phorcys, who Poseidon lusts for, whom he stalks after, and eventually rapes in Athena's temple since Poseidon replaces Phorcys as lord of the sea. The story becomes even more complex when Athena curses Medusa, and exiles her from Greece. Again, Athena and Poseidon are Olympians, but Medusa is a member of the Gaian family that had once been a formidable enemy of the Olympians. Given these circumstances, it is important to question the reasons why she is cursed. She is blamed for violating Athena's temple after Poseidon rapes her. Medusa is a scapegoat representing the transgression of an unmarried mortal woman having sexual intercourse. The crisis must be put to an end, the taboo rooted out of Athenian society. In every culture, there is a search for a scapegoat who serves a purpose forced to be an example of lawlessness, and therefore bringing a halt to transgressive behavior. But it could also be argued that Medusa must know her rightful place as a Gaian, inferior to the Olympians, and to recognize herself as a subservient, mortal woman compared to the goddess whom she worships.

In "Medusa and the Female Gaze," Susan Bowers provides much research that also explains more about Medusa's role in Libya after she is exiled and what she represents within that region. In this study, the history of Medusa is very contrary to that of Greek literature which characterizes her more as a victim of both Poseidon and Athena. In Bower's account, Medusa is a powerful goddess (not mortal), reigning in Libya among Amazon women, revered for her wisdom, a symbol of the divine. In the comparison between Gorgons and Amazons, Diodorus Siculus (60–30 BCE), tells the story about Amazonian and Gorgonian races of women in North Africa who triumph in war. In comparison, Homer, Pindar, Hesiod, and later Ovid leave a narrative gap up until the time Perseus beheads Medusa. In the northern hemisphere of Africa upon the borders that are inhabitable, the Gorgons are an eminent race of women famous for valor and warlike exploits. Their manner of living is completely different, keeping themselves virgins. They go out as soldiers into the field and after so many years of warfare, they are accompanied by men for the preservation of their government. Women run the government while men attended to household duties. Their fen is near the ocean, the river Titron running through it. The women have an ambitious desire for war, conquering all cities of this island that is now Ethiopia. The island is scorched with many eruptions of fire, the bowels of the earth enriched with precious stone. In the meantime, Perseus decides that going to war with the Gorgons would be the greatest and most noble enterprise. Athena assists him: In *The*

Beauty of Medusa, Apollodorus (second century BCE) explains that when Perseus ventures out to fetch Medusa's head:

> He stood over [the Gorgons] as they slept, and while Athena guided his hand, and he looked with averted gaze on a brazen shield, in which he beheld the image of the Gorgon, he beheaded her. When her head was cut off, there spring from the Gorgon the winged horse Pegasus and Chrysaor, the father of Geryon; these she had by Poseidon. So Perseus put the head of Medusa in the wallet (*kibisis*) and went back again; but the Gorgons started up from their slumber and pursued Perseus but they could not see him on account of the cap, for he was hidden by it.
>
> (Apollodorus 34)

It is important to note that similar to *Theogony*, Greek poets speak about the gods as abstractions, personifications. They may be described as acting or moving about in human form. However, when they are personified, they are specifically gods, not mortals, who have the power to affect human affairs, and change the course of a mortal's life or ambitions, arousing interest in the heroic past. Because ancient Greece is polytheistic, men and women worship many gods in a society with several goddesses and even women warriors. According to Joan Connelly in *Portrait of A Priestess: Women and Ritual in Ancient Greece*, the Greeks believe that a religious system should be based on the human condition which realistically needs to reflect "gender, sexuality, and the life cycle" (30). Gods and goddesses, most importantly, are first identified by their gender and then by human experience. The Greeks recognize that men and women are different and complex. The gods they worship mirror the plurality of men and women. This develops into a system that also helps to understand the fallibilities revealed through human experience.

The Medusa head in Greek myth

In *Metamorphoses*, Perseus pursues and defeats the Gorgon, then journeys across the Libyan dessert. Using the winged sandals, he flies at rapid pace across the lands in spite of bad weather and finally lands on "the far Hesperian shore / The realm of Atlas" (Ovid 93). Once he arrives, he rests in preparation for the next day when he meets Atlas, and to win the Titan's admiration, he discloses his lineage in relation to his father Zeus. But Atlas does not trust Perseus, recalling the oracle foretelling that the boughs of gold from his tree will be despoiled by a son boasting of his father Jove. Atlas warns Perseus to leave. Yet Perseus tries to reason with him, then eventually fights him, in which he loses badly. As a final resort, Perseus holds out Medusa's head causing the Titan's entire surroundings to turn to stone. After conquering Atlas, Perseus finds his beloved, Andromeda, pinned to a rock as this is the first time that they have met, and she narrates the details that have led to her wretched captivity. Perseus promises to free her, eventually overpowering Cetus to whom Andromeda is sacrificed. Triumphantly

washing his hands after stabbing the sea monster, he places Medusa's head on a bed of leaves in which the fresh seaweed responds to the power of the Gorgon and turns to stone. Here it is believed that the head is the very instrument that created coral, the springy leaves that remain so beneath the water's surface, turning to stone when it is exposed to the air.

Shortly after Perseus rescues Andromeda from the sea monster Cetus, they marry. When the wedding banquet comes to an end, Cepheus, Andromeda's father, asks Perseus to explain how he slew the snake-haired Gorgon. Perseus entertains his company with his tale, recollecting that he had to find the place below the mountains where Phorcys' daughters, the sisters Graiae, live, sharing the one eye, and while the sisters pass it between each other, Perseus catches the eye and uses it to force the sisters to reveal the dwelling place of the Gorgon. Along his journey through woods, land, and field, Perseus observes men turned to stone as a result of looking at Medusa's face. Ultimately Perseus hunts down the Gorgon in her den, discovering her while she sleeps. He uses the bronze shield reflecting her image to look at "her ghastly head" (Ovid 98), and he severs it clean from her neck, her blood giving birth to quick-flying Pegasus and Chrysaor.

During a brief pause in Perseus' story, a chief asks why, of the three sisters, Medusa has the "snake-twined hair." Perseus explains that before the curse, Medusa's "beauty was far-famed … her hair the loveliest" (Ovid 98) of all her charms. Unfortunately, she is raped, "violated in Minerva's shrine by Ocean's lord" (Ovid 98). Despite the crime committed against her, "for fitting punishment," Medusa's lovely hair that attracts so many admirers is transformed "to loathsome snakes" (98). Later the Gorgon's head is placed on Minerva's shield to "strike her foes with dread" (98). Minerva's motive for transforming Medusa's lovely hair into snakes is to teach her a lesson, to punish her for adulterating her virtuous and noble temple. Yet clearly from the perspective of Perseus in *Metamorphoses*, Medusa is a victim. So Athena's motive for changing Medusa's beautiful hair into serpents is still unclear. There is no certainty of Medusa's life and challenges that she faces when she leaves Athens and resettles in North Africa. A significant section of Medusa's timeline is missing while she is in Libya, and her story ends rather abruptly when Perseus beheads her.

More relevant here in Ovid's narration of Medusa is the particular role that Minerva / Athena plays. There are two different versions told by Hesiod and Ovid about how Medusa loses her virginity. First Hesiod states in *Theogony* that she and Poseidon consort with one another in a meadow. But later Ovid claims that Poseidon rapes Medusa at the altar of Minerva's temple. What's more is that the whole time Poseidon assaults Medusa, Minerva is actually watching them and makes no attempt to stop him. Instead she punishes Medusa by turning her into a monster. Ovid's myth concludes that Minerva turns Medusa's lovely hair into serpents and exiles her from Greece. However, while Medusa was beautiful and consistently pursued by male suitors, a description first shared "by one who claimed to see her" (98), she turns all of them down. She does not want to be married or loved for her beauty. It can be argued that her hair is her most

attractive asset, and her punishment is the loss of her loveliness altered into something horrific. Yet it can also be argued that this outcome is not necessarily a curse. After her transformation and exile, the Gorgon will never be required to marry like other women of her rank; Medusa will live a solitary life that she desires from the beginning. Furthermore, no man can look at her without turning to stone, inferring that she is protected against male objectification and sexual violation in the future; she now has the freedom and the capability to rule and govern herself.

The traditional role of ancient Greek women is their subservience to men, hence requiring Medusa to marry but instead she provokes "the jealous hope / Of many a suitor" (98). So it could be argued that Minerva's curse "liberates" Medusa from all these alternatives: married, subordinate, raped. Furthermore, though the myth centered around turning men to stone alludes to fear associated with looking at a terrifying woman, I argue that men actually suffer greater anxiety by looking at a beautiful woman. The male spectator gazes in awe of such beauty, but to be caught looking while wanting to possess and dominate the object of their desire, when the woman returns the gaze, she causes him to feel anxious and self-conscious. It is easier to gaze at a woman, to objectify her when the gaze is not returned because it gives the spectator total control over the object. But a returned gaze suggests that the spectator is also now being objectified, that the male subject's role is reversed, and he is now inferior to the woman who catches him staring. It can lead to embarrassment, even shame, because the male spectator no longer has complete dominance over the object, and is consequently threatened by becoming objectified, subservient to the woman. The male spectator turns "the temple maiden" Medusa (beautiful, unavailable, chaste) into a one-dimensional image of eroticism by looking at her, making her a conquest. Typically in ancient Greece, women do not have the right to look. After Medusa is cursed, the power of the gaze belongs entirely to the Gorgon by turning men into a permanent object made of stone. These male "victims" of the gaze are to be gawked at, hermetically sealed in the "reality" of stone-sculpture. It produces a figurative doubling back. Aside from Greek myth, Medusa asserts her own subjectivity by returning the male gaze and looking back in rebellion. She initiates a political and gendered resistance, thwarting power relations between men and women.

This chapter argues earlier that the Medusa head operates as a metaphorical double that mirrors Perseus. According to Siebers, Athena is yet another double of Medusa. Athena orders Medusa's death and guides Perseus along his quest so that he can be victorious over the Gorgon and use the head to conquer his enemies. To complete his quest he must deliver the head to Athena which becomes an apotropaic feature on her shield (Siebers 13). But even though Medusa is destroyed, there are several similarities between the goddess and the mortal woman that produce this doubling effect; they are in fact one and the same. Athena is queen of Athens, while the Gorgon's name translates into queen; Siebers argues that Medusa has been named as the "queen of hell" but to be more accurate, she is the queen of the coastal plain, queen of the

desert, queen of North Africa (14). Medusa is decapitated by the sword blow of Perseus, while similarly Athena is born when the head of Zeus is opened with an axe, and Athena springs forward. The birth of Athena compared to the manner in which Medusa gives birth to Pegasus and Chrysaor are important features of their stories. Conditions under which they come into the world or exit the world are very much alike, goddess and monster.

To explain more on this subject, it is important to first address whether or not the beheading of Medusa symbolizes murder, sexual intercourse or both. Medusa gives birth immediately after Perseus slays her. Killing Medusa can be interpreted as matricide where Perseus overcomes his maternal dependence by metaphorically murdering the surrogate mother figure. But then again, Perseus never faces Medusa (fear of castration), nor does he allow his mother Danaë to marry. Athena provides all the magical objects necessary to defeat Medusa, and like an insecure child afraid to look directly at his mother, Perseus views her through a mirror with desire combined with fear of looking at her body. The condition was that if he promised Athena Medusa's head, then she would show him how to cut it off. He must use the shield in his left hand, and fly backwards through Gorgon territory to avoid petrifaction. Roman poet Lucan (c. 61–65) contends that even though Perseus found her sleeping, "some of the serpents on her head kept watch and darted out to protect her." At first Perseus almost loses his nerve, but Athena guides his hand to deliver the blow, and though he could see her through his shield, he averts his eyes as well as Athena, to avoid the horrifying expression in the Gorgon's eyes. Athena ruffled the dead serpents, making them serve as a veil. Without the help of Athena, Perseus is weak and helpless and could never strike down such formidable enemies. The hero relies on Athena for his superhuman powers to face these challenges, the Gorgon being the greatest threat of them all. At the same time, Athena reinvents Medusa, allegorically giving birth to the deadly, cursed Gorgon. The two women have had a dominant / subordinate relationship of goddess and mortal that evolved into two rivals. But in this recreation of Medusa, Athena ironically gives her extraordinary historical and mythical significance, far more than had she remained a humble temple maiden. Though it can be argued that Athena gives birth to the Medusa myth, the question leads me to ask, what significance does this therefore give Athena who creates an unforgettable monster? It appears that the imagination of readers is more fixated on Medusa than on the warrior goddess, Athena.

It is really Athena who must overcome the significance of Medusa before she can regain her own identity. Ancient Athenian scholar Apollodorus (second century BCE) alleges that "Medusa was beheaded for Athena's sake." Athena represents wisdom, and from this fact, one can assume that she applies reason in her final decision to "curse" and "exile" Medusa. But Athena's jealousy causes her to behave impulsively. In truth, she has a history of reacting on this human fallibility, which usually results in her wrath. Medusa's beauty incites her jealousy, confirmed by Pindar in *Twelfth Pythian Ode* who describes her as the "beautiful-cheeked Medusa" (line 16), alluding to rivalry between Medusa and

Athena, which begins when Medusa challenges Athena to a beauty contest. Christine de Pizan, a defender against women in 1405, writes that Medusa

> was so incredibly beautiful that she surpassed all other women. What's even more extraordinary and almost supernatural, she had a charming gaze, coupled with a lovely face, body and curly long tresses that she held any mortal creature who glanced at her transfixed by her look.
>
> (187)

She attracted the attention of "every mortal creature" with her exotic features and long blond curly hair. However, a goddess will prevail over a mortal, and such a threat triggers Athena's envy and rage. Siebers even implies that Medusa's haughtiness and insolence, not her rape, causes Athena to curse the Gorgon (14). Similar to the doubled effect of Cellini's sculpture of Perseus victoriously holding up Medusa's head, a comparable double is artistically rendered of Medusa and Athena, in which Siebers names them as the "two-headed monster" (15). On a terra-cotta Pelike jar (450-440 BCE), there is an image of Medusa sleeping while Perseus grabs her by the hair, looking away from her deadly gaze, and beheads her. On one side of the jar is Medusa in her beautiful form while the other side depicts Athena helmeted as the goddess of war / wisdom with snakes behind her. In Greek sculptures of Athena, she is often decorated with snakes. Athena stands on the other side of Perseus, looking on, calm while holding her scepter in her right hand. The vase painting alludes to Athena guiding Perseus' death hand, that he is only an instrument satisfying Athena's intention to destroy Medusa. While sleeping, Medusa appears harmless, serene. Medusa's hair appears to be curly, but missing are snakes. Athena is clearly more daunting in this depiction while Medusa appears to be at peace. While similar to this terra-cotta jar, snakes do not always appear in representations of Medusa. Siebers reaches the conclusion that the snake is the double of Athena, comparing Athena to the Minoan snake goddess (15). There are several examples of Greek sculptures at the Louvre and terra-cotta vases and jars at the Ashmolean Museum in Oxford and British Museum that show snakes at Athena's side, around her waist, and over her shoulders. Similar to Medusa's stony gaze, Athena has a fiery gaze. According to A. B. Cook, Athena is reputed as having an evil eye. The goddess also has a flute that when played, imitates the hissing of snakes.

In *The Severed Head: Capital Visions*, Julia Kristeva observes that in Ovid's narration of Medusa, "he brings *reflection* into the play" (29). Ovid argues that Medusa lets herself be trapped by Perseus, throwing herself at a false shadow, while Perseus strikes her from behind. In his description, Ovid provides a more heroic impression of Perseus who simply avoids Medusa's menacing teeth when he beheads her. Ovid also insists that Medusa turns all living things into stones, the power of petrifaction turning plants into coral when her blood flows into the sea. To protect Medusa's head, Perseus sets it on a bed of leaves which quickly harden. In Greek, coral translates into *gorgoneion*. As noted earlier,

marine plant life is supple and springy in water but turns to mineral when it is exposed to the air. So according to Ovid, it is Medusa's fatal touch that leaves living things paralyzed in stone. In most mythical narratives, it is not her touch, but her gaze that leaves this effect. In Greek, *gorgoneion* also means "to designate the fixed, visible image of a living original, inaccessible to view" (Kristeva 29). The etymology of the word "coral" could also originate from the word coré, or young maiden which alludes to Coré-Persephone, queen of the dead to whom the severed head of Medusa belongs. In another interpretation, psychologists, anthropologists, and even artists concur that the bloody head and slithering snakes represent the female sexual organs, the vulva that causes so many modern spectators to still recoil in fear. Kristeva describes the mythological terror of Medusa that is connected with female sexuality:

> In unpacking the medusan symbolism, however, we cannot forget to pause at the eye: Medusa-Gorgon cannot be viewed, her look petrifies, her eye brings misfortune; an evil eye, it kills. Female vulva, Medusa's eye is a slimy, swollen, sticky eye, a black hole, its immobile iris surrounded by ragged lips, folds, pubic hair.
>
> (29)

In Libya, the sun burns up the soil, the earth unproductive and infertile. Drops of blood from Medusa's head dot the desert sands, forming smooth, deadly serpents of many kinds, in which legend has it is the reason Libya is still mysteriously plagued with venomous reptiles today. In *Pharsalia* (c. 61–65), Lucan explains that the Gorgon lived in this territory "where the ocean laps against the hot earth in a wide, untilled treeless desert which she turned entirely to stone merely by gazing around her." The story is that when she was beheaded, snakes "were bred from her fallen blood and came hissing out to display their forked tongues." The snakes drink the poisonous blood, dripping from Medusa's head, which became even more poisonous by contact with the burning earth. The first snake to spring to the ground after the rain of Gorgon's blood is a deadly asp with a puffed neck, that never visits cold regions, always keeping to the desert west of the Nile. In Roman myth, Medusa "loved to feel the serpents curling around her neck and down her back, but their heads were always raised to form an impressive bang, which had become fashionable in Rome; when Medusa combed her hair, their poison flowed freely." No living creature can bear to look at that face without turning to stone. Even the snakes that replace her beautiful hair cannot gaze at the Gorgon. Lucan explains that this is why they curl up on her forehead, giving the appearance of a shorter and evenly cut bang, a popular and commonly worn hairstyle by Roman women. It is believed that men looking at her do not suffer in death—in fact there is no emotion whatsoever. As one gazed at Medusa's face, he never experienced fear because he had no time to feel anything. One cannot even describe what happened to him in death; his body—not him—petrified. Medusa was dreaded

by her own father, and her sister Gorgons; she could paralyze everything in sea, in sky, or on earth by turning it to stone.

Leeming contends that in Greek myth, Medusa is clearly a victim, "a being long detached from any archetypal role as a reigning queen or goddess" (93). This is established by being raped by the new sea god, Poseidon, who ironically replaces the old sea god, Pontus, Medusa's grandfather. She is punished by the goddess of wisdom, and Perseus murders the rape victim. It is important to note that among her parents and sisters, she becomes the only mortal in her ancient family, so her story produces a sort of "realism to it" (Leeming 93). In this way, there are no artistic conventions attempting to make the final death scene implausible. To be more exact, Medusa must die. It marks the final end of power and influence among the old order of the gods, the Gaian family. Because she is the only mortal who can die, it makes for a permanent end to this family line, while the rest of the family is reduced to sea monsters. Leeming explains that she "is a scapegoat, a ritualistic victim set up by the Olympians," a symbol of eradicating the old order. Decapitation in other ancient tales implies the same premise: that the old order has reached its natural end. In almost every case, from ancient Egypt, the decapitation of Humbaba by Gilgamesh, the Green Knight by Sir Gawain in medieval literature, the new order must defeat the old structure by decapitation (Leeming 94).

Freudian theory defines decapitation in terms of castration, figuratively de-masculinizing the old order as a way of establishing new power. In doing so, Freud suggests a profound unease with the feminine. Simone de Beauvoir straightforwardly observes that "Freud never showed much concern with the destiny of woman ... he simply adapted his account from that of the destiny of man, with slight modifications" (39). A woman's destiny therefore cannot adequately be understood through Freudian psychology. Freud's analysis of the Medusa Head gives an insufficient if not dubious explanation of the cursed woman. According to Freud's interpretation, her only purpose for existence is in relation to man who beheads the woman therefore conquering diabol-ical women who transgress conventional standards. This is yet another example where women are feared under the Freudian assumption that a woman feels mutilated because she lacks the phallus, and therefore her method of seeking power is to emasculate men. But I believe there is a better cultural explanation for this that carries far more import.

The head of Medusa, for example, is explained as a safeguard against evil, but also feared not only for its abnormal size and physical attributes, but for its power to petrify whoever gazes into its staring eyes. It is ironic that it can repel evil influences, when it has often been thought to be a source of evil. But these interpretations are confined to Greek studies. In comparison, Roman influences are quite different and perhaps more emphasized in Western thought as demonstrated in the romanticized version of Medusa depicted by Ovid before the curse, then repeated later in the nineteenth century that becomes an obsession among poets such as Shelley, and of course Symbolist

painters. The story that follows the beheading reads like romantic fiction when Perseus uses the head to defeat Atlas, turns the people of Seriphus to stone, and rescues Andromeda. Artists attempt to focus attention on the apotropaic meaning: the eyes of Medusa are the source of her petrifying power at least characterized by Caravaggio. The image of Caravaggio's Medusa was very real and penetrating, the expression in her eyes, vulnerable and horrified, are effective and bear a great sensibility to the viewer. Her creased forehead, expressing shock at her own image, which she cannot negotiate, the mouth agape in terror, her teeth even, her wide brown eyes, these become expressions of actual life. But also her face appears somewhat androgynous with the exception of the mouth, which seems more sultry, pouty, though it is meant to be an expression of terror. The eyebrows are thick and raised. The facial features seem rather delicate, which gives her that more feminine appearance. These are not sporadic or eccentric themes. It tends toward the macabre, the uncontrolled, the strange. The object here might be to astonish the reader's mind. But it also shocks one's moral sense because it is difficult to imagine the horrific and the beautiful coexisting in one body. But I argue that it is the narrative that we attach to the Medusa that makes her so tragically beautiful and horrifyingly ugly at the same time.

The grim-looking Gorgon on the shield of Agamemnon is terrible at a glance. The powers of Medusa have both a figurative and non-literal meaning alluding to her as a safeguard. This feature is understood in her disproportionately large eyes set deeply in her head, like that of a cat. But this image is later juxtaposed by Symbolist painter Jean Delville in *Idol of Perversity*, where the eyes are narrowed slits, where we cannot really make out her eyes compared to the "swollen, sticky eye, a black hole" described by Kristeva, the eye that figuratively represents the female vulva (29).

Also exaggerated are the winglets of Medusa, augmenting her apotropaic nature. The enlarged winglets allude to the dark, primitive, mysterious character of the Medusa, her powers to pursue perpetrators of evil and to be vigilant at all times. Her winglets were her only mode of locomotion since she lacks a body. Her snake-infested tresses were ominous, dangerous, but like the winglets of Medusa, vipers symbolize her means to protect, to ward off evil. She performs a guardian role, and the snakes are emblematic of that role. They are also, again, symbols of a dark and mysterious nature. Knotted snakes below the chin of the Medusa form a Herakles knot (Hercules), that in addition to protection, carries the power of fertility and healing. The meaning amplifies a talismanic force, which can have a magical, superstitious significance. Such an image can also represent a satyr or young Silenus face instead (tutor of Dionysus and leader of the satyrs, a woodland deity), a creature fond of wild merriment, lustful and lecherous, associated with butterflies having grey or brown wings. These mythical images are frequently characterized by Arnold Böcklin in his Symbolist painting. This poses a double-headed image, the antithesis of what we might think of Medusa, often taken to be a serious symbol meant to protect and heal. In Roman mythology, there is a suggested dual character to Medusa.

One head faces one spectator, while the other head faces yet another, alluding to the changeable nature of Medusa.

The hero in these myths embarks upon such a journey for this very purpose, and hence the hero must prevail, holding up the head in a gesture of victory. In the classic theme of the hero defeating the monster, Medusa must be characterized as a beautiful woman, whose threat to male hegemony must be foiled, making the Gorgon a victim. The struggle between conflicting worlds, the old and the new, is resolved by her defeat. The fallibilities of the old world must be exploited, shown as weak, the new Olympian world, more dominant, overpowering. According to Leeming, as the myth continues to develop during the Middle Ages and Renaissance, she becomes a woman, a femme fatale, that Dante expresses: "Should the Gorgon show herself and you behold her / Never again would you return above." Medusa's myth infers that she represents hell and death. Yet Gorgo also means earth in Greek. Perseus is ironically considered a hero because he kills an earthly tyrant. Needless to say, from a patriarchal reading, Perseus is a prudent man destroying a base and earthly vice, and by ascending upwards, he is raised to understand the noble and eternal truths of Heaven. Rather than keeping with the dubious nature of her sex in early talismanic representations, the gargoyle image of Medusa with a bodiless, full-frontal face is now transformed into the full-bodied feminine form associated with subsequent femme fatales such as Salome, Helen, Eve, Delilah. Her beauty becomes the greater threat to men, compelling them to look at her, though she is meant to terrify them. Throughout the centuries her myth develops into other stories about tyrannical women, the sexually charged enchantress. Men who are lost or longing for home, facing innumerable challenges, are going to be most vulnerable to her gaze. From a male perspective, the Medusa conjures up the threat of the other; she is a harbinger to the femme fatale that reconstructs the definition of Medusa as an exotic, seductive, mysterious woman, a menace whom men are forewarned against her magic and mystique. Still they cannot help themselves. It is the hero who embarks upon his journey that is most greatly threatened by her. The Medusa / femme fatale jeopardizes the completion of his quest, throwing him off-course. She exists in many different forms of female characters who are exotic, tempting, a distraction that endangers the stability of any sort of order. The hero is on a quest to restore and stabilize the community, and if this means decapitating a beautiful woman, then he must do so by whatever means.

Yet Medusa is far from envying Perseus his power. Without Athena's help, there might be little chance of Perseus actually killing Medusa; it is Athena, after all, who puts him up to it. His hero status is only the result of Athena's obsession to murder Medusa, and he is not necessarily heroic since he murders the Gorgon in her sleep, relying on the "cap of darkness," or "Hades' helmet," winged sandals, a magic bag for the gorgon's head, and a reflective shield to behead her, all provided by Hesperides, who Athena instructs Perseus to seek out. The hero in this case must master control over his impulses, which otherwise would have been to look at her—to be afraid of her, and to act

without using reason. Perseus must return to Greece victorious, bringing back Medusa's head. Ironically in the end, Medusa derails all of them, giving birth to Pegasus the winged stallion, pure white, a symbol of wisdom. The use of power demonstrated by both Perseus and Poseidon can only inspire Medusa with indifference. The seductive woman enshrouded by snakes manifests phantasmic figures or supernatural phenomena, for example, like the moon, mysterious elements that remain obscure to reason, and can only be experienced though this tangible connection between the unconscious and the imagination.

Bibliography

Alighieri, Dante. "Canto 9." *The Divine Comedy of Dante Alighieri: Inferno.* Trans. by Allen Mandelbaum. University of California Press, 1980.

Apollodorus and Hard, Robin. *The Library of Greek Mythology.* Oxford University Press, 2008.

Bowers, Susan R. "Medusa and the Female Gaze." *NWSA Journal,* 2(2), 1990, pp. 217–235. www.jstor.org/stable/4316018.

Connelley, Joan. *Portrait of A Priestess: Women and Ritual in Ancient Greece.* Princeton University Press, 2007.

Cook, A. B. *Zeus: A Study in Ancient Religion,* 3 vols. Cambridge University Press, 1940.

Hesiod. *Theogony and Works and Days.* Trans. by M. L. West. Oxford World's Classics, 2008.

Homer. *The Iliad.* Trans. by Robert Fagles. Penguin Classics, 1990.

Karoglou, Kiki. "Dangerous Beauty: Medusa in Classical Art." Metropolitan Museum of Art, New York. 2 August 2018.

Kristeva, Julia. *The Severed Head: Capital Visions.* Trans. by Jody Gladding. Columbia University Press, 2012.

Leeming, David. *Medusa: In The Mirror of Time.* Reaktion Books, 2013.

Lucan. *Pharsalia.* Trans. by Robert Graves. Penguin Books, 1957.

Ovid. *Metamorphoses.* Trans. by A. D. Melville. Oxford University Press, 2009.

Pizan, Christine, and Brown-Grant, Rosalind. *The Book of the City of Ladies.* Penguin Books, 1999.

Pindar. *Olympian Odes. Pythian Odes.* Trans. by William H. Race. Harvard University Press, 1997.

Siculus, Diodorus. *The Historical Library of Diodorus the Sicilian, in Fifteen Books.* Trans. by G. Booth, Vol. 1. W. McDowall for J. Davis, 1814.

Siebers, Tobin. *The Mirror of Medusa.* University of California Press, 1983.

3 Symbolism in the Medusa myth
The decapitated head of Medusa

In "The Uncanny," Sigmund Freud interprets the decapitated head of Medusa and its significance to psychology. By writing about Medusa, Freud is once again making connections between mythology and psychic causes in order to understand human behavior. He links Medusa to the terror of castration, figuratively experienced through the sight of the severed head. An example might be when a young boy who does not feel threatened by castration suddenly catches sight of the female genitals of an adult woman, presumably his mother. Medusa's hair, represented in art as snakes, translates into the castration complex. But as I will explain in the following chapters on Symbolist painting, Medusa's face and body are not always meant to evoke horror, though looking at the serpents may produce this effect. The horror these snakes evoke from a psychoanalytic perspective is that they replace the penis, the absence causing this terror. Therefore, Medusa's hair, which is multiple symbols of the penis, signifies castration. Gazing at Medusa's head causes one to be "stiff" with fright, turning them into stone, alluding once more to the castration complex. Becoming stiff, according to Freud, is to become erect, a consolation to the spectator: "stiffening reassures him that he still has a penis" (Kofman 85). Freud even goes onto claim that because the Greeks were strongly homosexual, that it is without doubt that a woman should be represented as frightening because she is castrated.

Medusa's head not only takes the place of the female genitals, but isolates the horrifying effects of pleasure one might experience by looking at her. Yet on the other hand displaying the genitals is analogous to a protective act. This might appear confusing, but the genitals are a metaphorical shield against evil by arousing horror in oneself, producing the same effect upon an enemy in which one defends himself. For example, Freud recalls Rabelais and how the devil takes flight when the woman shows her vulva. By using this example, Freud means to demonstrate that the erect male organ therefore also works as a protective shield. To display the penis, or any phallic symbol, according to French theorist Sarah Kofman in *The Enigma of Woman: Woman in Freud's Writing*, is to say: "I am not afraid of you. I defy you. I have a penis'" (85). This is a means of intimidating an evil spirit. In short, the fear of castration is directly linked to the fear of a horrific sight. Exposure of the female genitals, mitigated

by the phallic snakes on Medusa's head, is equal to petrifaction of the male erection. Therefore, to combat such a fear of the castration complex, viewing the genitals, or an erect penis figuratively, represents a form of power over the female that resists his fear aroused by actually viewing her.

While Poseidon's rape / seduction of Medusa leads to Athena's curse, according to sociologist Philip Slater, Perseus severing Medusa's head represents her sexual debasement in Freudian terms, eliminating all thought of closeness that the once beautiful and striking Medusa had attracted. To support his argument in *The Glory of Hera: Greek Mythology and the Greek Family*, Slater explains the development of Perseus' relationship with his own mother, Danaë, that leads up to his conclusion. Since this is ancient Greek culture where respectable women are secluded within their homes, the only influence they have on public life is raising their sons who will eventually grow up to enjoy masculine privileges. For the mother, this causes two problems: 1) she excessively loves her son, and 2) she envies the social and public power that her son will have in his adult life. In response, the son is ambivalently attracted to the mother, because she is his first interaction with human love, yet he fears the mother's sexuality. To illustrate these points based on the story of Perseus, Danaë raises her son on her own, and the two escape treacherous situations, imprisoned in a chamber, then sealed together in a floating chest. Perseus has no father figures, and when Polydectes expresses an attraction for his mother, the son is jealous. When Perseus finally beheads Medusa, Slater argues that he figuratively eradicates the frightening aspect of his mother's sexuality. It is not so much that Medusa looks monstrous, or even that she has lost her beauty, but it is because she has been defiled as a cursed woman, that she is unapproachable, the forbidden mother (as Freud metaphorically refers to Medusa) who repels all who desire her. In Freudian terms, she is terrifying to men because of the castration complex, not because men literally turn to stone when they look at her. Identification with the mother's powerlessness causes terror. Freud explains that the terror provoked by the mother's castration, that she has no penis, causes man to draw away and predisposes him to homosexuality. These points lead to Lillian E. Doherty's questions about the reliability of Slater's argument. In *Gender and the Interpretation of Myth*, Doherty claims that considerations of Slater's work have been "harshly critical," adding that she "can see three reasons for this" which are methodological, psychoanalytical, and narrow-mindedness (61). First, Slater's details are a combination of a variety of myths about Medusa spanning large gaps of time that randomly jump from one story to another written several years later, hence stories that have little in common though they are based on Medusa. Second, psychoanalytic theory is lodged in the study of late nineteenth-century bourgeois families which is inapplicable to Greek culture. Finally, Slater takes a strong bias when he observes only the most salacious aspects of Greek society: rape, incest, violence, and murder.

The Medusa that Freud writes about is from a far more narrow perspective compared to what she is or can become. I argue that she is unapproachable to men, not because she is petrifying but instead she threatens to emasculate men because her power exceeds that of men; in this case, of Perseus who can

only defeat her with the aid of Athena while Medusa is sleeping. Athena is also unapproachable for the very antithesis of Medusa: there is nothing sexual about the goddess. She is remote and isolated. Not only does she represent chastity, but viewing her does not call to mind the same fascination and excitement as Medusa. Athena wears a symbol of the serpent on her dress, but unlike Medusa, she repels sexual desire. She is a goddess characterized by her role to establish order. But in contrast, Athena does not evoke the mystery or inquisitiveness that is otherwise attached to Medusa, the example of a woman that no matter how many stories about her are shared, we will never know the Gorgon woman, and will yearn for something more that can never quite be satisfied. Here is where I want to pull away from the degraded mother figure / woman object. I do not believe the image is true of Medusa.

How can Medusa be objectified when the threat of looking at her will turn men to stone? Men are compelled by the fact that she is "the unknowable," perhaps representing not so much men's fears, but their frustration with all women, that her secrets remain indecipherable. Only she or other women can unscramble and translate such meaning. She is a manifestation of patriarchal anxiety in the cultural imagination. The attempt to objectify her is a failed effort to discover the meaning of Medusa. But unlike Freud, Symbolist artists and Romantic poets attempt to structure a much more idealized version of Medusa. She becomes an empowering spectral image that evokes desire among men, and a strong source of identification for women who view her neither as a victim nor a predator portrayed in sculpture, paintings, or poetry. Carl Jung, unlike Freud, suggests that much can be learned by combining material from the unconscious mind to the conscious, our ability to reason. This is crucial to understanding more about Medusa and the emotional and intellectual effect she has on her spectators. Jungian psychoanalytic theory identifies archetypes as patterns of symbols and images residing in the unconscious, as these images are gradually revealed to the conscious mind. In the very first images of Medusa in twelfth century BCE, she is introduced to social consciousness as a symbol—not as a myth that portrays a beautiful woman turning men to stone. As explained earlier, Medusa is a central example showing how myth is born out of symbols, or representations. A symbol is a constructive means by which the conscious produces meaning. The symbol of the Medusa head in its earliest origins can mean one thing: protector against evil. But the head can also signify other things: castration, desire, lust, and anxiety as she becomes less androgynous, evolving more into a woman. The threat in this case represents the risk of acting on impulses that originate in the unconscious mind and therefore threaten to dominate the conscious. But if the "threat" is integrated with the conscious rather than overpowering it, those impulses can also be moderated in a healthy way.

Jung espouses that Medusa represents the archetype of the Terrible Mother to the male because the son fears and resists her, battling and attempting to overcome her. But women, just like men, have a shadow realm that tends to be anti-social, the immoral self. For men, the shadow image transforms into the opposite sex, and it manifests as both an internalized struggle against the

self, or against his worse self associated with femininity. That feminine aspect, foreboding and frightful, is the so-called Terrible Mother. The shadow among women functions a little differently and does not transform into the opposite sex. Rather she is a more dominant figure, an overpowering figure, the mother / daughter relationship in which the daughter fears and resents her mother. But the shadow figure in Jungian theory can also have positive aspects as well. It can include everything outside our consciousness, everything of which we are not aware. Jung makes the point that we do not need to fear what we do not know. He observes that everyone has a shadow, and the less it is embodied in the individual's conscious life, the blacker and denser it is because the individual is blind to it. In other words, the shadow can more literally be "defects of the conscious personality" even if one is not aware of the faux pas, or slip that one might make (Jung 144). Conscious awareness of one's self must reach a higher level to confront and detach from this defect. But if the shadow is very much a part of his consciousness, then it will be impossible to confront the very thing that must be changed in order to attain that higher state of being. The shadow could allude to our instinctual life, our imagination, the very elements that symbolists and romantic poets explore in their own art because it manifests as a form of self-liberation.

If women can come to explore the shadow self, their dark side, then this will illuminate better insight by the conscious mind. Yet that side can also be irrational for both men and women. On the other hand, an amalgamation of both dark and light sides / unconscious and conscious activity engages us with reality. So for women, they must identify existing patterns within the unconscious, their shadow life, the wild woman with hissing hair. To a woman, Medusa for example comes to mean something very different compared to men. Culpepper as I mentioned earlier, identifies that shadow self finally emerges as a guardian in the case of a physical threat. The Medusa self can also help women face threatening situations. It helps to weigh our choices, the two sides that must come together and how this can consequently bring together something more positive. To obliterate the subject / object dichotomy in the image of Medusa is to understand from a more Jungian perspective that the dark shadow cast out onto others is usually an avoidance of what resides in our own hearts. Medusa embodies the material of the dark shadow, but also the possibility of being reborn, renewed into lightness, such as with the birth of Pegasus, purity and beauty.

The snake archetype

A comparison of Freudian theory with Jungian archetypes helps to demonstrate how these psychoanalytic approaches can be applied to reach a more enriching comprehension of Medusa in the modern period, to see how our understanding of her myth from ancient Greece transforms in contemporary culture. Using the snake archetype, Jung demonstrates that there are things in life which cannot be rationally explained, but still require a language by

which they may be communicated. So for example, snakes are considered mysterious, expressing instinctual powers and psychic energy that take root beyond the ego and archetypal images. From the perspective of the Medusa myth, onlookers could study freely the Gorgon's serpent hair without turning to stone. While the onlooker may not be paralyzed with fear, in Jungian terms, the primary symbolic meanings of the snake are insanity, so the onlooker takes a great risk of losing his mind by looking at Medusa. The appearance of a snake in dreams represents the transformation of darkness and evil, alluding to a reconciliation with the gloomy and mysterious aspect of his soul which is problematic. In modern life, people do not believe in gods and demons that either lead to the belief that one can overcome evil, or that one is limited to living in fear. Those gods and demons reside within the human psyche. In "The Image of the Devil in C. G. Jung's Psychology," Robert Avens explains that those who emphatically believe that they possess some kind of power over the bad things that happen in life can be vulnerable to a mental or nervous breakdown when faced with the reality that self-will cannot overcome inevitable circumstances. He uses the examples of Christians who claim that they can "trample so-called evil underfoot" (196). Jung offers a way out by proposing that we give up "the illusion of absolute certainty as to the nature of good and evil" (Avens 196). According to Jung, the source of meaning beyond the ego lies hidden in the unconscious; dreams translate the non-rational side into individual dreams—to the subconscious, a conduit to rational thought or the conscious mind. The snake symbol stands for something significant which the unconscious attempts to communicate. In one of Jung's case studies, he discovered that the snake can also be translated into the snake mother, "a caregiving mother" that supported a female patient in childhood against her father's misbehavior (Khodarahimi 165). According to clinical psychologist, Siamak Khodarahimi, in "Snake Mother Imagery in Generalised Anxiety Disorder," this point leads Jung to conclude that the unconscious is the source of mental health. The snake image attached to Medusa is a symbol of different interpretations, healthy and medicinal, or dangerous and impulsive. To understand this is to see that Medusa represents both monstrous and beautiful, good and bad. But the collective unconsciousness becomes more complex than just dividing archetypes into binary oppositions.

This insight questions Freud's otherwise dogmatic argument that Medusa is the figure of men's peril. This is too narrow a perspective. So, for example, when a man dreams about a snake, the serpent is a symbol for something the unconscious is trying *to say* to the individual. What the unconscious wishes to communicate depends upon the state of the individual's inner condition. It could be darkness, earthiness, or evil if the meaning is incumbent upon Christian ideology. But it can also mean the spirit of light and wisdom. Snakes can be a threat to one's innermost self. However, in Greek culture, the snake has an empowering image that is not meant to frighten, but instead transforms into a symbol of protection. The snake archetype can be transfigured into a sign of healing and renewal. So, conditions under which the man dreaming about the

snake archetype is significant to understanding how the unconscious, pulling from an image affects conscious thought and reasoning.

Snakes, according to anthropologist Marija Gimbutas, are associated with water and water gods, Poseidon, god of the sea, a symbol revered as deities of wisdom, which once more alludes back to Athena as the snake goddess, a belief dating back to Old Europe. In "Ferocious and the Erotic: 'Beautiful' Medusa and the Neolithic Bird Snake," Miriam Roberts Dexter observes that in the figure of the snake, Medusa represents "regeneration" and "death," a cycle of life. A snake can be both venomous yet counteract a toxin. These images then emerge as narratives in the conscious mind that can be rationalized. Mythologers like Joseph Campbell are in agreement with the ancient narratives, naming Medusa as a cautionary tale whose face is hidden by a mask, and behind it is a beautiful goddess; she personifies good and evil. The snake is a symbol of power and knowledge in the Garden of Eden, a creature that communicates the distinction between good and evil. But a more careful study of Medusa helps to expand beyond such simplified binary positions. Is Medusa at one with her serpent tresses, or similar to Ann Stanford's Medusa, at odds, wishing "to wake up in another place and look *for* my self again" (my italics)? Poets and artists through their work bring about this possibility.

In "Medusa's Hair: An Essay on Personal Symbols and Religious Experience," Anthropology Professor, Gananath Obeyesekere, explores the symbolic meaning of the hair and identifies religious rituals in which a woman's hair resembles Medusa's snake-like tresses. The main point of his essay is to show that cultural symbols can also reflect individual motivations, refuting the notion that culture can only pertain to a group. On a visit to Kataragama in July 1973, Obeyesekere describes the first woman whom he sees, her matted hair resembling snakes and calling to mind Freud's Medusa head. This association leads to sudden fear, describing the woman as "ugly … her teeth stained with betel nut juice and bearing repulsive matted locks" (6). He concludes that since there is no such thing in nature as snakes replacing a woman's hair, maybe Medusa's hair was just matted. For Obeyesekere, matted hair comes to have symbolic meaning, even working as a reflection of one's religious ideology. In fact, he cannot get over his first sighting of this woman, a female fire walker, dancing with her hands thrust outward as if in a trance, a form of worship where she submits herself to God, her hair unconfined in the wind. The woman's wild hair and ritualistic dance ceremony cause him to feel uneasy. Similar to Medusa before the curse, these seven women that Obeyesekere studied over the course of years are female ascetics, strictly devoted to prayer, fasting, abstaining from all indulgences. The snake becomes a symbol of a creative life force used in these religious ceremonies. Furthermore, though little is known about Medusa before she is exiled, it is believed that the custom of her life strongly resembles an ascetic, the practice of severe self-discipline to show her devotion to the gods and goddesses. While these symbols are personal, they can be understood by everyone within that culture. But I go back to that moment in Obeyesekere's study where he cannot help but feel anxious and repulsed by the first woman he observes.

Did he feel emasculated by her image? Would this again have been a similar reaction that has been so frequently discussed about Medusa? The hair and overall appearance of Medusa is a persistent stereotype that is meant to cause men to fear female emancipation that threatens male power. But Obeyesekere overcomes this stigma by disregarding the illusion of absolute certainty about the nature of good and evil that I discuss earlier. When Obeyesekere becomes aware that the rituals practiced by these Medusean-like women are to bring about peace and to honor life, he is free from this otherwise patriarchal construction of women, and instead, he finds comfort. In fact, after meeting the women, he finds them attractive and enjoys their extroverted nature, their sense of humor, and he becomes friends with them. His experience testifies to the fact that men do not have to be afraid of strong women once they understand how a woman's power can be put to use, in this case as an ascetic. Obeyesekere admits that it was his anxiety and associations with Freud's castration complex that led to his initial attitude about the women when he first saw them.

Women, on the other hand, do not fear Medusa. In "Medusa: The Letter and the Spirit," Italian literary scholar, John Freccero, explains that "Medusa was said to be powerless against women" (7). The image of Medusa's hair and what it might be, matted and "snake-like," suggestively alludes to a different appeal among women. Women held minimal status in ancient Greece. But after the myth of Medusa is introduced by Homer in the eighth century BCE, her narrative could have secretly offered a dramatic and gratifying fantasy to young temple maidens, ascetics, and priestesses seeking some form of autonomy instead of marriage. Medusa is an iconic figure representing social, political, and cultural empowerment between women in the twenty-first century, whose rebellion and fear that she instills among her male enemies leads to gratifying and far more liberating opportunities. In Greek life, female emancipation is more or less a fantasy that releases women from mundane tasks of ordinary life, the potential abuse they face from husbands, and loneliness they might experience, or daily oppression they face. By being able to identify with Medusa, the myth liberates all women from all ages over time. Medusa is a warrior against men, who can roam wherever she pleases. She dominates North Africa which male figures desire to take for themselves. Medusa is also associated with Oceanus, the personification of the sea, which is plausible given her marine parentage, her affair with Poseidon, her dwelling place in central north Africa with marine deities, and her role to guard against disease.

The snakes on Medusa's head after her curse represent immortality, divinity, and healing. According to Susan Bowers in "Medusa and the Female Gaze," the snakes also signify polarities: life and death, birth and re-birth. It is important to explore various interpretations of Medusa's powerful female gaze. As an African queen, and similar to Athena, a goddess of wisdom, the Gorgon governs by her ability to use sound judgment. Looking at her takes on a different meaning within ancient African culture. In one explanation, her flowing blood is magic and metaphorical menstrual blood. In "Blood Symbolism in African Religion," M. Y. Nabofa observes that common among African beliefs is that "in order

for [one] to receive life, health, and happiness he has to treat blood reverently. Blood is not only conceived as a natural symbol of life, but it is life itself" (390). Medusa's blood is a life force, not corrupted or unnatural. But another inter- pretation is that because of its magic, in some ancient cultures, they believed that looking at a woman who is menstruating would turn them to stone (Bowers 220). This again repeats the notion that menstruation represents both death and life to ancient African cultures. Another tribal culture, the Maori, believe that flowing blood signifies a complete human being that has died, while the blood presents itself as creating a living human being. Another belief that Mary Douglas discovers in her anthropological studies of tribal groups is that men- strual blood implies danger. For example, the Lele culture regards a pregnant woman and unborn child as being in "constant danger" (Douglas 96) because the gender of the child is unknown, and there is no telling whether or not the child will be healthy. Again, the polarity of life and death presents itself, espe- cially to understand how it relates to the feminine power of the Medusa. But in Western culture, stereotypes of the Medusa image reflect the point made by Simone de Beauvoir:

> the female monster is a striking illustration made to represent all of man's ambivalent feelings about his own inability to control his own physical existence, his own birth and death. As the Other, woman comes to represent the contingency of life, life that is made to be destroyed.
>
> (qtd. in Gilbert and Gubar 34)

The woman portrayed as a monster is de-feminized because she does not idly submit to punishment or become a passive scapegoat. She refuses to suffer for being a woman and rejects social oppression. Society wants to define her as less womanly if she refuses to accept authority. However, Medusa portrays a meta- phorical scale between the two realms of life and death, showing that without her, there can be no harmony or order in the world; polarities establish such harmony, and she is a liminal figure, a passage between two worlds. While men attempt to control the way in which the world is ordered, women are at the very center of this cycle by providing life.

The rite of passage

In *Purity and Danger*, anthropologist Mary Douglas cites French ethnographer and folklorist Arnold Van Gennep who sees "society as a house with rooms and corridors in which passage from one to another is dangerous" (Douglas 97). These passages mark transitional states, for example, the state of living, the state of dying; throughout life, we are always in transition whether there is movement forward or brief periods of inactivity. These transitions contain emo- tional qualities where in the middle of such changes, the individual experiences uncertainty or disorientation. The danger they face in between these passages is that they can no longer be what they once were. Douglas clarifies that

"Danger lies in transitional states, simply because transition is neither one state nor the next, it is undefinable" (97). Most precarious is when the individual has not yet crossed the threshold to the status they will hold when the transition is completed. There appears to be no means by which one can prepare before entering a passage. Here is where the individual is forced to pause, perhaps looking back in fear of seeing themselves disappear, fading into darkness while eventually emerging into something entirely new that is unfamiliar and frightening to them, as if seeing themselves in the mirror and no longer recognizing their own face. The middle stage is disorienting because they no longer hold their former status, and at the same time, they have no idea what to expect, of what awaits them on the other side. Douglas explains that there is yet another phase, that while transition is perilous, even more dangerous are the "rituals of segregation" (97). That period of segregation requires the initiate to determine their own subjectivity without the guidance of something more authoritarian or experienced, such as a parent. They must identify their own value or worth through the process of this transition. An example might be when a woman is warned to fear for her safety. First this comes as a warning, and secondly it signals to the woman that no one will be involved in the particular phase to take care of her. Transition requires that the individual is unescorted or unaided, and therefore responsible for making their own choices. The completion of that process ultimately leads to structuring a new identity, in a different period of time, and within an unfamiliar community. It might be safe to say that one is reborn into this new state, but it is always at the cost of leaving parts of themselves behind, while grieving the loss of the old self. Stemming from the Greeks in more literal terms, "the soul of man [is] immortal, born and reborn in various incarnations" (Harrison 589). According to Harrison, Orpheus believed that rebirth and reincarnation was actually "*new* birth." New souls are really old souls in an endless succession that metaphorically represents a wheel or cycle. Old life transitions into new life. The rite of passage is a constant cycle in both life and death.

In *The Rites of Passage*, the expression itself is translated into "life crisis" which includes three major phases: separation, transition, and incorporation (van Gennep vii). To explain these three phases more at length, it is best to begin by imagining a door, a particular unit. This door signifies the threshold and becomes the boundary between foreign and domestic worlds. To open the door and step outside, is to cross the threshold and enter a new world. But such entry becomes a rite, a ritual of passing through the door, performed on the very threshold itself. It is a rite of separation from one's previous surroundings. From there, follow the rites of incorporation. The rites taking place on the threshold are not "union" ceremonies, but in fact, separation. Incorporation therefore unites one with the new world, a period of assimilation and adjustment. Oftentimes the various stages through which one passes are so incompatible that it is impossible to make this transition without an intermediary period, and that is the in between part, the figurative bridge between two different worlds, a passage through which one must travel. In the middle stage it is hard

to determine where one is going or when the journey might come to an end. The transition, to be more specific, is marginal space and distinguishes between dying and rebirth. After that transition is complete, specific and separate social groupings can be clearly identified, from the "higher and lower levels of civilization" (van Gennep 1). In Greek myth these divisions are between gods and goddesses from mere mortals.

Marginal states and contact within them are most dangerous. A novice becomes an outcast who only temporarily resides outside the margins of society. There is a separation period from their community, requiring them to live either far away from it or "near enough for unplanned contact" (Douglas 97). There are a number of circumstances that restrict Medusa within such margins, which begins with Athena's curse, a form of ritual that exiles Medusa from Greece. But once she leaves, she never again makes contact with Athenian society. Though being both cursed and exiled are examples of a rite of passage, Douglas claims that marginal people who do not return home go through a rite of seclusion. While novices are only temporarily sent away, Medusa's exile is permanent, denied full access of resources, and the privileges of Athenian society. Other monsters or deviants may even re-enter a former community despite their exile, to prove they are powerful and dangerous, but Medusa remains hidden. Society, however, cannot seem to leave the Gorgon alone, revisiting her image, reconstructing her as a threshold figure, the serpent-haired lady either standing weary and alone at a portal, or becoming a conduit, a symbol representing a rite of passage through which other mortals must pass. Though society does not welcome her back, it paradoxically forms an obsession with her. In the case of being cast out, Medusa creates her own society of women. Though it might appear that she has no place within the social system, over time, she manifests as a metaphorical figure for a rite or ritual, which becomes an important feature in Symbolist art. A different translation of her name is an "etymological derivation of 'Medusa' or 'Mudsusa' [that] comes from the Hebraic root, 'Med,' which means battle, quarrel, struggle; and 'dsus,' which signifies the tyrant, the violent, the conqueror of cloud" (Stafford 309).

The Medusean myth constructs a powerful community of women where they perceive each other as equals, whose narrative, whose own myths, generate a new vision of themselves. Conditions in ancient Greece pressure women into reticence, dependency, a training in femininity. But by abandoning domestic life, Medusa does not have to endure any of these constraints, settling comfortably into Athena's temple. Even when she is exiled, Medusa remains in the company of her two immortal Gorgon sisters whose hair is also transformed into snakes. When they move from Greece to the furthest region of north Africa, there is no vegetation or life. The isolation might seem unbearable, but they bear up well when they form their own Gorgonian society of women. Perilous though transitions and rituals might be, in Medusa we see how it necessitates growth, that a woman whose social value may have been based on beauty or acquiescence alone are trivial compared to Medusa's new persona used to empower

herself as well as other women. Ceremonial ritual might seem old-fashioned in the twenty-first century, but we are environmentally conditioned to experience a plethora of different rituals, whether we are aware of them or not. We participate in rituals, traversing through dark passages, entering the unknown, feeling separate and apart from society because we have changed. Whether we see ourselves within this operation or not, the clearest indication of such a ritual is the experience of making a transition in life, regardless of how subtle or dramatic it might be, and eventually recognizing how we are different.

In *Mythologies*, Fulgentius, Bishop of Ruspa (late fifth century), characterizes Medusa as a wealthy queen whose deception is symbolized by her serpent hair. King Phorcys, Medusa's father, leaves his wealth to his three daughters. Of the three sisters, Medusa is more enterprising, by developing the land through agriculture and increasing her wealth. Her name "Gorgo" for *georgigo*, meaning earth in Greek, alludes to her husbandry skills. By making comparisons to early Greek poets Hesiod and Pindar, who describe her as "fair cheeked … Of gold begotten," her "fate a sad one" after the curse, Fulgentius certainly characterizes her as an innocent beauty, but a domineering matriarch much changed by wealth and power. Because he wishes to conquer and own Medusa's land, Perseus slays Medusa and carries off her head, the symbol of her true nature, the very essence of divine power, a sacred force, her vital energy. When Perseus presents Medusa's head to Athena, the action alludes to tribal rituals of which the head is offered as a sacrifice. With her head, Perseus overcomes his other enemies and prospers by ruling her domain. In this retelling of the Medusa myth, Fulgentius questions stories written by poets Ovid and Lucan, even declaring that they are fabrications, and that their purpose was to inspire three kinds of terror: to weaken the mind, to burden the mind with fear, and finally transform the face into an expression of melancholy and despair. The three names of the Gorgon sisters symbolize the poet's meaning: Stheno, Greek for "weakening" or astenian which means sickness, Euryale which means "broad extent," and finally Medusa which translates into "meidusam," which means one cannot look upon her. Perseus is aided by Minerva (Athena) which is wisdom, and wisdom combined with manliness destroys these terrors. A display of manliness requires man not to consider his own feelings of terror because it will only derail Perseus' quest for the head. All terror, on the contrary, is reflected in the heart and in physical appearance, such as the men turned to stone.

From Medusa's blood Pegasus is born, and he has wings that are not just meant for flying, but are also associated with the heavens. By striking the ground with his hoof, a fountain springs forth, used by the Muses to create their own system of telling stories about famed heroes. The wisdom of good counsel therefore metamorphoses into an everlasting fountain. Endowed with wings, Pegasus looks down on the whole world, seeing clearly how it functions. From his elevated, heavenly place, there is nothing to obscure his perception. Though he is born from the blood of the Gorgon who represents fear, Medusa is also attached to the heart of Athena, which suggests that Pegasus embodies both wisdom and fear. Only when one has encountered and prevailed over their

fear is wisdom born. Pegasus, born from the blood of the terrifying Gorgon, demonstrates this meaning. Wisdom replaces fear that Medusa inspires.

Perseus does not show fear. By not looking directly at Medusa, he does not acknowledge such terror, using the shield to avert his direct gaze at her. If he were afraid, it is likely that he would act foolishly like other men turned to stone. Fearing the Gorgon would certainly lead to his defeat. Facing fear leads to new wisdom. Wisdom grows from fear of its master, and when everyone fears a threatening monster, they grow wise by having confronted terror. Surely Perseus would have turned to stone by looking at the Gorgon. But given the circumstances under which he beheads Medusa, is he really a hero? It is a feat largely guided by Athena who needs Medusa killed to protect herself, and Perseus is motivated to acquire land and wealth, which could only be achieved by killing Medusa. Both Athena and Perseus benefit by the Gorgon's death. Pegasus, however, puts the struggle between these old rivals, the Olympians and the Gaians, to an end. The winged horse is a symbol for poetic inspiration, opening up the Hippocrene spring on Mount Helicon by stamping his hooves. Athena ends up riding Pegasus, associated with the sea and lightning bolts across the sky. The vitality and strength of the horse is combined with weightlessness, bringing order by overcoming worldly impediments. The lightness of Pegasus alludes to freedom often symbolized by the bird, the indomitable poetic spirit. But it also has a darker side visible in Centaurs, mythical monsters with a horse's body and human upper body, the culmination of discord and internal tension.

Contrary to other poets that illustrate Medusa as a threshold figure that men must seek or face in order to complete a rite of passage, Petrarch writes love poetry about Medusa, idealizing the Gorgon's distant beauty, unavailable, and unpredictable, comparing a beloved woman to her who

> has the power over me that Medusa had over the old Moorish giant, when she turned him to flint; nor can I shake loose that lovely knot by which the sun is surpassed, not to say amber or gold / I mean the blond locks and the curling snare that so softly bind tight my soul, which I arm with humility and nothing else. / Her very shadow turns my heart to ice and tinges my face with white fear, but her eyes have the power to turn it to marble.
>
> (342)

Petrarch memorializes his first sight of Laura, his beloved, by likening her beauty to the stunning powers of Medusa. He retells the story of Perseus turning the giant Atlas to stone by showing him Medusa's head. The poet also puns his own name, Petra, meaning stone or rock. It is important to note that Petrarch expresses bouts of ardor and despair, snubs and reconciliations, by making an analogy between Laura and Medusa. There is the knot right below Medusa's chin, a knot of snakes used to protect her. Gold symbolizes the sun, a precious metal, which can allude to esoteric knowledge, wisdom possessed by Medusa. That she is unobtainable increases her value which is greater than gold. Gold / amber signifies the value of her "blond locks" a curling snare, that her hair is a

figurative trap that attracts attention and turns giants into stone. That her hair is gold, perfection, the light of heaven can be contradicted by the effect her hair has on men. Her shadow turns his heart to ice, makes him cold as if he can feel nothing, paralyzed by her image. Shadows are not merely the obstruction of light, but dark entities with a nature of their own. A shadow is a mysterious double of a person, understood even as an image of that person's soul. Shadows of a person appear when the sun is close to the horizon, direct representation of the person being taboo. What the poet therefore sees in her shadow is not really her, but a representation, a double, a lack of corporeality. In myth, being unable to see one's own shadow means that the person is marked for death. Her eyes have the power to turn the poet's face to marble, commonly used for sculpture. Pure white marble, insinuated by "white fear," the lady is free of impurities, and comes from the purest limestone. Shades of green, however, allude to the stone's impurity. When marble is recrystallized by intense heat, it is made pure. Marble has a softness to it, easy to carve. It has a waxy look, giving it life. Her eyes therefore soften the effect of the poet's paralysis caused by her intense beauty, having the power to revitalize him from ice to the intense pressure of heat. His mood constantly shifts whether he adores her or despairs over her.

According to Coluccio Salutati, Medusa signifies oblivion, "the art of oratory," by changing men's desires, and erasing their former thoughts. Salutati emphasizes her voice, reminiscent of the sirens distracting men from their duties. But it is Medusa's speech rather than song that dazzles men, leaving them confused and forgetful. In one reading, Salutati's discussion of Medusa is perhaps overly romanticized, and once again alludes to the problem that comes with objectifying Medusa, questioning the use of her power and influence. The Florentine humanist references Hesiod's *Theogony* that Medusa and Neptune "lay" together, the only difference is the place of their union, the temple in the case of Salutati's version instead of the meadow. This interpretation suggest that Medusa is complicit, seduced rather than raped. Salutati further suggests that the source of Medusa's "special glory" is "the decoration of her hair." This last daughter is more impressive than the other two because of her blond and luxuriant locks, a rather superfluous feature of a woman, which suggests that beauty diminishes her vigor and adaptability. Even worse, Salutati claims that with the removal of her hair, any woman would "appear most unsightly" (53). But her hair is also combined with her speech that mesmerizes men into oblivion. Yet he also implies that the strength of Medusa's voice comes from Neptune who represents moisture since he is of the sea. Moisture makes the voice eloquent. Medusa's family is also from the sea, her grandfather Pontus is replaced by Neptune, lord of the ocean. Therefore, Medusa's artful oratory does not necessarily derive from Neptune but rather from her own heritage. Her voice and hair are the very features that turn heads. Salutati insists that before this union with Neptune, Medusa had no adverse consequences. But trying to achieve the same autonomy as men was certainly leading up to some form of punishment. Being raped by Neptune resulted in consequences, but it was also her ambitious nature by wanting to devote her life to worship at Athena's temple rather than

marry that helped to create these circumstances. In other words, Medusa is of her own creation, not by Athena's curse. Snakes are a symbol of both knowledge and temptation, especially during the Middle Ages when Salutati is Chancellor of Florence (1375–1406). Salutati claims that "Every time the art and instruction of speaking are joined with natural eloquence in Minerva's temple, the shrine of wisdom, then Medusa's hair is transformed into snakes." The snakes symbolize the head of wisdom, and when the snake is in danger, it always hides and protects its head, leaving the body open for attack. Like martyrs, the body can be sacrificed, but never the head. The art of oratory is to persuade. Nature is represented by Medusa's beauty and it joins art and wisdom. The combination fascinates and attracts admirers before and after the curse, onlookers who are both spellbound and terrified into stone.

Should Medusa be feared, proselytized, desired? Either she has healing, restorative powers, clearly demonstrated after Perseus destroys her, and Pegasus is born from her blood, or she is a powerful warrior, a fierce combatant who an aspiring young Perseus must confront in battle. Or she signifies lust incarnate, coveted yet dangerous to look at because the gaze of the spectator leads to his death. All creatures whether human or animal turn to stone, immovable by looking at her. Natale Conti writes a didactic interpretation of the Medusa myth by insisting that humankind easily succumbs to pleasure and must therefore keep it constrained; succumbing to pleasure should be followed by guilt and remorse. Narcissism leads to consequences by indulging in the hedonistic pleasure that comes with looking, or glorifying one's self, based on trivial factors such as physical beauty. According to Conti, Minerva punishes Medusa to teach her a lesson, and all who succumb to the pleasure of looking at Medusa show a lack of respect to the Gods. Medusa does not deserve the attention of mortals, rather the Gods should be paid this high esteem. By giving into pleasure by looking at Medusa, Conti argues that one violates all privileges of humankind by serving themselves with their own needs rather than serving a higher authority; by paying such trivial attention to a woman's beauty, they renege on their duties, driven only by lust. Pride and arrogance are other negative features leading to competition between Medusa and Athena over the beauty of her hair. Worrying about such vain matters undermine the influence and devotion of prayer. Worship, independence, and creativity construct a purpose of life according to Conti. Pride and narcissistic pleasure must be kept under control in order to recognize God as the Almighty. But gods and goddesses, mere mortals who operate on prideful ambitions, seem to suffer consequences, and Medusa loses her hair and is destroyed by Perseus as a result of her pride. Pleasure can be even more damnable for men, eventually destroying them.

In that one long sleep, snakes quiet or hissing around her head, Medusa does not shut out the shadow self. Medusa is the spirit of contradiction, polarities of Medusa too monstrous for human comprehension. But she coexists with her "other," the shadow self. The sleeping Medusa does not share Perseus' ambition for victory, for love, for heroism. She does not share this desire to assert her own will. She does not even mean to terrorize men. In sleep, Medusa is equal to all

living things. The beautiful face, perhaps illuminated by the shining reflection of Perseus' sword used to behead her, is at once compliant, defenseless, the shadow self running counter to Perseus' own sense of self.

Philosophical influences on the Symbolist Movement

At the end of the nineteenth century, an emergence of new regional artists in Germany become recognized as the harbingers of the Symbolist Movement in art. They liberate themselves from bourgeois conventions, salon art, and Impressionism that represent the material world. Instead these painters concern themselves with the ideal of truth, emphasizing the loss of nature, the need for spirituality, and the actuality of the unconscious. They value truth as an ideal rather than attempting to create an ideal from the physical world or from experience. In order to achieve this effect in their art, they rediscover Greek mythology which provides this source of inspiration with the intent to convey an idea through the spectator's reception of an image in a sensory mode. The imagination operates in a sensory mode which exceeds knowledge taken from experience. Though the sensory mode relies on the signifying process, it disrupts logical meanings. By disrupting that process, the spectator is no longer seeking pleasure to satisfy the will by moving rapidly from one signifier to the next. So instead of relying on experience to gain knowledge, symbolism is a reaction in favor of spirituality, the imagination, and dreams, hence a reaction against naturalism and realism. The Symbolists attempt to show that the signifying process is disrupted when it no longer relies on logical meanings and definable objects.

The medium used in Symbolist art is an object meant to interact directly with the imagination of the spectator in order to produce a greater awareness of the active role played by the medium, the object. That object serves as a symbol. The imagination is the creator and receiver of symbols, that for painters of this genre, the symbol is associated with a mystical vision of the universe. By using unconventional styles that specifically represent reality in its grittiness, these painters rely on anti-idealistic symbols to elevate the humble and ordinary over the ideal in order to express and to reach truth. In both art and literature, Symbolists believed in Hermeticism, which refers to the unconscious that is associated with God, the All, or the One. Through Hermeticism, art comes to signify truth that can only be described or recognized indirectly. Thus, Symbolists paint and write in a very metaphorical and suggestive manner, endowing particular images or objects with symbolic meaning.

September 18, 1886 marks the birth of Symbolism according to Ingrid Ehrhardt in *Kingdom of the Soul* when Jean Moréas published *Symbolist Manifesto* in *Le Figaro*. Moréas explained that symbolism is hostile to "plain meanings, declamations, false sentimentality and matter-of-fact description," and that its goal instead was to "clothe the Ideal in a perceptible form" whose "goal was not in itself, but whose sole purpose is to express the Ideal" (qtd. in Reynolds and Ehrhardt 17). Given the interest in Greek mythology which is often referenced

in their paintings, Symbolist artists rely on Medusa images in their work. She is the object meant to produce a symbol that transforms into a certain ideal that the spectator perceives through the imagination. The question is, how does Medusa become the Ideal form? How does her image develop into an expression of the Ideal in Symbolist paintings?

It is not necessarily that she is an ideal. In fact, she can be interpreted as a threat to the order of the world. But to answer this question it is first important to explain why Symbolist writers and artists were also influenced by Schopenhauer's *Aesthetics*, a doctrine that argues of the primacy of the "Will," the faculty of the mind that selects the strongest desire from among the various desires present. Will does not refer to any particular desire itself, just what we crave the most in the moment. The Will is a distinct part of the mind, the *thing in itself*, the ground of life and all being. According to Schopenhauer, individuation of the Will is evil stemming from desire. For Schopenhauer, it is important to make distinctions between the appearance of things and the very thing in and of itself. The Will is drawn to the appearance of things that produce desire. But one must distinguish what is real, separate from desire, otherwise one is at risk of purely acting on the Will, which leads to a deliberate action. Schopenhauer believes that art offers a way for people to temporarily escape the suffering that results from willing. Basing his doctrine on the dual aspect of the world as will and the world as representation, he believes that if consciousness or attention is fully engrossed, absorbed, or occupied with the world as painless representations or images (symbols expressed in art), then there is no consciousness of the world as painful willing. Aesthetic pleasure results from being a spectator of "the world as representation," by having a mental image or idea, without any experience of "the world as will," which is a need, craving, or urge that one desires to satisfy by impulse. Art, according to Schopenhauer, also provides essential knowledge of the world's objects in a way that is more profound than science or everyday experience. To understand this difference between "the world as representation" and the "world as will" is made even more clear by understanding Aristotle's distinction between vice and virtue.

In *Nicomachean Ethics*, Aristotle makes an important observation that virtue and vice are "up to us" (Aristotle 30). To act out on one's own Will is likened to vice. But for Schopenhauer, the Will is aimless and irrational, an action motivated by blind compulsion. This means that although no one is willingly unhappy, vice by definition always involves actions which are decided upon willing. Vice comes from bad habits and aiming at the wrong things, not deliberately aiming to be unhappy. Vices, then, are voluntary, just as virtues are. There is some disagreement here since according to Schopenhauer, people are bound to motives, not necessarily free will. While Schopenhauer does not believe that we have free will, he does conclude that we can learn to become conscious of and therefore avoid certain motives. Aristotle states that people have to be unconscious not to realize the importance of allowing themselves to live badly, and he dismisses any idea that different people have different innate visions of what is good. So how might making this distinction between vice and virtue be negotiated through the image of the Medusa?

It is useful here to apply a detailed understanding of Aristotle's point about this difference between vice and virtue, how it affects one's life, and to apply this methodology as a critical lens to understanding the circumstances of Medusa. Before she is cursed by Athena, Medusa does worship therefore choosing a more unconventional lifestyle, by remaining independent and unmarried, which is not ordinary for women in ancient Greece. Culturally, Greek women who would have been the same age as Medusa, the temple maiden, have two tasks: to marry and to bear children. A woman's first menstrual cycle becomes a critical age for marriage and female responsibility. So around the age of 12 to 14, young females are valued for modesty and purity. Women have to be virgins when they marry. While the typical marital age for females is 14, males are usually 30. These women have no independence or much responsibility prior to being married and go from living at home with their parents to running the household, becoming pregnant, and serving their duties as wives to their husbands. Given their gender, age, and lack of experience, women are certainly not mature enough to be considered equal, but rather inferior to their husbands. In fact, Athenian law dictates that women are treated under the same category as children, having the legal status as a minor. Moreover, these women are not trained or skilled in any particular field such as politics, religion, military, or education. Women are specifically meant to be silent, complicit, and dependent, and their position in society makes them completely reliant on their husbands.

On the contrary, Medusa rejects these conditions of women in ancient Greece when she decides to devote her life to worship at Athena's temple. Figuratively, it can be argued that she crosses a boundary. But this is where the subject of Aristotle's *Ethics* becomes critical. He makes a distinction between vice and virtue, showing that through virtuous acts, one can conclusively enjoy a happy life. For Medusa, her *actions* are virtuous, by worshipping her goddess, Athena, because her *intentions* are virtuous. First there is a distinction between the *concept* of happiness, and various *conceptions* of it. We are not called good or bad, neither praised nor blamed based on our feelings. Virtue and vices are based on rational choices, not by feelings.

Medusa turns down her suitors, rebuffs the role of mother and wife, and instead conducts work more specifically attributed to men—not women—by being independent, solitary. The question now, which leads to much speculation, is understanding the true motives of her choice. This could involve a number of reasons. Feelings can lead to our state of being, which is a condition that can be judged as a virtue or vice. So, hypothetically, if Medusa desires to have a relationship with her goddess, if she truly loves Athena, her feelings of love motivate her choice to make an unconventional decision not to marry. Her feelings of love motivate her state of being. But what kind of state is this? Is her love for her goddess considered selfish because her devotion is to one entity, one thing, and not to a family, a husband and children?

In the twenty-first century, I would claim that her actions are not selfish at all. But my values are not a product of ancient Greece but of Western culture largely constructed by a democratic view that calls for equality among men

and women, a belief that women have an equal right to independence as much as men. Faulty logic is applying my postmodern morality on ancient Greek culture. Can my judgment be accurate since it is now applied to a culture that existed thousands of years ago? This is where I find myself in a major quandary. Aristotle helps with these questions by identifying first what the object or person is, and clarifying the function of that object or person. Does that person meet the duties or obligations in terms of her function? So if a woman decides to be a worshiper, someone showing devotion to a deity, what is the function of that role, and how is she meeting that role? There, again, is an important distinction between the ancient period compared to modern times. For one, temple maidens in ancient Greece are virgins, and all young women at this level of worship must be celibate. Living within the secular walls of Athena's temple, Medusa is in prayer, one of her regular rituals, when Poseidon arrives. How does Medusa function within this role? If she performs this activity of prayer and worship well, then she is virtuous. So why does Athena find no fault with Poseidon, and instead she punishes Medusa? Medusa's transgression is the result of attracting the attention of Poseidon and therefore undermining her role from an antediluvian perspective of women. But is Medusa vain, narcissistic, even arrogant to think that she will be guarded by the temple walls?

Poseidon is Athena's uncle, an Olympian god, and Medusa a mortal, which leaves Athena powerless to punish her uncle. Furthermore, Medusa's virtue is questioned with regards to her relationship with her goddess. According to Apodollrus, Medusa boasts about being more beautiful than Athena, which makes pride antithetical to true worship and devotion to a goddess. Moreover, Poseidon is of the older generation of Olympian gods, and his niece Athena is of the younger generation; younger gods have no power over the older gods. Athena is a virgin, and Medusa has lost her virginity in Athena's temple. Among the Greek gods, when a temple is violated, the person responsible must suffer a physical metamorphosis. Once Medusa is observed by Poseidon, there is nothing that she can do to avoid her destiny, angry and enraged though we readers might be making the argument seemingly inconclusive. Something is missing here, and the reason is because the crossed wires between ancient civilizations to postmodern thinking are at odds. They do not relate. Furthermore, Greek heroes are often the result of rape, such as Perseus whose mother Danaë is raped by Zeus. Aristotle makes another key point that might help clarify this argument. While one's feelings cannot be named as a virtue or vice, feelings can motivate actions (or a state of being), and an action can qualify as either virtuous or immoral. Medusa wants to be independent; she does not want to marry. Yet she is a mortal woman which would suggest that she does not really have a choice. Regardless, there she is in Athena's temple alone and vulnerable to Poseidon's attack. Being at worship certainly keeps her away from men, but not from the gods, or male gods for that matter who are known rapists and pedophiles; Medusa also understands the effect that her beauty has on men. While postmodern thought concludes that Medusa should have the freedom to venture wherever she pleases, to a certain extent it is also true that women

today are still not safe to travel or explore wherever they please, and definitely not in Medusa's society. A woman cannot wander alone and expect to be protected or safe, and a mortal woman in ancient Greece certainly lacks the physical strength to defend herself against a god.

Aristotle warns his reader about allowing for our emotions to cause us to border on extremes: we love too much; we do not love enough. There needs to be "equidistance" between the two, otherwise we become ill-disposed. These feelings can likely lead to a state that is either excessive or deficient. It might have been that Medusa is taking a great risk to live a life based on her own terms in a culture that clearly does not value such temerity among women. Medusa loves her freedom, her liberation from conventional rules, and for that alone, she must be punished. She is headstrong and values her autonomy while other Greek women are not allowed to engage in such feelings or reach a status of being self-governing.

It can be argued that Medusa is a virtuous character because regardless of her unconventional ambition to seek solitude and of the transformation that she undergoes, she is not controlled by her desires, which Schopenhauer determines is illogical, aimless, and hollow. She retreats away from society by finding tranquility in the temple. While the laws in ancient Greek culture will not encourage women to seek solitude, she makes a rational choice, which is neither excessive nor deficient. To be either excessive or deficient in one's choices is characteristic of vice, of willing, of craving. But as a temple maiden, Medusa is dutiful, not cowardly or impulsive; she accepts her punishment without protest after Poseidon violates her. Therefore, the myth of Medusa alludes to strength and integrity of her character, which is later a source of inspiration among contemporary female writers and artists by the twentieth century. Aristotle explains that there must be some kind of balance, a "mean," that we take something that is relative to us and generate a balance that is neither deficient nor excessive (Schopenhauer 30).

Primarily, Schopenhauer's treatise on the world as representation and the world as will inspires Symbolist painters and artists to use symbols as a means by which they evoke ideas, that produce emotions and feelings, though they are subjective. Symbols, however, provide an objective form that can communicate subjective thought, in which Arnold Böcklin, Franz von Stuck, Jean Delville, and Edvard Munch express a psychological truth through shapes, colors, and forms. Other important aspects deriving through the concept of the Will are outlined by Aristotle in the following way: not everyone who stands firm on the basis of rational and even correct decisions between vice and virtue possesses self-mastery. They are still influenced by willing, the craving to act on desire. Even those who consider themselves virtuous could act as a result of stubborn behavior, which is more likened to a person without self-mastery led partly by his pleasure that comes from being victorious or being right. On the contrary, not everyone who fails to stand firm on the basis of his best deliberations has a true lack of self-mastery. Therefore, dogmatism, a lack of flexibility, can undermine true self-mastery. A means by which this flexibility can be put into

action is through art and symbols in art, by negotiating this kind of self-mastery, and even relieve one from stubborn behavior. As an example, Aristotle gives the case of Neoptolemus who refuses to lie despite being part of a plan with which he agreed. A person lacking self-mastery can have knowledge, but not an active knowledge to which they are paying attention. For example, when someone is in a state such as being drunk or enraged, the individual may have self-knowledge by realizing the consequence of his actions. But this alone is not motivation to change the behavior. Therefore, they decide against using knowledge that they have by not using it all.

For Schopenhauer, the Will is an aimless desire to perpetuate itself, the basis of life. Desire produced by the Will is the source of all the sorrow in the world; each satisfied desire leaves us either bored or with some new desire to take its place. A world in which we are driven by Will or desire becomes a world of suffering. Since the Will is the source of life, and our very bodies are stamped with its image and designed to serve the purpose of our desires, then the human intellect is, in Schopenhauer's more noteworthy and in a well-known simile, like a lame man who can see, but who rides on the shoulders of a blind giant. It leads to recklessness in how one lives based upon Will, to be driven by desire. Medusa is not a symbol of Will, but rather in Symbolist artistic interpretations, she signifies the willfulness of her spectator. In other words, she represents the very ideas, feelings, and emotions that society has constructed of her, and therefore she is an image that symbolizes their willfulness. While she is a temple maiden, worshipping her goddess, Medusa is willful. She expects that she can live by her own terms in a society that does not value her beliefs. She lives contrary to acceptable behavior, and she certainly suffers the consequence by being raped. But following the curse, Medusa is not Willful nor is she irrational nor reckless. The gods certainly act these behaviors: jealous, impulsive, and destructive. Athena and her uncle both force Medusa into submission by means of rape, curse, and exile. As for Medusa, she is not acting on revenge, but can only look and stare at other mortal men, paralyzing them into a stony image of themselves *if* they return the gaze. It is the result of men's own Will to stare back and to look at her. What desire does she inspire among these mortal creatures?

Schopenhauer's aesthetics is an attempt to break out of the pessimism that naturally comes from this worldview. Schopenhauer believes that what distinguishes *aesthetic experiences* from other experiences is that contemplation of the object of aesthetic appreciation temporarily allows the subject a respite from the strife of desire, and allows the subject to enter a realm of purely mental enjoyment, the world purely as representation or mental image. The more a person's mind is concerned with the world as representation, the less he feels the suffering of the world as "will" (my quotations), eradicating the impulse to satisfy desires, only to have that desire terminated and replaced by yet another. Schopenhauer analyzes art from its effects, both on the personality of the artist, and the personality of the viewer.

Genuine art cannot be created by anyone who merely follows standard artistic rules. A genius is required, that is, a person who creates original art

without concern for rules. This point is reflected by the Symbolist Movement, their work generating symbols that represent the world as representation. The experience of the artist is purposefully absent from the work: in other words, the personality of the artist is supposed to be less subject to Will than most. Such a person was a Schopenhauerian genius, a person whose exceptional predominance of intellect over Will, over desire, made them relatively aloof from earthly cares and concerns. In other words, artistic expression is of the "true nature of life and of existence" (Schopenhauer 406). There are examples of the artist who is liberated from such material concerns, such as the poet living in a cramped attic, the absent-minded professor, or Vincent van Gogh struggling with madness—these are all (at least in the popular mind) examples of Schopenhauer's geniuses: so fixed on their art that they neglect the "business of life" that in Schopenhauer's mind meant only the domination of the evil and painful Will. For Schopenhauer, the relative lack of competence of the artist and the thinker for practical pursuits was no mere stereotype: it was cause and effect. For this reason, Symbolist painters and writers adhere to these concepts to show how their art "expresses the innermost nature of all life and existence" (Schopenhauer 406).

When Schopenhauer, for example, claims that "all the arts speak only in the naïve and childlike language of *perception*," he uses the term "perception" to show how art takes us beyond a narrow human point of view, taking the spectator to a place that is not dominated by individual interests. Art does not have to have a useful human purpose; there is no motive or agenda. Art does not attempt to manipulate, therefore free from the Will. Art just simply shows us things as they are in themselves, articulating the primary interests of the Symbolist Movement. Women in Symbolists paintings appear in different guises, and they are beautiful in their perfection of the female, yet cold and androgynous. Images of Medusa lead to an exploration of psychological states of mind, profound emotions, primarily identified in the work of Edvard Munch. Medusa evokes anxiety, failure, depression. She alludes to the fragility of life, the mercurial aspects of everyday life. The artist alludes to both divine principles and abject horror in these images of women, the femme fatale, the destructive nature of life and of spiritual transcendence.

Symbolists consider Art as a contemplative refuge from the world of strife and Will. They desire an artistic sanctuary and use characteristic themes of mysticism (becoming one with God or the Absolute) and otherworldliness, a keen sense of mortality, and a sense of the malign power of sexuality, which Albert Samain termed a "fruit of death upon the tree of life." Mysticism seeks to experience an altered state. Mallarmé's poem *Les Fenêtres* expresses all of these themes clearly. A dying man in a hospital bed, seeking escape from the pain and dreariness of his physical surroundings, turns toward his window but then turns away in disgust from "the hard-souled man / Wallowing in happiness." Charles Baudelaire in *Flowers of Evil* posits that there is universal harmony in relationships between the tangible and intangible. Nature provides hints of this relationship. The senses have an aesthetic impact on this ability to perceive the

relationship between the tangible and intangible. Examples such as color or perfume help demonstrate this connection between what we feel about something that remains formless compared to feelings that are produced by a tangible object. Eugene Delacroix suggests that

> The appropriate way to determine whether a painting is melodious is to look at it from a distance so as to be unable to comprehend its subject or its lines. If it is melodious, it already has meaning and has taken its place in the repertory of memories.

(63–64)

A painting that carries such tonality for the spectator means that the meaning is carried now by the subconscious mind. The artist's creation is deliberately either discordant or harmonious. The colors generate a tone, a mood whether sad or lighthearted. Baudelaire writes that "Harmony is the basis of color theory." The Symbolist Artists such as Arnold Böcklin and Franz von Stuck apply variations of dramatic moods especially in images of Medusa, or femme fatales whose bodies are enshrouded by snakes, or landscapes of loneliness and vast spaces. These visual effects evoke emotions that are on par with ancient tragedy, devoted to dramatic states of the soul. A rich imagination can identify in the physical world a number of metaphors and symbols that provide a wealth of material for the unconscious. So an object in nature manifests as a source or a bridge to the imagination that touches upon a profound sensation so that object can generate a number of diverse associations. It produces an effect on the very soul of the spectator. But this is incumbent upon the memories that are repressed and the means by which a painting by association of an object as a symbol reveals a new concept within the sight and understanding of the spectator. Making these associations is dependent upon the interplay of memory and intuition. The spectator's subconscious springs forth by a combination of the conflicts or contradictions harbored by the unconscious and revealed in collaboration with the imagination.

Bibliography

Aristotle, and Crisp, Roger. *Nicomachean Ethics Aristotle*. Translated and edited by Roger Crisp, St Anne's College, Oxford. Cambridge University Press, 2014.

Avens, Robert. "The Image of the Devil in C. G. Jung's Psychology." *Journal of Religion and Health*, 16(3), 1977, pp. 196–222. www.jstor.org/stable/27505406.

Bowers, Susan R. "Medusa and the Female Gaze." *NWSA Journal*, 2(2), 1990, pp. 217–235. www.jstor.org/stable/4316018.

Conti, Natale. *Natale Conti's Mythologies: A Select Translation*. Garland, 1994.

Delacroix, Eugene. "Realisme et Idealisme." In *Oeuvres litteraries*. (Cres, 1923), Vol. 1, pp. 63–64.

Dexter, Miriam Robbins. "The Ferocious and the Erotic: 'Beautiful' Medusa and the Neolithic Bird and Snake." *Journal of Feminist Studies in Religion*, 26(1), 2010, pp. 25–41. www.jstor.org/stable/10.2979/fsr.2010.26.1.25.

Doherty, Lillian E. *Gender and the Interpretation of Classical Myth.* Gerald Duckworth and Company, 2001.

Dorra, Henri. *Symbolist Art Theories: A Critical Anthology.* University of California Press, 1994.

Douglas, Mary. *Purity and Danger: An Analysis of Concepts of Pollution and Taboo.* Routledge, 1966.

Freccero, John, and Jacoff, Rachel. *Dante: The Poetics of Conversion.* Harvard University Press, 1986.

Freud, Sigmund. "Medusa's Head." *The Standard Edition of the Complete Psychological Works of Sigmund Freud.* Hogarth Press, 1954.

Gennep, Arnold van. *The Rites of Passage.* Trans. by Monika B. Vizedom and Gabrielle L. Caffee. Introd. by Solon T. Kimball. University of Chicago Press, 1960.

Gimbutas, Marija. *The Goddesses and Gods of Old Europe, 6500–3500 BC: Myths and Cult Images.* 2nd ed. University of California Press, 1982.

Jung, Carl. *Four Archetypes: Mother, Rebirth, Spirit, Trickster.* Princeton University Press, 1992.

Khodarahimi, Siamak. "The Snake Mother Imagery in Generalized Anxiety Disorder." *International Forum of Psychoanalysis.* 19. 2010, pp. 165–171.

Kofman, Sarah. *The Enigma of Woman: Woman in Freud's Writings.* Cornell University Press, 1985.

Nabofa, M. Y. "Blood Symbolism in African Religion." *Religious Studies,* 21(3), 1985, pp. 389–405. www.jstor.org/stable/20006199.

Obeyesekere, Gananth. *Medusa's Hair: An Essay on Personal Symbols and Religious Experience.* University of Chicago Press, 1981.

Petrarch, Francesco. *Petrarch's Lyric Poems: The Rime Sparse and Other Lyrics.* Harvard University Press, 1976.

Reynolds, Simon, and Erhardt, Ingrid. *Kingdom of the Soul: Symbolist Art in Germany, 1870–1920.* Prestel, 2000.

Salutati, Coluccio. *On the Labors of Hercules.* Persea Books, 1982.

Slater, Philip E. *The Glory of Hera: Greek Mythology and the Greek Family.* Princeton University Press, 1992.

Stanford, Ann. "Medusa." In *Mediterranean Air.* Viking Press, 1977.

Part II

Symbolist interpretations of Medusa

4 Jean Delville and *The Idol of Perversity*

She really did frighten me, the first time I saw her on June 6, 2013, a sublime, snake-haired woman with hollowed eyes who seemed to stare right through me. But as always, exhilaration and eagerness are fused together with terror, followed by a compulsion to do it all over again. The experience is likened to running back in line, to ride a rollercoaster several times more, to repeat the moment, the anticipation of the fall, the drop, when death itself seems imminently near. Do I want to die? Of course not. However, I do want to repeat something, not necessarily the action itself, but to relive the thrill that requires repeating the same action. The object of that action, which in this case at the D'Orsay Museum, is the painting, *The Idol of Perversity*, coupled with the action of looking at the fiendish, serpent-haired, bare-breasted woman. Looking at her perpetuates a sublime feeling made real by one's perception of the object. The feeling itself constructs an ideal, a state of perfection, the perfect state of being, the pleasure that comes with being scared. But it is only an illusion formed by the mind. Symbolist painter, Jean Delville, argues that on the contrary that ideal can lead to a heightened awareness.

Even during his most prolific work at the end of the nineteenth century, Jean Delville was isolated and misunderstood, likely driven by a powerful belief in his intellectual and creative independence. His work explores the nature of existence in an effort to understand how objects exist independently of individuals, and at the same time, how these objects exist within the mind of the observer. Characteristically, Delville's paintings are idea-based, expressing philosophical ideals derived from contemporary hermetic traditions. In Delville's early career, this hermetic, as a central theme in his paintings, deals with the complete change or appearance of an object into a more beautiful state, identified as the inner life of the soul. Through this change, the soul reaches towards a higher spiritual purpose. So Delville's paintings deal with themes that symbolize ideal love, death, and the relationship between the material and metaphysical dimensions. To articulate this fundamental connection in metaphysics, Delville uses a classical technique in his paintings.

This chapter will explain more about this technique used by Delville and the philosophical influences that lead to this process in his art to show how he attempts to paint the Ideal. Though I do not believe that there is such a thing

as a physical ideal, I do argue that a singular idea itself is the Ideal leading up to a creation of art. For that matter, the mythical Medusa is an ideal, out of our reach, which is why she is so appealing to Symbolist painters who attempt to achieve the effect of the Ideal in their art by painting various renditions of her. Throughout the next three chapters of this project, I will study the forms in which Deville, Franz von Stuck, and Edvard Munch use the Medusa trope to create their own version of the Ideal.

Delville achieved his best work from the late nineteenth century until the end of the Second World War before fading into obscurity, but his most disturbing painting was the snake-haired woman who he named *The Idol of Perversity* (also referred to in this chapter as *The Bride of Satan* or *Parsifal*). Though Delville does not confirm that this portrait is modeled after Medusa, there is a clear analogy between the Gorgon and Delville's artistic depiction. I argue that the woman is a Medusa figure characterized not only as a sexualized interpretation (which might seem obvious to the spectator), but more importantly, she signifies an inspirational muse meant to test the moral integrity of a neophyte preparing for a journey. She is a source of higher knowledge, light literally radiating from her, revealing secrets to the initiate as he undergoes tribulations and triumphs along his quest. Medusa is an appropriate symbol representing this odyssey assigned to a young man without any worldly experience; she too was at one time an amateur entering into a secret society by way of rituals, and suddenly kicked out because she failed the test. Now her experience of the Fall represents the fate of every new initiate who is bound to fail at some point and succumb to his own weaknesses and imperfections. These fallibilities are "secrets"—even from themselves—revealed only after having encountered each new challenge. The Biblical Fall is a common theme in the work of Franz von Stuck and Delville often characterizing Symbolist painters who search for meaning through themes of temptation and sexuality signified by the conspicuous symbol of the serpent. None of these artists intend for an orthodox Christian interpretation of their work, but rather they are inspired by mythology where mere mortals inevitably are unable to prevent their own destruction. Medusa, in this case, is an initiate (a novice as she is portrayed while she worships inside Athena's temple), and also becomes an initiator after the curse, testing the course of action of the hero, Perseus, who defeats her under the order of Athena, and uses her head to pursue and conquer his enemies.

While leading the Belgian Idealist movement in art during the 1890s, Delville believed that art should be the expression of a higher spiritual truth, based on the principle of ideal, or spiritual beauty. As a Theosophist, he believed that hidden knowledge or wisdom from the ancient past offers a path toward enlightenment and salvation, which I argue can be discovered in the mythological past of Medusa. For example, unresolved conflicts communicated in ancient Greek and Roman stories about Medusa are repeated throughout modern philosophy, criticism, poetry, and art, conveyed through the imagination of the writer or artist. Though I acknowledge that it is hard to discern these principles in *The Idol of Perversity*, Delville's black and white Medusean

sketching does show that terror is often a consequence that comes prior to, or in the early stages of, experience before a novice completes a necessary life journey or quest. Expressing divine nature through art, Delville constructs the serpent-haired woman that calls to mind images of Medusa, an appropriate subject for him to paint that brings new meaning to the relationship between materialism and knowledge of the unconscious mind. Delville explains that materialism imposes limitations, that it "does not know how ideas and thoughts vibrate, and how these vibrations impinge on the consciousness of the individual" (*New Mission* 11). The unconscious mind is more animalistic, and undeveloped. Instead "the painter's spirt [must] fuse itself with the very spirt of nature, and become the interpreter between nature and art, studying it to perceive the causes which make objects visible to us and under what laws" (*New Mission* Delville 6–7). In *The Idol of Perversity*, Delville demonstrates the paradox of innocence and experience in the grittier, darker aspects of this serpent-haired Eve which at the same time is immediately juxtaposed by transforming this same image into a carrier of light. The portrait exemplifies Delville's primary theme in his paintings and finished drawings that convey a highly sensitive visionary imagination articulated through precisely observed forms drawn from nature. Though many of his major paintings represent dozens of figures intertwined in complex arrangements painted with highly detailed anatomical accuracy, Delville does not use color in *The Idol of Perversity*, yet anatomical form is a key emphasis that addresses questions about the nature of reality. The woman's childlike face, for example, seems inconsistent with the voluptuous form of her body. This chapter explains how this paradox is resolved by Delville.

In his great work on philosophical influences in his art, *The New Mission of Art, A Study of Idealism in Art*, Delville writes that "the time has arrived when genius will no longer be unconscious: the genius of the idealist will, we boldly prophesy be superconscious" (*New Mission* 5). The superconscious mind encompasses a level of awareness that sees both material reality and also the energy and consciousness behind that reality. Delville is engaged in portraying this duality in his work, to show how the activity of the mind functions to raise this great level of awareness. Newly awakened, we are brought to a spiritual level of understanding. The role of theosophical ideas in the genesis of modernism argues that anti-materialist ideas can work together with the practice of science and the most avant-garde artistic practice, a catalyst in the creation of modernism. An example might be the ability to perceive the world of the occult and the divine.

The mysterious figure, for example, in *The Idol of Perversity* is the source of a higher knowledge, the inspirational muse. She comes in the visitation of a dream, the veiled muse, but then advances into consciousness. Rather than a symbol that points to the malaise of everyday life, this figure is far more complex. By experiencing deeper levels of the superconscious is to discover a deepening peace, calmness, divine love, and even bliss. For Delville, gaining access to the superconscious produces a greater creative force. Expressions of this kind of creativity are distinctive from those that come from the subconscious.

The superconscious is where ideas for truly great works of art, music, prose, poetry, great scientific discoveries, and deep spiritual experiences are found. White interiors in art signify the superconscious and imply a perfectionism of the inner life. The superconscious seeks this level of perfectionism. Making a distinction between the superconscious to the subconscious does not mean that artists like Delville are dealing with a simple opposition, but rather with a dialectical counterpart to utilitarian thought. In the early and mid-twentieth century, Delville's work demonstrates a great deal of effort to find a resolution to this conflict between idealism and materialism, and varied forms of spiritualism offer a third way of transcendence.

According to Brendan Cole, a prolific art historian who has produced a comprehensive study of Jean Delville's work, Auguste Villiers de l'Isle-Adam greatly inspired the artist, that is to say his "disdain for the material world in pursuit of the transcendental" (120). From the novels by Villiers, Delville gleaned that beauty can be attained through Divine love, where art allows one to perceive the world of magical beliefs and phenomena. I argue that given Delville's philosophical belief, Medusa is an appropriate motif applied in Delville's work to express this Ideal of beauty and the Divine in art, combining both visual and intellectual contemplation. This is also combined with his attitudes about the use of a Classical Greek style since "ancient Greece formed the aesthetic conception of the ideal man. A divine perfection of human form was attained" (*New Mission* 53). Furthermore, Delville's conceptions of Beauty is that it must be sublime. This combination of the sublime and classical Greek form leads to harmony and purity in art. Only one who has a superficial understanding of the purpose of art would fail to understand that Beauty must be sublime, that Beauty is therefore expressed by "pure conceptions of everything ugly" (*New Mission* 27). When Delville claims that a work of art must be beautiful in a threefold way, he more specifically identifies three dimensions of the Divine, the spiritual, and the natural (*New Mission* 27). Medusa, as a representation of ideal beauty and higher knowledge, fits within these dimensions, exemplifying universal law, planetary law, and fundamental law (*New Mission* Delville 28).

These laws are interdependent on each other, the planetary alluding to the motion of time, while universal laws respond to the motion of time by constantly changing. The natural law concerns morality. Yet it is hard to judge a moral law without putting into context the time period in which we study it, and without, of course, trying to impose our own contemporary beliefs over right and wrong compared to the ancient past. So, for example, such contemplation between the present and past would first require thoughtful consideration about the circumstances leading to Medusa's exile, after she is raped by Poseidon. In contrast to contemporary Western culture, if enough evidence prevails, a man would be punished for sexually assaulting a young woman. But this is not the case in ancient Greece, unjust though it may appear compared to Westernized laws today. Fundamental laws enforce justice, and are meant to reflect each society's set of moral beliefs. The natural law is the study of human nature, and it is used as a means to govern human behavior. Medusa embodies

the natural law of which she lived, that she is mortal, and her abuser is a god, over whom she is powerless, and Poseidon is also righteous. Her judge and enforcer of the law, Athena, is irreproachable. There is no proof from either ancient Greek or Roman myth that Medusa attempts to disobey Athena when she is punished. The curse that she must endure is also not based upon Medusa "looking." Men are not affected if she looks at them or not. But they cannot look at her, and this is ironic because the condition of her curse concludes that she cannot be objectified by men as an object or thing without being punished. The act of a woman looking at a man in an objectifying way suggests that she emasculates him, the castrating look. At the same time, Medusa accepts the image of herself newly transformed to an experienced woman. She also accepts her fate as the wronged woman. The conditions of the curse conclude that the universe is ordered, though it is always changing, according to Plato in *Timaeus*. In considering all of these factors, it can also be argued that Athena does not curse Medusa but instead blesses her, liberating her from the constraints of patriarchal society in her exile. She is entirely free to enjoy the life of her original choosing, to be autonomous, and to be the subject of her own experience.

Our fascination with the woman is combined with our effort to understand how a young, beautiful woman can become so corrupted by these laws that govern a society. This conundrum is resolved by the superconscious that leaves a feeling of sublime and exquisite beauty. By understanding Delville's philosophy and how it influences his art leads to greater insight on his production of the serpent woman. First, it is necessary to make a distinction between the conscious and superconscious mind. The conscious mind sees everything as separate from each other. A chair is only a chair, a person is simply the body they inhabit and nothing more. Conscious thought, in other words, has a very limited view of the world, an example of empiricism. The superconscious mind, however, sees that everything is, in reality, made of energy and consciousness and, therefore, it sees the underlying unity *behind* the outer forms. This is what Delville seeks to create in his art, and it is a major concept applied by other artists of the Symbolist Movement. Delville is inspired by the Classics, which he used as an art form to evoke subjective feeling and mood rather than emphasizing external reality recognized by the conscious mind. But according to Edith Hoffman in "Belgian Art at the Grand Palais":

> There is no nature lyricism and no innocence in the work of Jean Delville who swallowed all of Péladan's ideas and represents the esoteric side of symbolism. Paraphernalia of satanism and kabbalism appear in his paintings, snakes envelope figures which are strangely incorporeal, eyes of unreal blueness are turned to heaven. Occasionally he impresses by a picture of sinister beauty such as *La fin du regne* (1893) which shows a cut off head (one more of the symbolist themes) and is in its combination of horror and splendor very similar to Moreau's *Apparition*.
>
> (265)

Hoffman gives a severe criticism of Delville's work that seems to have more to do with personal preference than with an unbiased examination of his work. However, she raises an important point to consider by concluding that "Symbolism moves often on the borderline between eccentricity and bad taste and can altogether be appreciated if a literary outlook is accepted as the artist's point of departure" (265). In other words, there must be some kind of story-telling context for the art to have value. Myth serves as a device that produces meaning in Delville's work. It is important to understand the mythical context that goes along with *The Idol of Perversity*, also combined with Delville's passion for music, in particular Richard Wagner. Classical form provides a conduit between materiality and transcendence, a harmony between the physical and metaphysical, while critics, such as Hoffman, argue that a literary device must be present in the work to impart greater meaning and value; mythology in art provides this literary context.

Hoffman makes an analogy between Delville's *End of the Reign* and Moreau's *Apparition*, though she does not expand on this comparison. While Salome dances for Herod Antipas, who orders the execution of John the Baptist at the bequest of Salome, in *Apparition* a vision of the preacher's bloody head appears and interrupts the dance. The head figuratively represents a higher consciousness. Similarly, in Delville's painting, a Medusean depiction of a woman's decapitated head is held by its hair, the eyes of the woman closed, the colors and lighting emphasizing the exotic facial features of the woman, her head crowned in gold, alluding to her previous sovereignty, the male figure clearly unidentifiable. The coloring around the woman's eyes are darkened. Though Medusa and Salome are often compared and defined similarly as fatal women, it is clear that this analogy is flawed. Hoffman suggests that there is a greater likeness between the biblical John and defeated Medusa. Salome desires attention, while Medusa pursues a solitary life. Salome's intent is wickedly motivated by her mother Herodias, to exploit her daughter's sexuality and to subvert moral judgment of men, but in comparison to Salome, there is no evidence justifiably supporting the claim that Medusa is evil or desires the destruction of men. Of all female mythical and biblical characters portrayed as devious and cunning, Medusa is the least likely of them all. This is not to say that she is defenseless or powerless. On the contrary, she asserts her own will from the very start before she is even cursed. But Salome in contrast wishes to cause havoc and demonstrate her power over men. She epitomizes the castrating woman.

In Delville's painting, *End of the Reign*, between its horror of the bloody head and splendor portrayed in death is hidden melancholy, the mouth partially open, the features of the woman suggesting that she is still young at the time of her beheading. The colors Delville uses are darker, with a lighter yellow or bronze that more clearly distinguishes the woman's face, her profile. That feeling of melancholy alludes to craving, pining for something other than what can be produced by external reality, whether it be peace or redemption. Such yearning also insinuates the secret identity of the woman, the cause of her death, the puzzling result of dying young and beautiful. The darkened shades around

the eyes and mouth suggest that the woman's corpse / head is in the early stages of decay. She is held by one fist, presumably a man, alluding to his victory, that he has succeeded in conquering her, an implicit analogy to Perseus and Medusa.

Delville's sketching of *The Idol of Perversity* produces a different effect, more menacing compared to *End of the Reign*, which is more serene without the threat of temptation; there is a finality to the second portrait unlike the first, though both images allude to death. *The Idol of Perversity* is in black and white, the central figure seemingly unconscious, half-opened eyes, deadly in their gaze. Yet the face appears more childlike as if it does not belong to the body, a figure that is otherwise provocative and feminine, wanton and voluptuous. With a round face and thin lips, the woman's head bears no features either sexualized or beautiful. Critics argue that this image depicts aggressive female sexuality, looking down with a demonic intensity through a thin polka dot veil that covers her face; the diaphanous veil exposes everything. There is nothing demure about the woman, infantile though her face may appear. Her nose is turned upwards, which could imply a sort of superiority, and her forehead is enlarged as if it is deformed. Her thin eyebrows and the snake slithering across the crown of her head, resting in a sloping indention in the middle of her forehead, gives it a disfigured impression. The eyes and the mouth could give her a demonic expression, but this is still uncertain since the head and body, like many Symbolist paintings, do not seem to match. The figure seems to be more dead than alive. The eyes make out something that welcomes death, but the expression is not seductive in nature. The mouth is turned downwards in a prostrate pose. Yet in my summary of the Eve / Medusa image, I argue that she is more exotic than demonic.

According to Mario Praz, to experience exoticism is to "transport oneself in imagination outside the actualities of time and space in whatever is past and remote from him the ideal atmosphere for the contentment of one's own senses" (210). The exotic aspect tends to a sensual and artistic externalization; it makes itself concrete in an atmosphere remote in time or space, or both, that it gives the artist the illusion of an actual former existence in the atmosphere he loves. The possibility of encountering the exotic is extraordinary; it reaches beyond that of materiality or the physical level, but more toward the possibility of transcendence. This effect on the spectator is meant to go beyond the idea of "what we are," similar to Nietzsche's discussion of Apollonian and Dionysian distinctions. If a painting has the effect of self-forgetfulness, as Nietzsche describes it, then there is potential to look beyond what we believe ourselves to be and seek something greater of what we ought to be. Our external view of ourselves must come together with our internalized understanding of self. This dichotomy is most apparent in artistic depictions of Medusa, because what she is, happens to be contradictory to how we, the viewer, perceive her, alluding to our own confusion over how we perceive ourselves.

Looking at Delville's painting, *The Idol of Perversity*, it has an intentional disturbing effect. It disrupts the modern Westernized viewer's perception of order, because it appears so menacing, yet vulnerable, that one is not sure what

to make of it. It is believed that Delville's sketching is of a woman originating from an oriental past, primitive, distant and isolated. It is also striking, unusual, and strange. In the late nineteenth century, particularly in Europe, conservative ideologues argued that women were beings on the evolutionary scale, that women are intellectually undeveloped, lacking the same intellectual capabilities of men. These misogynistic views about women often develop into incarnations of the femme fatale, a smart woman who is abnormal because she thinks more like men which makes her dangerous, even more cunning. Consequently, she scares and threatens men by her ability to reason and strategize. In a different conventionalized representation, the female sex is allegedly animalistic, inferior in relation to men. The enigmatic female in Symbolist art comes to represent aggressive sexuality, that same degree of abnormality expressed by the cultural ideology purportedly implied in Delville's work. So it is important to investigate the degree to which Symbolist painters such as Delville either escape these stereotypes or help perpetuate them. At the 2017 "Mystical Symbolism: The Salon de la Rose+Croix in Paris 1892–1897" Guggenheim exhibit, Delville's *Bride of Satan* is described as

> [looming] large and looking down with a demonic expression as a phallic snake slithers between her pointed breasts and others radiate from her headdress. Her vaguely exotic appearance make her doubly other and uncivilized according to racial mores at the time. This ferocious image attests to the multivalent meanings ascribed to women at the fin de sièecle and to Delville's esoteric belief in the duality between the carnal / material and the spiritual transcendental.

The serpent woman does appear to be towering over her spectators. But her expression is not necessarily demonic as I see it as being in a half-conscious state, under a spell, or not entirely present. She is absent to us, while the spectator is easily compelled by her. In fact, she appears unmoved by anything around her, impervious to the snake slithering across her forehead. She represents carnal desire, but only to a certain extent. It is her nakedness in perfect view beneath the transparent veil that awakens a physical need, immediately contradicted by her isolation from us, her forbidding and indifferent demeanor. Yet she is meant to pose as a combination of carnal (material) and transcendental spirituality. For Delville, idealist art is legitimate, as he tries to negotiate these dualities in his art. In *Jean Delville: Art between Nature and the Absolute*, Cole explains of Delville's paintings that they

> should not be viewed purely as didactic expressions—or visual descriptions—of some intellectual idea or theoretical perspective; he was a highly articulate artist and his images have a power of immediacy largely because he knew how to manipulate the medium in order to communicate ideas, through affective means, relating to the Theosophical and hermetic sphere to which they largely refer. His art is therefore a synthesis of the

visual and the intellectual, and both these need to be kept in alignment in order to understand his work as poetic expressions.

(150)

Delville is not making an attempt to teach his spectator an idea or belief about the work he creates, though it conveys hidden knowledge and meaning. But it is a combination of visual imagery and the ideal. The "power of immediacy" is the emotions summoned by these images. In the case of the serpent-haired woman, she evokes fear and horror at first sight. But this is still a limited evaluation of her. His work has an emotional style of expression by combining the esoteric with the ocular effects. In this painting, Delville also explores the hidden nature of man. Philosophical influences of occultism allow for the artist to express "notions of spiritual renewal and transformation" (Cole 151). By revisiting the myth of Medusa, and certainly her death which produces Pegasus, a symbol of wisdom and innocence, the likelihood of redemption, of renewed purity and transformation is obviously possible. But it is also important to try and identify where such spiritual renewal is conveyed in Delville's painting, in which the image based on the title may have been intended to be deviant from conventional taste. There is obviously something more complex that may not be obvious to visual impressions of the sketching.

Delville's painted Medusan women represent the initiator of the male journeyman or knight whose virtue must be tested. *The Idol of Perversity*, in particular, embodies an important belief expressed by Edouard Schure in *Les Grands Inities*:

> on the descending road of evil, there is a point where the soul can still turn back. But once this point is passed, the hardening is definitive. From incarnation to incarnation it will roll at last to the bottom of darkness. It will lose its humanity. Man will become demon, an animal demon, and his indestructible monad will be forced to begin again the painful, dreadful evolution through a long series of ascending kingdoms and innumerable existences. This is the real Hell, in harmony with the law of spiritual evolution, and is this not as terrible and even more logical than that of exoteric religions.
>
> (632–633)

Schure suggests here that the soul endures a number of different challenges, namely temptation. Giving into temptation is surely the means by which the soul degenerates. These ascending kingdoms allude to the trials and tribulations of life in which the journeyman is forced to climb once more these kingdoms. The action of climbing, the attempt to ascend upwards repeats itself several times throughout life. Only upon hitting the bottom does one realize what has been lost. Perhaps in that process of falling, of losing oneself, such pain is suddenly felt. At that point the soul can transform before taking the risk of falling further. It can turn toward a different path. But it may also be that the soul is

unaware that it is falling, impervious to the destruction caused by giving into temptation. It is an important point Schure makes, clarifying that to be unaware of such destruction, that the lost soul is just as terrible as the warnings about hell preached by religion. Schure contends that "Man will become … [an] indestructible monad," an indivisible entity. It is man's spirit that cannot be destroyed as he pursues with temerity these transformative passages through life. By applying Schure's point to the myth of Medusa, the Gorgon woman epitomizes the experience of the initiate, the mortal woman who suffers recurrent trials. When Perseus defeats her, Medusa is finally put to rest, her soul liberated, further signified by the birth of Pegasus and Chrysaor. It could even be argued that her death redeems all the sins committed against her: rape, exile, and murder.

There is a fear of hell that can be imagined as a real place. But "hell" can also be a place within the mind, not a physical place. Delville's concern in his painting is to show that materialism and sensualism are obstacles against spiritual progress. These obstacles develop in different forms. During the initiation process, the challenge of being tempted by erotic desire, there are the alternatives for spiritual growth, or, on the contrary, deterioration. Though these paintings were never meant to represent a satanic subculture as it has been confused, or used by the Decadents of the late nineteenth century, it still warns against the smothering and extinction of the soul. It is therefore necessary to address these real needs and desires while at the same time choosing a transcendent alternative.

Medusa could be called the initiator, the "temptress" by capturing the spectator's gaze. But this is to return to the old patriarchal arguments that she is monstrous and evil, where Medusa lacks subjectivity, and is simply a symbol, an object of destruction, the very point that I argue against. As an initiate, however, she can come to represent the superconscious symbolically portrayed in art. While Medusa undergoes a physical transformation meant to scare men, the problem of arguing that she is monstrous is simply that there is no evidence supporting this argument since she has been entirely powerless over her circumstances. While it is inevitable that events in her life affected her, it was still the way in which Medusa responds to these events that transforms her. It was not Poseidon, Athena, nor Perseus in the end who determine her subjectivity. She defies the categorization of victim. In death, Medusa creates new life and generates renewed hope with the birth of Pegasus and Chrysaor. By creating life, she represents the fundamental of Ideal Beauty and Divine Love according to Delville. In death, her curse is replaced with redemption. Schopenhauer explains this belief that an object of beauty can help overcome suffering that is experienced in the world. Various artistic interpretations of Medusa change the widely accepted perception of the cursed Gorgon as a monster. Instead she is also depicted as an object of beauty, her solemnity speaking more to the spirit than to the libido. Still this can return back to the patriarchal narrative that objectifies Medusa even though men are not supposed to be looking at her without retribution. In this case, the viewer of such art images is the subject, and the object in the painting represents some form of suffering over which the

spectator tries to prevail, whether it is his guilt or shame for gazing at Medusa when the action is taboo. In order to transcend early suffering means to overcome desire by making the meaning of these objects in the sketching more apparent within the superconscious. The purpose of the art object is to diminish these aims of lust by eliminating the will, which is the source of all suffering. Viewing such images of Medusa can produce aesthetic pleasure, but the purpose of such pleasure by looking at these depictions is meant to distinguish desire. Delville explains that "Ugliness is only permissible in art under synthetic or symbolic forms" (15). While the Ideal of Beauty is to create great work without mistakes, ugliness appears by accident, expressive of an idea associated with the Ideal. Moreover, ugliness is a collusion of the mundane with the extraordinary. Beauty is therefore defined by the style of the painter, not in the work itself.

While Delville allows for a different understanding of Medusa given his aesthetic beliefs, it still makes it impossible to escape the objectification of Medusa, whereas I argue that Medusa is an initiate of her own life. It is not the cursed mortal woman who is vulnerable to sexual temptation; rather she becomes the victim of other men's lust, and her serpent hair now wards them off. But because she is raped, and portrayed as exotic, she becomes an object of desire, despite her features that would scare most people out of their wits. In *Rape and Ritual: A Psychological Study*, Bradley A. Te Paske provides a Jungian interpretation of the stigma attached to rape victims. Remarks projected onto women often suggest that they are responsible for their assault and that these women wish to "get raped" (23). According to Te Paske, even today, society tend to judge the victim harshly and doubt who is responsible for rape. This is demonstrated by the psychic process of the "rape fantasy." Sexuality, as Delville seems to suggest, has a natural affinity with the spirit. But this connection has for years been repressed by Christian orthodoxy. So when the rape fantasy leads to psychotic proportions, it stems from an intense rage against women, ironically combined with a defense against one's feeling of helplessness. Hypothetically, by exercising a forceful power over another woman, the rapist errantly proves himself to be masculine by no longer feeling threatened by her. From a Jungian perspective, there is a great fear and resentment against women often expressed throughout Western culture. To give two examples concerning this loathing against women, the early Christian author Tertullian describes a woman as "a temple built over a sewer." Saint Augustine repulsively concludes that "between shit and piss we are born." These historical figures, valorized as great thinkers, promote the most demeaning depictions against women, which has continued to permeate throughout social consciousness even today.

But regardless of what her body might look like, her face remains the same, though changed on an emotional and spiritual level, she certainly does not experience carnal pleasure. Instead Medusa ends up ruling the new region of Libya, according to second-century BCE novelist Dionysios Skytobrachion, where she is exiled. It develops into a female community, her tribe where heroes and gods have no influence. On the contrary, this leader with her community of Gorgonian women matter a lot to the men who want to dominate and rule them.

Left uninhabited by men while she is exiled, Medusa's body does not define what she is, does not form her subjectivity, and therefore there is no separation from the mind and the body. But it is men who feel threatened by her who do not clearly make this distinction between the two when they contemplate, paint, or write about Medusa. Delville, for example, alludes to this dread of the feminine in his sketching that suggests women can turn men against their own soul. It goes back to the earliest of beliefs that women tempt men to do bad things. But I argue that as an initiator, Medusa teaches men about the truth of their own character. She does not humiliate them, but they certainly are humbled by recognizing their shortcomings and imperfections concerning what she can do to them if they transgress that forbidden boundary of "looking."

Delville translates Schure's principles about the soul on a metaphorical level in *Idol of Perversity*. While the intention and meaning of the portrait might appear pretty obvious, I find that the symbolism in the sketching is far more ambiguous. It might appear to be the influence of the woman's erotically featured body that hinders spiritual progress, but this is not necessarily the case. Originally the sketching was not meant to be publicly displayed, but more or less for the contemplation of fellow Theosophists, the imagination conjuring up dark, fantastical nightmares and dreams. Inspiration for this portrait came from the paintings of Odilon Redon, whose dreams and fantasies are conjured up by strange subjects, such as insects and human heads in his work. Delville was also affected by the macabre stories of Edgar Allan Poe. Few portraits from the fin de siècle have been as shadowy and equivocal as Delville's *Idol of Perversity*. At first glance, the woman in the portrait might epitomize the destructive woman stereotype, conjuring up images of Medusa as she has often been portrayed in literature, the femme fatale, suggesting that she is wild and destructive. But this definition is inaccurate, or at best repeats the way in which she is constructed by dominate male culture, beginning with Greek and Roman myth. Upon closer study, she signifies dualities of purity and spirituality with debasement and anguish. It appears that Delville attempts to incorporate all dangerous women from religion, mythology, and literature: Salome, Medusa, Lilith, and Eve. But these historical literary figures of women pose greater complexities upon closer study. *Parsifal*, as she is also called, is the dark idol. So she does not necessarily represent contemporary fears within the culture of that time of aggressive, more determined women that threaten the patriarchal hegemony. Also in this reading, she does not represent social fears and sickness identified in late nineteenth-century Europe, largely contributed to a growing industrial age, materialism. The painting also precedes famous interpretations of women and the signifying power of the serpent by Stuck. So Delville's portrait continues an exploration of this motif, of healing and spirituality.

Cole suggests that Flaubert's historical novel, *Salammbo*, could have been the catalyst for Delville's *Idol of Perversity* since the description is closely linked to the image in Delville's portrait (247). The portrait is reminiscent of the sensual dance that the title character has with a python wrapped around her oscillating body; the woman embraces the serpent as she would a lover. In the portrait, the

bride's commanding power emphasizes the subordination of anyone looking at her, and this implies the same domineering power over which Medusa has among spectators, that she is not only feared by them, but superior to them, yet they cannot help but look. Rays of light from above her head radiate from all directions ephemerally in stark contrast to the rather obscure features of her expression, sightless eyes, her teeth partly visible, dark shadows enveloping her body. The halo of light circling her head alludes to the woman, though formidable, as a saint or holy person, the intense light suggesting her eminence. But upon closer study, the rays of light also reveal serpents, separated from the woman and moving independently, blending in with the light. The serpents are hissing and moving freely. The snakes are also very light in color compared to the snake moving between her breasts and the one resting in the middle of her forehead. The floral crown, the halo of light alludes to this uncertainty of the representation of the woman. Her expression is death-like, but her radiance hints at a life-force. The death mask worn by the woman might appear that she is not concerned about the redemptive qualities of her spectator. Yet the imposing figure at the same time can be viewed as figuratively judging the spectator by identifying some form of truth or flaw about the viewer of which he may not be aware, which causes discomfort for anyone gazing at her. Cole describes her eyes as "cold-blooded, and chilling" (248), though I take a slightly different view with the impression that she sees right through her spectator, that we are rendered powerless by her gaze, that she dominates us in some kind of hypnotic trance, while at the same time she seems not to see us, but to see that to which we are blind, something beyond us. To not exist, to be suspended between the material and spiritual realm, soulless, is more frightening to the spectator than the details of the figure.

There are other points that Cole makes which are critically important, though I am not entirely in agreement: that her distant stare is one of horror, that the eyes look as if she is ready to annihilate her prey. There is a superior force at work here, but I am not convinced that it is with the intention of destroying her spectator. To me, she challenges the spectator, not with what she can do to us, but what we have already done to ourselves, that we might be able to see her, but it is ourselves that we are even more frightened to know. Delville is urging his audience to look within, to see the concrete, but to also view that which is otherwise invisible to us, to reach to something more internalized. Cole describes her top lip as "a belligerent, rodent like, snarl" (248). His description brings to mind Algernon Swinburne's description of Medusa in *Essays and Studies*, the paradox of her dark beauty and power, "her mouth crueler than a tiger's, colder than a snake's, and beautiful beyond a woman's" (320). The shape and expression of the mouth is almost not human-like, more serpentine than rodent in similarity. A snake possesses qualities in which it can be well camouflaged, to hide out of sight, or to be there right in front of us without us knowing it. The snake blends with its environment, the coloring, filling in the shape or colors of the background. So we don't really see it unless it wants to make its presence known. I also do not find the shape of the mouth

particularly hostile or snarled. The shape of her mouth might communicate that she is angry, or antagonistic, but there are other conclusions that can be drawn here that on the contrary, the pose is complacent if not restrained. The nose is turned upward, but not "flared," contrary to Cole's description. Her nose points upwards at the tip. According to some studies, women who commonly possess this feature tend to be also prone to abuse, though they have a resolute faith that everything will work out. Certainly, it is easy to dismiss these personality traits to that of which we might see in Delville's portrait. But he uses dubious polarities that combine both the material world and the spiritual, her posture alluding to these contrasts that are dangerous, threatening, yet radiant and fertile. Her forehead appears oddly enlarged, while her eyebrows are very thin, yet prominent. Her facial features are so unusual that there appears to be little symmetry, and the infantile shape of the face is incongruous with the robust womanly figure as I mentioned earlier.

Translated into English, the poem "Physiologie" by Jean Delville offers many parallels to his painting *The Idol of Perversity*: "your mask has revealed to me the ugliness of your soul / and in your fatal eye from which the light has fled / stagnant like a cloak in the night / of infective thought and infamous hate" (75–76). Cole suggests that Delville may have contemplated the images in this poem before drawing *The Idol of Perversity* (249). If applied to the portrait, the facial expression is in fact a mask, in my conclusion, the death mask. The soul and a woman's beauty are intrinsically linked, that the face itself can reveal the contents of the soul, to show what cannot be seen. If the face is ugly, the soul matches external physical features and posturing. Furthermore, even if one tries to hide behind a mask, they still reveal themselves. The face eventually assimilates into the very image of the mask, which figuratively evolves into a reflection of the soul. In comparison, the daunting female figure, like Medusa, is a head with a body attached, or a mask connected to a woman's body, similar to the famous sixth-century pediment on the Temple of Artemis in Corfu described in Chapter 2. The vacant eyes of the woman insinuate impending disaster or destruction, that there is no light left in the eyes, that the woman is soulless, the irises are barely visible. Yet her eyes provide insight into one's inner life. The pupil acts like the aperture on a camera, dilating or contracting to regulate the amount of light coming into the eye, pupils enlarging and decreasing in size depending on the light. In studies conducted by psychologists Sebastiaan Mathôt and Jan Theeuwes, the pupillary light response can communicate the emotions and intentions of an individual (517). This study confirms that:

> Perhaps even more surprisingly, we are also not aware of the fact that with each eye movement there is a corresponding shift in our retinal image of the world. Somehow, despite incomplete and unstable visual input, we feel as though we have a complete and stable percept of the world and are able to effortlessly perform visually guided action.

(517)

By shifting one's gaze in response to the light, pupils adjust their size in advance to the amount of light we *expect* to encounter at the new location, not at the exact time that it happens. This intuitive shift toward light or darkness could even insinuate that the gaze of the woman in the portrait is reflecting back at the world its own soullessness, its own threat to itself, a world pulling itself back and forth, away from the natural, and away from the spirit then suddenly returning nearer to it.

Physiology of the women defines a woman's domestic and social role in the nineteenth century. The uterus specifically was used to define the female duty of propagating. In the portrait of the woman, her stomach and breasts are strongly emphasized, suggesting that she is pregnant. Her stomach is swollen and full, her body round and supple. This could also allude to the woman being "mother earth" or Eve of the modern world. Her facial features are impassive, emotionless, but not cruel. Her mouth is so small, like a child's expression on a stony face with a woman's voluptuous and thriving figure, or on the contrary the hollow opening of a serpent's mouth. Her thriving sexuality is distracting and reminiscent of dangerous nineteenth-century women whose grizzly passion borders on the hysterical, a woman ruled by her impulses, dangerous to men who easily become submissive to her needs. Schopenhauer observes that the reproductive organs are a manifestation of the will, and in fact, the cause of one's suffering. The woman is lust incarnate that rules over the judgement of men, which makes her frightening because men are easily subdued by her powerful sexuality.

Parsifal was the title given to Delville's sketching, *The Idol of Perversity*, at the D'Orsay when I first saw the work. While the central figure, Parsifal (*The Idol of Perversity*), may appear ominous, there are many elements of dark and light that help minimize her threat. The world is projected from the gaze of the woman, reflecting good with evil, redemption juxtaposed by purgatory, death with life. All of these polarities must exist: the negative with the positive, even the material with the spiritual. Schopenhauer notes that "the world seems to us full of contradictions" (634). While life tends to be unpredictable, it certainly is not "arranged for the purpose of containing a happy existence" (Schopenhauer 634). It requires a number of trials marked by thresholds dividing innocence from experience. So what is the goal? While pleasure and joy can be very decep-tive because it never reaches one's expectation, sorrow is very real because it often exceeds our expectations. Though this may appear to be pessimistic, there is certainly a purpose for having discovered and accepted these contradictions. According to Schopenhauer, it "reveals life's deepest meaning" putting the world "in harmony with [one's] insight … not with his wishes" (635).

Benediction comes at the end of a religious ceremony, a blessing received by the neophyte about to embark on some new transition or journey. The flowered diadem worn by the "bride" in Delville's sketching is used as a symbol to convey a benediction, both a beginning and an end of something. The female figure consents to this transition, initiating a new journey, while, at the same time, progressing from innocence to experience. The crown places the woman

at a level above all others, legitimizing her as a superhuman creature. Flowers adorning the crown further imply the attainment of a high stage of development, elevation of the spiritual element over the corporeal, one who transitions into a new state of existence. The flower paradoxically is a universal symbol of young life, though also standing for a loss of life. A flower is prized for its aesthetic value. They can be harbingers of spring or signify carnal lust. The transitory nature of all beauty is embodied by the flower. Similarly, the flowered crown comes to mean a series of polarities. In summary, the flower manifests a pattern of life that has both a beginning and an end.

In the poem "Bénédiction," Baudelaire declares: "I know that suffering is the sole nobility / Which earth and hell shall never mar, / And that to weave my mystic crown / You must tax every age and every universe" (28). The poet humbly thanks God for the suffering he has endured at the hands of all humanity, represented principally by the speech of mother and mistress. Pain endured by the poet is his blessing, and for the poet to acknowledge his own suffering places him at a higher state of being because he has learned through his experiences, lessons from which his mistress and mother agonizingly teach him. Neither heaven nor hell come to matter in this case. The emotional effect caused by suffering is noble; there is greater virtue and honor by experiencing pain, having succumbed to and weathered tragedy. The "mystic crown" signifies that the person wearing it has achieved unity with a god or something absolute, who believes in spiritual truths beyond the intellectual, which resonates with the Theosophists. In order to achieve this spiritual experience, "all times and all worlds must be used" (Baudelaire 28). The result of suffering for the Poet leads to the experience of warmth and love. Baudelaire did in fact have a pure love for his mother, happiest as a child when he was in her company. The connection between Delville's sketching and Baudelaire's poem is that the image serves as a conduit between the earthly and spiritual realm. But to transition to higher knowledge and ascend to a greater state of being, suffering is inevitable. The flowered crown symbolizes the attainment of a high stage of development, the elevation of the spiritual element over the earthly, natural world.

The woman's body and face are covered entirely by a transparent veil, noticed only by the dotted pattern. Generally, the veil is a symbol of modesty and virtue, signaling a withdrawal from the outside world, removal from the vanities of this world. While meant to cover the face, the veil is often used by the bride. But in ancient societies dating back to Assyrian culture in 1400 BCE, there are strict laws enforcing wealthy women of social prominence to wear a veil compared to female slaves and prostitutes who were forbidden to cover themselves, or they faced harsh penalties if they did so. In ancient Greece, women of higher status were also required to cover both their face and hair. The veil symbolizes both revelation and concealment that resists fixed meanings about women since the face is covered; yet only women of a privileged background can escape objectification by being allowed to wear the veil. This symbol of the veil can create meaning and then subvert it or at least hide it.

This becomes pivotal in trying to understand why the woman in Delville's portrait wears the veil. The title of the painting identifies her as "the bride of satan," conspicuously pregnant and blatantly challenging religious codes about the unsullied bride, pure and virginal. It is important to explore the emotional effects produced by the veil. The diaphanous veil holds some kind of mystery, a question of what exactly is being concealed. The woman is the mysterious figure that causes awe or inspires fear. The veil is a symbol of complex, emotional feeling, depending upon conclusions made by the spectator. It can work as an instrument that casts a luminous power over the spectator. As a spiritual and emotive power, it perplexes and even mortifies people who experience much anxiety by not understanding what might really be hidden underneath the veil. Though we can see the woman perfectly through its transparency, it still protects the spectator from the consequences of what power she might have over her audience. For now, when we see her, she radiates, beaming light pouring out of her; it is hard to tell exactly where the material of the veil ends and begins. Yet the thin material, transparent though it is, still protects the viewer from whatever darkness might be discovered, from the serpentine qualities of the woman and her dreadful gloom. Though the veil on a more literal basis may not have any detachable or intrinsic significance, the meaning that it carries and impact that it generates depend on the intentions of its use, and the context of the woman. Does she mystify us or terrify us?

Delville explains that the "The Idea, in the metaphysical or occult sense, is Force, the universal and divine force which moves worlds, and its movement is the supreme rhythm whence springs the harmonious working of life" (*New Mission* 11). The combination of both light and dark, heaven and hell, all polarities contend that all worlds lead to an esoteric wisdom held by the woman behind the veil. She represents that "Force," life with a more dominant pulse. The spectator will be hindered by the elements of what they see such as the veil, snakes, and her half-opened eyes. But Delville is urging the viewer to explore the unconscious, that other world that leads to increased understanding, once such meaning transitions into our superconscious awareness. If she is both dark and light, then why? How might we be affected by this paradox? Lifting the veil suggests revealing the woman's mystery. But Delville in his definition of "force" suggests that our understanding of that mystery will still be very limited.

Because the veil worn by the woman is very thin, and the spectator can see everything, it is easy to assume the woman has nothing to hide. These symbols and elements in the sketching that have been addressed are so incongruous, the very sight of her only causes more perplexity and confusion. This would mean that the woman is the symbol of esoteric power, that to know her secret is to gain spiritual knowledge. But that knowledge cannot be accessed through the material, only as a result of the superconscious. The emotions conjured up by her image, as Delville explains, is "the Emotion of the Spirit" or a "reflex of the Soul" (*New Mission* 12). But those emotions need to be brought into harmony with the work of art itself. Delville's portrait represents the Eternal Feminine. Nineteenth-century ideologues rely heavily on this image of women, used to

define their social role as driving men toward a moral and spiritual path, or by driving them away from it. If the woman can serve a greater good, then the spectators must see that she must be modest, pure, and graceful. Originally, the concept is defined as woman representing pure thought, while men represent action.

Nietzsche argues that the Eternal Feminine symbolizes life and death, metaphorical death and awakening to new knowledge. This corresponds with the duties of women in ancient Greece, both in childbirth and care of the dead, private rituals managed by women. But the virtues of women are inherently private, symbolized again by the veil. Still the veil assumes a plethora of possibilities and interpretations. Meaning is not simply limited to the veil itself. The veil is not, therefore, just an object, but a symbol that transforms the person attempting to decipher its meaning. Raising the veil can reveal the mystery according to Theosophists, but it also has a signifying power in and of itself. The Eternal Feminine is the Ideal. A study of other elements—not just the woman herself—is necessary to have some understanding of the Eternal Feminine, to reach some form of enlightenment. The disparate parts of the portrait, the protruding forehead, the slit eyes, the thin lips, contradictory to conventional idealized images of women, help to establish a symbolic order, a kind of structure, so that the unique parts can be analyzed for their own merit, and it is in this process of understanding that emotions are powerfully evoked from these symbols that in the end bring the work holistically together.

The feminine allure in Delville's portrait represents these features, and of course, Medusa is portrayed similarly throughout literature, the embodiment of lust and death. Because this has been so universally accepted about the Gorgon, it is deserving of further inquiry when comparing her images to dark and light artistic incarnations of other such feminine portraits. It is important to note the degree to which either Medusa or the feminine portrait are representational of a cruel nature. This would mean to know the intentions of the object. But as an art object, only the spectator can discern these intentions, which are largely based on his own desire and temperament constructing meaning of the object at will. All these literary female figures can signify the dangerous lust in the spectator, certainly, which comes at a cost. Salome, for example, can be viewed as serving only an evil force in the way that men attempt to exploit her, and that men are willing to sacrifice whatever cost to enjoy her charms for their own lustful purpose. Therefore, men objectify her for this particular purpose. Art magnifies this objectification of the feminine power that can of course be put to a debauched motive.

In the poem "La Danseuse Satanique," Jean Delville describes Salome, the biblical femme fatale, who dances not only for pleasure, but for revenge. In the Gospel by Matthew and Mark, Herodias, Salome's mother, is responsible for devising the revenge plot, encouraging Salome to offer Herod, her mother's husband, whatever he desires for this birthday, but only under the condition that Herodias can have the head of John the Baptist. She is angry at the prophet

for claiming that her marriage with Herod is unlawful, and therefore she uses her daughter as an instrument of revenge against John the Baptist. Given this translation from the Gospel of Mark and Matthew, Herodias is more cunning and vindictive than her daughter, Salome. Yet it appears to be only Salome who is in a position to persuade Herod because she has the body and the allure to lead men astray from moral judgment. They act not of their own will, but of hers. Whether Salome gains any pleasure from carrying out such a tragedy instigated by her mother, she is still willing to perform the deed. Medieval Christian artists are first to personify the biblical femme fatale, Salome, in much of their work, and the tradition continues to influence artists and writers of all epochs of history. But the degree to which this characterization is accurate deserves more analysis. This is not to argue that the biblical Salome is innocent. But her actions are clearly motivated by her mother, who appears to be more the femme fatale, using her daughter to carry out her reprisals.

The similarities between Salome as characterized by Delville in "La Danseuse Satanique" and *The Idol of Perversity* (*Parsifal*) suggest another narrative upon which the sketching is based. In the first line, Delville describes the dancing woman: "In front of those whom she loves, she dances! Her learned body undulates as a beautiful snake, in a lascivious, frenetic or creeping gesture to the morbid and soft sound of a heavy cadence" (134). In *The Idol of Perversity*, the woman's arms are hidden from view, as if her whole body is more serpentine than human, her body writhing like a snake in a wild uncontrolled way. Music has a "morbid ... cadence" implying a deep fall in the pitch, reaching an end which corresponds with the profound sadness and cruelty concerning the purpose for the dance. Delville also confirms the selfish lust of the people who watch the dance: "The loveless peoples seek her beauty, never seeing that within her, intoxicated and sensual, it is Death dancing and giving herself away!" (134). Delville makes this distinction between love and carnal desire, that the two cannot be experienced at the same time. The man lasciviously gazing at the dancing woman can only feel intoxicating desire; her twisting movement excites all men watching Salome, but it will wear off quickly. Yet the emphasis concerns consequences incurred by men's lust, not the repercussions suffered more by women for playing the object, the harlot. The men ignore these consequences, while their lustful needs lead them further away from the spiritual into darkness: "Death ... prostitutes itself" suggests that for their own sexual proclivities, they pay with their life; the cost of their own soul is at stake. Yet this description evokes sensual pleasure in which male spectators are willing to give up anything, despite its warning of the dangerous effect that this objectification of the feminine has on men. In "The Metaphysics of Sexual Love," Schopenhauer explains that there are varying consequences that go along with carnal desire, whether it be motivated by love or not. For example, sexuality can have "an unfavorable influence on the most important affairs" by sabotaging relationships or disturbing one's concentration on crucial matters (533).

Delville's comparison between *The Idol of Perversity* and "La Danseuse Satanique" symbolizes birth and death, heaven and hell, a combination of all worlds. The similarities between Medusa and Delville's "Bride" allude to the ambiguous nature of the feminine, the protruding stomach insinuating that she is pregnant similar to Medusa, eventually giving birth to Pegasus and Chysaor when she is beheaded, proof that she is not a virgin. Woman is also the giver of life juxtaposed with the personification of death. Delville's bride signifies the initiator of temptation, in which mythology similarly portrays Medusa. Yet Delville's portrait yields to a cruel nature that is not discernible in a careful study of Medusa, though myth contends that Medusa is a ruthless mistress and enemy of all men, a representation that deserves further inquiry by comparing her image to dark and light incarnations of other feminine portraits. Though this is more aligned with a modern invention of Medusa, she is the dark mistress of death to men who dare to look at her.

By discussing the role of a woman who operates as an initiator of male experience, it can be argued here that the temptress acts as a spiritual cata-lyst, reminiscent of Wagner's *Parsifal*. Parsifal is actually the name of the hero in Wagner's opera who consistently prevails and triumphs over all challenges against his moral virtue. The alternative title of Deville's "Bride of Satan" or *Idol of Perversity*, however, alludes to the complexities of Wagner's Kundry, cursed because she ridicules Christ. In the opera, Kundry means to both protect and injure the hero, Amfortas. The magician Klingsor uses Kundry in his plots against the knights of the Holy Grail. Because he is refused admission to the temple Titurel, the castle of the wounded Grail king, he lures many knights into a garden with seductive maidens coercing men to their ruin. Amfortas is wounded when he attacks Klingsor's castle hence losing the Holy Spear. Parsifal enters, having shot a swan, a deed he now regrets. He knows little of his past, except that his mother was Herzeleide, Sorrowful Heart. Kundry convin-cingly explains that his mother died when he left her. Having persuaded him to believe that his absence was the cause of his mother's death, Kundry has now completed her task, by manipulating Amfortas and distracting him from his quest. After Kundry seduces Amfortas, she steals the Holy Spear, injuring him with it, while Amfortas suffers from a wound from which he never heals thus marking his fatal flaw, his downfall.

The scene changes to the temple of the Grail where Titurel asks Amfortas to display the Grail, but he refuses, since the sight of the holy vessel makes his wounds bleed more as a sinner. Eventually he carries out his allotted task, and the sacred bread and wine are given to the assembled knights. Parsifal stands fascinated at what he sees, yet does nothing to alleviate the suffering of Amfortas. When Klingsor sees in his magic glass the fool approaching, he calls up Kundry, an unwilling instrument of his desire to destroy Parsifal, the blameless fool, whom he now sees attacking his knights. The scene is transformed to that of a magic garden, where the flower maidens attempt to charm Parsifal. In a more seductive guise, Kundry sends them away and tells Parsifal of his mother. As their lips are about to meet, Parsifal comes to his senses and breaks away, feeling

the pain of Amfortas' wound, which he now understands. Kundry begs him to save her from the curse under which she has labored since she laughed at the crucifixion of Christ. By understanding her wiles and her possible salvation, he rejects her advances. Klingsor hurls the Holy Spear at Parsifal, but it remains suspended above his head. Parsifal seizes it and makes the sign of the cross with it, at which point the garden and castle disappear.

By the third act, the Kingdom of the Grail is in desolation, and the knights live on roots and herbs. Veteran knight, Gurnemanz, finds Kundry, disheveled and weary, as in the first act, but her face is transformed. A knight approaches, while Parsifal holds the Holy Spear, which he venerates. It is Good Friday and Kundry and Gurnemanz bathe and anoint Parsifal, who baptizes Kundry. The scene changes to that of the temple, where Amfortas will perform the ceremony of the Grail for the last time, to atone for the death of his father Titurel. Parsifal enters the temple, with Gurnemanz and Kundry, and he heals the wound of Amfortas with the touch of the Holy Spear, presenting it to the company. It is Parsifal who now must perform the ceremony of the Grail, which he does as a Holy Dove appears above his head and Amfortas and Gurnemanz acknowledge their new king. In the story, Parsifal is the heroic youth who defeats the wicked magician, Klingsor, seizes the Holy Spear, heals Amfortas, and releases Kundry from the curse.

The opera thematically focuses on the inability to resist erotic temptation where all characters struggle, and Delville's "bride" is representative of such conflicts. Kundry is the analogous "bride," but she can only be redeemed by a man / hero whose only fatal flaws are exposed throughout these challenges he must face. Though Kundry is the source of such temptation, she too cannot resist succumbing to her own desires. She tries to seduce Parsifal, but unlike her success with Amfortas, she fails. Kundry is a perfect analogy to the temptress queen, the queen of the dead, queen of the fallen. The earliest collection of British folklore about King Arthur, the Mabinogion manuscript, identifies Kundry as Heriodas, the mother of Salome, who laughs at the head of John the Baptist and is forced to wander for eternity. While she is complex, and it is seldom easy to qualify her intentions, she is the very obstacle Parsifal must face in order to achieve self-mastery. In other words, Parsifal must not be deceived by her tricks, and he must recognize the means by which she uses his own impulses toward sexual desire to manipulate and control him. The story creates this hellish world of desire where the characters have naturally good intentions but are corrupted by their inability to prevail against erotic sensuality, the materialistic. The mysterious nature·of Kundry is first introduced in the opera by the good fortune she brings.

But Kundry is complex, clearly recognized by an otherwise inherent eagerness to do the right thing, though she is at the mercy of the magician, and cannot will herself into action of her own moral sensibility. Instead she is used entirely as an instrument to do harm. By making this comparison between Wagner's *Parsifal* and Delville's *Idol of Perversity*, it can be argued that the soulless gaze of the woman puts the hero / the spectator under a hypnotic trance; she

is already cursed, formed, and constructed by the magician who wills her into action, to harm and destroy all that is light and radiant, and innocent. But she can still regain her purity, though redemption is only possible under the condition that a brave knight prevails against all challenges to his moral integrity and is therefore worthy to save Kundry and alleviate the curse. It is only within a man's power, not her own, to be restored to her former self. This is problematic. For example, when the initiate awakens, he gains new knowledge after the veil is figuratively lifted. Therefore, Parsifal reaches a new state of self-awareness before he can save himself or anyone else. Kundry seems to be trapped in darkness by the magician who uses her to betray the knights and innocent men so that he can gain power. But before Parsifal can release Kundry from the curse, he must conquer his own passions whereas the other knights fail at this task of refraining from sexual temptation.

These struggles against carnal lust is key for the initiate that is based on Delville's Theosophist philosophy demonstrated in his art. The analogy between Kundry and the "bride" expresses Delville's belief that art can "regulate Life and the Ideal, weigh Spirit and Matter, make repose god-like and movement sublime, who couldst balance in such proportions all parts of the human form" (*New Mission* 53). In the early stages before such trials endured by the initiate, the initiator of temptation does not even realize that her role is to test the moral virtues of men, and that the degree to which they prevail determines whether or not they possess heroic qualities. Yet this also comes at a consequence to the female initiator who literally is used by other men as an impetus of the initiate's journey. The temptress is not really the master of men, but instead other men construct her as an instrument to be used within social patriarchy, and to manipulate the fate of the initiate. Otherwise, the temptress is simply objectified by men, and powerless over her own subjectivity, she must rely on a hero to save her. Or like Medusa, she must be killed, and wiped out completely, eventually used as an instrument to protect the hero against his enemies.

The "bride" is the goddess of desire and death, but sustains other unknowable qualities that present a far higher spiritual purpose. I do not want to simply conclude that she only plays a part in the initiatory process. This is a significant role that she portrays within the story. But in many cases, such as Kundry, the temptress has no will of her own. Delville's "bride" is often characterized as treacherous. She certainly is uncanny, evoking fear and dread. The "bride's" face perpetuates repulsion among viewers, but there is a halo of light glowing about her. The hidden nature of the bride evokes the uncanny. That other mysterious side can best be described as the potential for transcendence, not just for men challenged or manipulated by her, but by her esoteric knowledge of all other worlds. Looking at her, one fears to touch her or go near her. Yet she is compelling, capturing the gaze. Without features of both light and dark, she certainly would not have redemptive qualities. But to provide an alternative, she must be that alternative, protector, nurturer, goodness, spirit. The duality of the feminine might be quite common, but it is deserving of a far more contemplative ideal

for women spectators. She is a kind of protector, though Delville might not have intended her for such a purpose. This image is once again alluded to in Delville's poem "L'Inconnue." The poet pleads for the seductress to disclose her mystery: "Tell me your heart and soul of sphinx, o, you, whose beautiful eyes absorb my thoughts, and tell my pain, by your tired calm, if your look is being of a virgin or a lynx" (Delville 46). But she can only convey that which is true to him, that when he sees her, he gazes into the mirror of his own reflection. The poet suggests by knowing more about the mystery of the woman, the initiator, helps the narrator to understand more about himself; Delville illustrates this process of self-awareness.

There are strong similarities between Delville's *Idol of Perversity* and Kundry from Wagner's *Parsifal* that work as a narrative illustrating insightful meaning about the artist's mysterious figure in the portrait. But while there are important elements of light and dark along with the symbol of the snake in this sketching, the mythical Medusa is not meant to be portrayed as the femme fatale, nor is she a monster. In Greek and Roman myth, Perseus is not sexually drawn to Medusa, despite the rumors about her great beauty described in Pindar's *Twelfth Ode*. Rather Perseus wants to defeat her and take away the region of land over which she rules, using her head to defeat his enemies, King Atlas, Phineus, and Polydectes. But without Medusa's head, he is powerless over his foes. In another similarity, the serpent works as the key motif that connects Delville's woman to Medusa. From a Christian context, the serpent signifies the Fall. Medusa faces her demise from virginal young maiden to raped and defiled woman, her sisters also banished along with her. From a Christian perspective, she has lost everything as a result of tempting the gods with her beauty. But this Westernized, ideological context is narrow, rendering Medusa a helpless female victim that now becomes monstrous, a physical manifestation of her curse. Instead she rebels against male authority that forces women into subservience, in complete subordination to their husbands. A woman who defies social codes in a culture that subordinates women (though goddesses are granted special privileges) encounters punishment, not because she has fallen, but because she acts against oppressive laws, and therefore she exercises free will. On the contrary, the snake becomes a powerful image that represents both life and death—not sin; it can signify a union of polar opposites, and the possibility of rejuvenation and eternal life.

The snake has to fit within the esoteric tradition, that it means something other than what society or culture has assigned it to mean, that it has a more transcendental, spiritual purpose. The Fall of Adam is from an erotic intoxication. When Adam realizes he and Eve are naked, he desires her; they desire each other, and lust is named as the Fall of Adam and Eve, repeated in Wagner's *Parsifal*, expressed in Symbolist paintings, though Delville claimed that he was not influenced by Christian tropes. At the same time, Delville rejects atheism that is popular in the late nineteenth century, leading to intellectual and moral disorder. In his view, materialism is the very root of this disorder, the conscious mind that dismisses the possibility that meaning

exists from that which cannot be seen. For me this leads to an interesting quandary. *The Idol of Perversity* has often been criticized as an image that emphasizes misogyny, demonizing women, making women who transgress social boundaries as inherently distorted, defective in both body and soul. Yet according to Delville's philosophical views, he is very concerned with the problem in his culture which does not share his belief that art must have utility and "remind us of the human soul of the inner and divine aspirations of Love, Charity, and Light" (*New Mission* 86). He is hostile towards scientific materialism and claims that it is born out of destruction. He rejects Zola's art because it is nihilistic and corrupt. This leads to the question of what the serpent-haired woman represents for Delville. What was his motivation for creating her? In trying to answer this question, it is important to keep in mind that the contemplation of works of art triggers the instinctive capacity that combines with intellectual thought. But aesthetic feeling begins with the inner life that makes the spectator aware of the spiritual order that aligns with a new perception and understanding of reality. The revelation of this spiritual order can achieve transformation within society as well as the individual.

While Symbolist painters are not arguing that sexual relations between men and women are flawed, the aesthetic capacity experienced in art advances the idea that an object is not empty or limitless. An object must raise the spirit. Similarly, our ability to gain aesthetic sensation from art objects is a means by which we must experience the world and other people. Otherwise men and women objectify each other to satisfy their own "personal vanity," leading to their limited understanding of one another. By this form of objectification where a vision of a higher life is missing, sexual relations come to mean nothing, though it can result in a petty struggle for power and control. Men and women gain knowledge that is supposed to be forbidden to them, but that knowledge, according to Delville's perspective on art, must evolve into higher aspirations that lead to Love, Charity, and Light. From the perspective of Schopenhauer and later conveyed by Delville, the heightened pleasure of sex enslaves humanity. So it is this obsession that keeps one distracted from a higher purpose to gain other knowledge about the world and the spirit. That aspect of an enslaved humanity, not just sex, destroys society. The love of our own destruction becomes instincts of this force. But we destroy ourselves, not on purpose, but for the feeling of pleasure associated with this source of destruction. We destroy ourselves, enslaved to the material needs of our culture, the feelings that we attach to the indulgence of these destructive activities. Medusa *is not* destructive, but Poseidon certainly causes destruction to her. Exiled and forced out of sight, Medusa is literally never to be seen. Yet men ironically travel to see her. And for what purpose? Is it because of the erotic connotations that she provokes among men? They seek esoteric knowledge and power that Medusa possesses. Though she evokes unease, discomfort, gloom, she is an object of intellectual uncertainty, whether she is really dangerous or not, a beautiful woman who cannot

really be ugly, or a woman who is so frightening that we cannot help ourselves but look and gaze at her. We become our own source of destruction, not the person objectified. The woman in Delville's sketching causes no harm other than what we make of her. If she evokes feelings of pleasure and sensuality as well as depravity and evil, then what causes this dichotomy between desiring her and loathing her?

Stuck's portrait *Sin* and Delville's *Idol of Perversity* overlap one another in many ways with esoteric ideologies of material versus spiritual. Keeping in mind that female sexuality is shunned, rejected, and oppressed in the late nineteenth century, these images are blatantly unapologetic, solitary and distinct in a representation of a woman's strength and fearlessness. Cultural evolution in postmodern society is progressive, though slow, most notably recognized by the suffrage movement and continuing on with feminism in various parts of the world. Unlike the portrait of Delville's bride, a revisionist myth of Medusa today offers a strong female presence, the resilience of a woman's spirit and her body, and her complete command and power over her own sensuality. This is an image of an empowered female of today, only to become even stronger in the world of tomorrow.

Images of women later discovered long after the myth of the Medusa, lovely beggar maids, infected and degraded prostitutes, all of these subjects are an embodiment of the Medusa, the beautiful combined with the horrific, beauty that is corrupted and contaminated; these images of women are impregnated with the bitter taste of reality. The often characterized, degraded Medusa more accurately alludes to perspectives on how culture values women over the centuries, representations that embody unhealthy sexual attitudes about women throughout the seventeenth, eighteenth, and nineteenth centuries (with the exception of the Romantics).

Given this comparative analysis between *The Idol of Perversity (Parsifal)* and Medusa, I argue that the Gorgon is an exotic. To be more specific, an exotic is one estranged from her own present and actual self, but who also is paradoxically endowed with a metaphysical intuition. She can discern behind the complex outward appearances of things, the permanence of a unique essence. The Romantics seek to give material form to the grotesque and whimsey of the imagination. They want to translate these wanderings of the imagination into real life, to give some basis of real experience. The famous Medusa painting by an anonymous artist from the Flemish School (wrongfully attributed to Leonardo Da Vinci), left a deep impression on Percy Bysshe Shelley. In his poem on Medusa, Shelley contemplates her sad expression that he describes as "The agonies of anguish and of death" (line 7). Viewing the portrait leaves a deep impression on Shelley who reconstructs her image as less monstrous, and instead an image of "darkness and the glare of pain, which humanize and harmonize the strain" (lines 15–16). The artist humanizes the Gorgon by exposing her anguish terror of death. The poet experiences the loveliness of Medusa as a spectator looking directly at her, and reflecting upon her grace.

Bibliography

Cole, Brendan. *Jean Delville: Art Between Nature and the Absolute.* Cambridge Scholars Publishing, 2015.

Delville, Jean. "L'Inconnue." *Frisson du Sphinx.* H. Lamertin, 1897.

Delville, Jean. *The New Mission of Art, A Study of the Idealism in Art.* Forgotten Books, 2012.

Delville, Jean. "Physiologie." *Les Horizons* Hanté. *Journal Officiel De La Librairie*, 1892, archive.org/stream/bibliographiede35unkngoog/bibliographiede35unkngoog_djvu.txt.

Hoffmann, Edith. "Belgian Art at the Grand Palais." *Burlington Magazine*, 114(829), April 1972, pp. 262–265.

Mathôt, Sebastiaan, and Theeuwes, Jan. "Visual Attention and Stability." *Philosophical Transactions: Biological Sciences*, 366(1564), 2011, pp. 516–527. www.jstor.org/stable/41061262.

"Mystical Symbolism: The Salon de la Rose+Croix in Paris 1892–1897," Guggenheim Exhibit.

Praz, Mario. *The Romantic Agony.* 2nd ed. Oxford University Press, 1970.

Schuré, Édouard. *Les grands initiés: esquisse de l'histoire secrète des religions: Rama, Krishna, Hermès, Moïse, Orphée, Pythagore, Platon, Jésus.* 61st ed. CreateSpace, 2016.

Schopenhauer, Arthur. *The World As Will and Representation.* Trans. by E. F. J. Payne. Dover Publications, 1958.

Swinburne, Algernon Charles. *Essays and Studies.* 3rd ed. Chatto and Windus, 1888.

Te Paske, Bradley. *Rape and Ritual: A Psychological Study.* Inner City Books, 1980.

5 Medusean images in paintings by Franz von Stuck

In an article titled "A German's Horrible Art," an anonymous *New York Times* author chastises Franz von Stuck for "silly exaggeration and vulgar absurdities," adding that:

> Horribly energetic—in a frenzy—is that German painter Franz Stuck. He would do away with all that is tender and gentle. Here is blood and iron in art, for no matter what Stuck handles, with his fierceness he carries you off your feet. As to your own personal locomotion, you might rather like to be wafted, as is a leaf by a gentle stream, than to be slung into space by a cyclone.

This description is consistent with Stuck's work, which is not pleasant, but rather strange and disjunctive. When Stuck first exhibited *Sin* to American audiences at the 1893 World's Columbian Exposition in Chicago, the United States both loved and recoiled from his work. By 1898 when Stuck gave his following exhibition in the US at the Carnegie Institute where he showed both *Sin* (for the second time) and "Beheaded Orpheus" which critics described as "gruesome," Stuck was on the Advisory Committee and held this position for many years. By noting that the spectator is "[carried] off his feet" swiftly rather than gradually, the *New York Times* critic accurately conjures up the experience of viewing *Sin* in person.

The first time I saw the painting was at the Ange du Bizarre Exhibit at the D'Orsay, and it knocked me hard, leaving me awestruck. I wondered at the time why it was featured with all the other Medusa paintings by Caravaggio, Arnold Böcklin, Jean Delville, and Edvard Munch whose Medusa figures were more obviously the Gorgon of Greek myth transformed into an image that represented the time period in which these artists painted her. But I was quite "stuck" on Stuck, horrified and transfixed at the same time, as if the woman and snake combination put me into some kind of hypnotic trance, a completely uncanny experience. There was certainly nothing "tender or gentle" about the snake, that seemingly threatened to attack me while I stood there staring at the painting. But the woman posed a different kind of threat to my sense of well-being, even as a woman, daring me to *do* something scary and frightening rather

than being subjugated to the thing that caused so much terror. The woman, not the snake, tested my mettle. She provoked me to be that woman always transgressing boundaries. To me, she also meant to taunt the male spectator, by being a woman purposely on display, yet completely out of reach. Getting to her meant overcoming the large, menacing serpent that enveloped her, hence the subtle smile in her expression that played out like a joke. She is "blood," the symbol of life itself, of flesh yet atonement, and at the same time contaminated and taboo, while the snake is iron, which in the ancient world is a metal that can scare off demons and evil spirits. The snake is often a symbol that protects against demons. In an even more recent discovery, while a snake is poisonous, its venom can counteract disease like that of iron. Though such conclusions were not perhaps intended by the critic at *The New York Times* when he wrote his review of *Sin*, this can certainly be an interpretation of symbols applied to the painting and ironically referenced in the article.

Stuck's subject matter was primarily from mythology, inspired by the work of Arnold Böcklin. Large forms dominate most of his paintings and indicate his proclivities for sculpture. His seductive female nudes are a prime example of popular Symbolist content. Stuck paid much attention to the frames for his paintings and generally designed them himself with such careful use of panels, gilt carving, and inscriptions that the frames are considered an integral part of the overall piece. The primary themes of Stuck deal with principles of human behavior that are timeless, derived from the power of myth. He exposes and confronts emotional and human impetuses. One of the primary themes expressed in his paintings deals with the paradox of virtue and sin. Sin is represented by the fall of man as the origin of all guilt, depicted in canvases of the last judgment. In *Sin*, the woman is not only a biblical Eve, but a human archetype, a primeval creature, a demon without a home, without ancestry, and like Eve, she has always been and is still among us. Hell is a place of everlasting torment, but this is not the place to which the woman in *Sin* is confined. Instead she seems forced to wander, though such torment is certainly not hinted at in her expression. On the contrary she is submissive to her fate, no longer in control over it, and rather indifferent to it, while the snake dominates her. Nor is she embarrassed by her nakedness. Though the snake, not the woman, seems most dangerous, it is "sin" that should be an even greater threat because we are far more vulnerable to it in comparison to the literal images in the portrait. In contrast to *Sin*, Medusa is threatening from a literal perspective, turning men to stone who stare at her. But in death, Medusa's blood is healing, and from her death arises Pegasus, a symbol of wisdom, knowledge, the very thing that ironically leads to the fall of man, the cycle repeating itself all over again. We are born innocent, yet doomed to misbehave.

Stuck led and influenced the Symbolist Movement at the end of the nineteenth century in Munich. His painting *Sin* was one of Symbolism's most important works, which made Stuck a star at the Munich Secession, and he presented this at his first exhibition in the United States at the World's Columbian Exposition. Charles M. Kurtz, Assistant Chief of the Department

of Fine Arts for the World's Columbian Exposition, described Stuck as marking his work "with the cachet of strangeness, which comes from a modern treatment of legendary, biblical, mystic, or symbolic subjects" (46–47). Henry Wilder observed that "individuality is that requisite for admission to the ranks of The Secession which is most rigidly insisted upon the artists" whose work was selected (46). The committee of the Munich Secession wanted to avoid accepting too many mediocrities, therefore fewer artworks were included for display. To limit the number of selections, the committee dismissed artists' work that practiced a common style or shared the same artistic goals. Those artists chosen for the exhibition were unconcerned with conventional depictions of beauty, and instead portrayed elements that pleased the senses. Beauty depicted in some way as corrupted or tainted, yet producing pleasure, is best described by Rainer Rilke: "For beauty is nothing but the beginning of terror, which we still are just able to endure, And we are so awed because it serenely disdains to annihilate us. Every angel is terrifying" (151). Rilke shows how beauty crosses boundaries, and immobilizes the spectator, as if our own breathe is cut off by the thick black serpent in Stuck's painting that winds itself tightly around the woman, its weight an oppressive force. The Secessionist movement was never meant as an aesthetic program; instead it was socially motivated without any organizational structure. In fact, young artists revolted against older Impressionist painters who still dominated the art world at the end of the nineteenth century. These viable young painters sought freedom above any agenda, to create without constraints. Artists of this movement did not replicate the artistic styles of their predecessors, but instead they revised and upended them with gawky body gestures, thus attacking artistic conventions. Unlike the previous generation of Impressionist painters, the Secessionists worked individually, having a personal goal in view, such as focusing on the movement of light.

While Franz von Stuck was also considered a Secessionist with similarities to that of the French Impressionists, such as Max Lieberman, there is a slight distinction in which the Secessionists were considered individualists with personal strategies that they applied in their use of color and light. Unlike Lieberman, Stuck's canvases almost appeared to "have been painted in the interior of a tomb" ("German"), signified by very dark shadows, which poses an antithesis to the use of light that traditionally signals a keener awareness, enlightenment and our dependency on reason (Anonymous). Rather, enlightenment in Stuck's work comes from within the shadows where one gains the greatest insight. Shadow contains impulses and drives that often contradict one's value system—a person's sense of self. Environmental influences usually trigger these compulsions, whether it be sexual desire, aggression, jealousy, vanity, or self-centeredness, any negative trait that is unacceptable. Stuck introduces a contradiction to that belief, suggesting that by stepping within the shadows is to become consciously aware of these very features of one's character that are otherwise repulsive. Stuck therefore emphasizes central themes that include "idealism, naturalism, fantasy, ardor, and movement, gravity, and repose, decorative and artificial color schemes, a reproduction of natural color, rich in

tonal quality" (Danzker *Von Stuck* 30). Like *Sin*, the image frequently applied in Stuck's paintings is of a naked woman whose body is enshrouded by a larger than life snake, as if it seems to sneak out at the viewer, protecting the female form, threatening anyone gazing at the woman's nude body that is forbidden, yet on display, insinuating danger in ogling her, that we should not look and yet our gaze is immovable—the spectator cannot turn away. The woman's gaze, however, is also transfixed on the viewer, and her calm expression suggests that she is pliable, submissive. In Stuck's other controversial painting, *Sensuality*, the woman is again nude, leaning against an engraved block, the head of the snake peaking over her shoulder, her nakedness partly hidden by the body of the snake, her breasts full and exposed, her arms reaching behind her, wrapped about the body of the snake that curls around the woman's mid-section. Her head is slightly tilted, and she gazes at the audience.

While Stuck's artistic vision challenges conventional ideals, his students describe him as taciturn and silent. Josef Albers, Stuck's pupil and master of the spatial qualities of color, recalls that Stuck "said little. Whenever he came to the painting class to check on our work, he generally shrouded himself in silence. He let everybody paint in their own way. When he did say something, we all sat up and took notice" (Schmoll 118). By having students create personal goals, Stuck's instruction among his students encouraged individualism. Though Albers said that he learned nothing from Stuck, years later when Albers was at Black Mountain College and Yale University, he admitted that Stuck had been correct by acknowledging that "shadow colors appear warm and seem to advance" (Schmoll 120), qualities of color that can be found in Albers' own work. It is important to note how Stuck uses shadow colors in the 11 variations of *Sin* (Danzker 71), especially in the features of the woman's face, the eerie and dangerous features of the snake on her shoulders. These shadowy images soften the mood in the paintings, the expression of the woman's face more subtle, innocent, yet aloof. On the other hand, Wassily Kandinsky, also a student of von Stuck, did not think a great deal of Stuck's use of color in his great paintings like *Sin*. Paul Klee, however, openly admitted his indebtedness to Stuck, confirming, "No–I learned from Stuck." Eventually Kandinsky, in his publication *On the Spiritual in Art*, acknowledged Stuck's teachings on color and describes him as a seeker of "the inner by way of the outer" whose work reflects "the search in the realm of the non-materialistic" (33).

Distinguishing between these two realms is necessary in order to deter-mine how all things connect together. To do this one must first master the inner world before moving on and making meaning of the outer world. In short, the dark shadows occupy the inner world to which is invisible to us. Yet trying to make connections to external conditions can often lead to confusion within our internalized space when people seek materialism as a means to gain happiness or instant satisfaction, often observed when one acts on impulse or finds dissatisfaction by his inability to obtain an object of desire. Kandinsky provides the example of "the world deeply [impressing] the child" (72). But eventually "This vivid, intense interest passes" and the individual goes on to

seek fulfillment in something else. People often believe that gratification and fulfillment of life can only be achieved from out there, hence cutting themselves off from that inner world seeking truth and understanding. A closer study of Stuck's technique helps to understand how the artist achieves this effect between these dualities of inner and outer worlds. His use of tonality combined with color and light create the outer layers of Stuck's paintings in order to seek what might exist within the symbol itself, *Sin* who is really Eve guarded by the snake, the shadowy background alluding to mankind's extraordinary impulse to break cultural taboos, to experience the fantastical.

In *Four Archetypes: Mother, Rebirth, Spirit, Trickster,* Jung explains that "the inferior function is practically identical with the dark side of human personality" (57). *Sin* is a representation of something powerfully secret or insightful, hidden within that taboo that must be transgressed in order to understand the perilous nature of the image of a naked woman enshrouded by a snake. Jung further clarifies that the

> darkness which clings to every personality is the door into the unconscious and the gateway of dreams, from which those two twilight figures, the shadow and the anima, step into our nightly visions or, remaining invisible, take possession of our ego-conscious.
>
> (57)

This suggests that, first, each individual naturally has an inferior function and therefore cannot escape from their dark side. Dreaming allows for entry into the unconscious mind, introduced to the true self and shadow side of which are inferior to the ego. So there is danger when one becomes possessed by his desire to remain in the shadow, and though it may not be apparent in the daily routines of everyday life, darkness can take possession of the ego by the subject acting out on impulse. For the spectator gazing at *Sin,* the taboo is actualized by looking directly at the woman, even more so, straightforwardly at the snake. The viewer is afraid of the consequences that come with sin, but willing to take the risk.

The outer and inner realms can be further explored in a comparison between the constant vacillation of the Apollonian and the Dionysian observed in Stuck's art. In *The Birth of Tragedy,* Nietzsche describes Apollo as the soothsaying god "of all shaping energies" who "rules over the fair appearance of the inner world of fantasies" and designates "measured limitation, that freedom from the wilder emotions, that philosophical calmness of the sculptor-god" (21). The ability to reason and use good judgement leads us to believe that we have a certain control over external influences or conditions. But this is simply a delusion. Stuck characterizes reason in a world represented by religious subjects, austere and solemn, yet these religious concerns become an oppressive weight. Religious ideology is represented by the ego, and at times when reason seems to have abandoned us, a "stupendous awe seizes us, a blissful ecstasy rises from our depths, the principle of individuation collapses, and we are brought under the sway of Dionysus" (Danzker, *Franz von Stuck* 12). The magic of the Dionysian can

equally conflate us, just as much as we depend on reason to construct the ego, and generate our sense of stability and understanding of the world. But to rely too much on one realm or the other can cause us to regress both emotionally and intellectually, failing to make sense of anything. Citing Schopenhauer, Nietzsche explains that when we see something unrecognizable, a certain dread overcomes us. The conflicting images between a naked, submissive woman displayed in *Sin* coupled with the treacherous snake leering out at the viewer would lead to that feeling of doom. That feeling is caused by an exception to our own principle of reason. We cannot make out these conflicting images that don't seem to belong together. They even frighten the viewer. Self-forgetfulness is the opposite of being ego-driven. By being ego-driven, we construct our reality based on how we perceive ourselves. This can lead to a false identity. Nietzsche argues that we need to be awestruck, that it is healthy to create balance between the Apollonian and the Dionysian. That feeling of "delightful rapture" helps us break away from "individuality" that is more dogmatically ego based. Then we can experience self-forgetfulness. In Stuck's art, the Apollonian and Dionysian is represented by a combination of religious subjects and classical mythology. For Nietzsche, myth is a ruling idea / ideal that embodies culture's values and human life with meaning and purpose. Art is in fact a function of myth.

Stuck's subjects in his art dramatically shift between the Apollonian and the Dionysian, worlds of somber pretenses compared to ostentatious celebrations of excess, and wild emotions. Art encourages the viewer to escape these appearances, to conflate religious subjects, while prioritizing the importance of classical mythology. A struggle for existence ensues in the natural world, which leads to individuality. These are inherent perpetual conflicts that begin with the element of dream, Apollonian, with the element of ecstasy, Dionysian. In Stuck's artistic embodiment of unresolved dualities, only periodically are these two realms reconciled in his work, which ends in a fascinating conclusion that "riders in the night and fallen angels remain among us and are indeed ourselves" (Danzker, *Franz von Stuck* 12). The loss of self-consciousness is induced by the Dionysian, and nature, that has been long alienated, and celebrates a reconciliation with man. The Dionysian artist metaphorically chisels and molds man into this transition, a union with nature, freedom from self-consciousness. To create such an effect, Stuck used a number of different elements that included tempera painting, a medium that looked and handled like oil while providing a surprising degree of luminosity. Also, Syntonos dried quickly, allowing the artist to paint over or add new touches to finished paintings. Stuck squired the technical means of creating large-scale canvases of extraordinary color, intensity, and freedom of brushstroke and expression for his modern subjects that construct this fusion between the Apollonian and Dionysian worlds (Museum Villa Stuck, Munich, 27 May 2017).

I argue that the image of the Medusa epitomizes Apollonian and Dionysian dualities and represents the balance between both these worlds. The conflicting form of a beautiful woman combined with venomous snakes for hair speak to the spectator. The sublime combination of beauty and danger conflicts with a

rational perspective of reality, that the two are not separate at all, but actually function together to create new meaning. Medusa embodies this concept. Her curse can be perceived as gloomy and sad when we gaze at her, but while we continue to look at her, our own inhibitions are lifted. Her image generates a dream state, and we find ourselves suffering in these scenes conjured up by the fantastic, the inner world. But it is only a dream, frightful though it might be immediately before awakening. Nietzsche contends that we experience "the dream itself with deep pleasure and joyful necessity" (11). Because Apollo is the God of light, he also commands a higher truth, "the inner world of fantasy" (12). Our perception of everyday reality is flawed, and a higher truth is found in the dream state that heals and helps us bring new understanding to our consciousness. But reality and the dream state must be in harmony, where dreams do not deceive our perception of what is true. In this case, we discover that Medusa is not a threat, but has been constructed as one to impose certain limitations and restrict impulses about transgressing certain social and cultural boundaries.

In the Museum von Stuck, miniature sculptures and paintings of the Medusa head are hung throughout the rooms, exhibiting her wild serpent hair, parted lips, and wide-shaped eyes. These images combine the ancient Greek talismanic Medusa with mythologically evolved feminine form. In Stuck's sculpture work of only Medusa's head, the Gorgon's mouth is wide open, an expression of fear, horror, and suffering presumably right as she is decapitated. Stuck clearly demonstrates that there are various ways to portray Medusa, even in different examples of biblical and historical femme fatales that from a clearly patriarchal definition are Medusean figures. Because *Sin* was among the collection of Medusa paintings at the Ange Du Bizarre Exhibit in Paris, implicit similarities can be made between the Gorgon myth and biblical Eve. The ambiguous nature of Medusa has to do with repeated interpretations about her in writing, paintings of women—either lascivious or tortured—and transformations from temple maiden to the serpentine Gorgon that poets and artists produce in their work.

When *Sin* was first shown in 1893, the image of the nude woman with a snake's teeth sinisterly bared to the viewer was very unconventional. To capture images of women in his paintings, Stuck and his wife photographed their models at the Villa Stuck where they operated a photo laboratory. Stuck arranged his models' pose with care. Hans Purmann explains that "he often required more than an hour to do so, and it appeared that he always associated a visual idea with the movements he had the model perform" (qtd. in Birnie Danzker 155). Standing poses were important to him, and according to Purmann, he

> spoke in detail about the human body, the way light affects it, then about its possible movements about the relationships of the pelvis to the shoulders. Heaven help us if the foot of the weight-bearing leg was not drawn or painted absolutely vertically below the hollow at the base of the throat.
>
> (Korner 155)

He also put odd things into the models' hands, such as a lily meant to signify chastity and virginal love. Common in his paintings was taking the rather unformed features of his young photographed models into the painting but also adding an aloof indifference of antique ideal faces inspired by Greco-Roman art sculpture. Though the artist's goal is to achieve a resemblance between his model and the portrait he paints, the exploration of photography leads to different variations rendered in the artist's paintings. As David Ehrenpreis explains in "The Figure of the Backfisch: Representing Puberty in Wilhelmine Germany," Stuck "[recasts] the mundane" and presents it into "symbolic language" (23). This conversion from photography to painting involves recognizing the difference between outward superficiality to inward awkwardness, inferiority, and authenticity of the models who posed for him. His process was to photograph his models and then reproduce the image on canvas, making changes to enhance specific themes in the expression and pose of his subject. Still in the late nineteenth century, artists did not publicize the fact that they often used photography to paint portraits. Yet the creative process of the artist involves a transfiguration of raw material taken from nature and its value is determined by how it fits into a work of art. The artist, in other words, takes a photograph and transforms it into a particular idea or concept that will evoke specific emotions from his audience. The woman with the snake serves as a juxtaposition to her femininity and innocence, combined with peril, poison, darkness, making this representation of the reptile with the woman difficult to mediate.

Yet in Stuck's work, the combination can elicit sexual desire. He establishes a distance from the event he creates in the painting with a temporal tension that generates a balance between emptiness and indifference. Time seems to elapse for the viewer by gazing at these paintings sustaining that dream state bordering on conscious reality. The transition of a life drawing and a studio situation into the painting gives the scene a drastically natural appearance and a historic asset. So the woman in her pose seems to be very natural, her body relaxed, her gaze calm yet provocative, somewhat daring, the expression of the mouth submissive, yet seductive, the snake getting in between our figurative access to the woman posing, while the viewer gazes at a desirable object. The overall pose and construction of the painting, the lighting, the use of dark colors makes the image dream-like and enigmatic with an odd alliance between a woman and a snake. In his 11 variations of *Sin*, Stuck used a neoclassical frame with a rather elaborate inscription. One explanation for Stuck's repetition of the theme itself, sin, is that after a while it becomes banal. We see examples of this today where repeated images in the media eventually desensitize the viewers' emotional response to it. Pornographic content is a good example since it is so ubiquitous in the twenty-first century, raising few eyebrows, if any. A commonplace subject minimizes shock value, and questions that might be more typically raised about the vices or moral transgressions of the subject matter, become far less important. Similar features in all 11 variations of *Sin* are further described by Gudrun Korner in "Sin and Innocence: Images of Women in the Works of Franz von Stuck" with:

flanking channelled half-columns underscore the cultic character of the image. The light, whitish-yellow, herm-like torso, generally characterized as female by high, more or less strongly modeled youthful breasts, is concealed at the side by long black hair. A bluish-black snake coils around the hips and abdomen, concealing the pubic area. In several variants, the snake's size rivals that of the female torso. The reptile creeps along below the navel to the lower edge of the canvas, then rises upwards in a swelling curve next to the voluptuous hair. After coiling out of sight behind the figure's back, his head, mouth slightly open, re-emerges between breast and neck.

(157)

In each variation, the model is posed similarly with her head and dark hair in shadow. In one of the paintings of *Sin*, these features are much darker than in others, making it far difficult to make out the woman's face, even causing her to appear older. The torso, though, is always strongly illuminated, pure white. There seems to be a break right in the middle of the neck where light fades again to shadow, the snake facing the viewer from the lower right side of her chin. As Korner suggests, it could even be that heads and bodies are painted and combined separately, especially in considering that the photography of models had distinguishable differences compared to the paintings. The "cultic character" is of course the biblical Eve in the garden after she is tempted. Eve is a Medusean trope, mother earth, autonomous, the first woman to seduce mankind. She represents imagination, the unconscious, the first femme fatale. She is ageless.

The facial features, very subtly, differ from portrait to portrait. The audience is penetrated by a double gaze of the woman and the snake. The separate gaze evokes fear, though for different reasons. As Korner points out, we are not sure if the large snake holds itself up on its own, or curves around the body with the help of the woman (157). The snake seems to make contact with the pubic area in some of the portraits, but in other depictions there is a shallow space emphasized by the lighting in the portrait. The woman is shown only to the hips with no frontal nudity below the torso. In later variations, the expression of the woman is more lascivious. While she gazes at us, seemingly unconscious of the snake coiled around her, the snake is open-mouthed as if ready to bite, and stops in its movement over her shoulder. The spectator might be less preoccupied with the threat of the serpent, concentrating more on the lovely eyes of the woman and her blossoming young figure. The snake appears inextricably linked with the woman. Given the movement of the snake flanked around the woman's body, it appears that she is at the center of a figurative circle, the center very light and luminous, while the outer layer, the snake, is dark and imposing. The implication of a circle alludes to the perfect form of snake and woman, the phallus and the object, limitless, eternal, absolute. The shapes in the portraits also allude to a more natural meaning, a more primal principle. A circle has no end, no beginning, and even in *Sin*, the shape of a circle in combination of the woman and the snake, there seems to be no telling where one figure begins and

the other ends. The woman's face is more augmented compared to the gaze of the snake. Combined together, they suggest change in nature, even form, into a completely different one, the woman transforming, her youthfulness, perhaps naivety, changing into something darker and unrelenting, into the nature of the dominant snake. This metamorphosis produces anxiety, that something young and innocent can transform so quickly.

But snakes often appear in Stuck's paintings, and there is always something disturbing, the juxtaposition that can be identified between the woman posing and the serpent representing the phallus, the superiority of men over the inferiority of women. In the Villa von Stuck, the painting dominates all other work, framed in a special gilded alter devoted to *Sin*. No other work is given such special attention. In *Sensuality*, painted in 1891, the female subject literally appears confined by the snake wrapped around her body, but she is also submissive to it; there is no resistance. The snake is metaphorically a giant penis, again, covering the genitals of the naked woman, her breasts full and voluptuous, completely exposed to the viewer while she gazes out at us. Similarly to *Sin*, the size of the snake is wider than her torso or body. Korner alludes to what the model might be thinking, and claims that she knows what she is doing: "I've got it, but it's evil." He refers to her expression as "whorish." I disagree. There is definitely a submissiveness to the expression of the woman, but I would not name it as being whorish, a woman degrading her sexuality, or purposefully exploiting it. Instead the expression and her features appear unsuspicious, as if she is acting according to instructions coming from a person of greater authority, therefore exploited by something or someone else. There is something going on that is far deeper, the woman engaged in some ancient bacchanal ritual. Stuck frequently used the same models who took his meticulous direction in the poses that he desired from them. The woman's gaze in the painting is obedient, conforming to the desire of the spectator. The snake's head slithers over her shoulder and moves toward her breasts, while it gazes directly at the spectator. Similar to the snake wrapped around her body, she too responds in an equal tight embrace, her arms reaching behind her from where she stands, holding fearlessly to the serpent's body.

The original photograph taken by Stuck before painting *Sensuality* is in black and white. The woman has a slightly different expression in the two posed versions. Her body looks young, sensual, broad curves, full breasts. But the face does not necessarily match the body. The snake is posed similarly to *Sin*, circling over her shoulder, directly gazing at the audience. The woman's face appears somewhat older than the rest of her body, which might have more to do with the model's lifestyle, though this is quite speculative. In comparison, the face in the painting also appears older, but for different reasons. To be more specific, the model's expression and facial features in *Sensuality* are more contextually reflective: she is both being seduced, and she is the seducer. Because the subject's age is so ambiguous—young girl or older, experienced woman—this leads to some indifference considering conventional attitudes about the appropriate age of a young woman becoming sexually active. In *Sensuality*, the model

seems too seasoned, perhaps a little hardened. She does not smile, and her gaze is somewhat vacant, almost as if she does not know where she is, but she also does not care, hence her submissiveness to the painter and the spectator. Korner calls these features of Stuck's painting as bordering between seductive and comical, though I do not agree.

In *Sin*, for example, there is something sinister lurking within the portrait that the spectator identifies with the snake. The threatening serpent may seem to dominate an otherwise submissive woman, but it can also be argued that it protects the woman from the spectator; she can be completely naked, but the spectator poses no threat to her innocence. Another interpretation is that she is devoid of purity, and sin is the dominant, intended theme. Korner suggests that Stuck makes a mockery of traditional, biblical definitions of "sin" by placing the portrait in a gilded aedicula frame transformed as the artist's pagan-altar at Villa Stuck, a sacred site that more or less venerates Greek tradition. While Stuck might be satirizing these forms of Christianity, showing that these beliefs are antiquated and redundant in a modern sensibility, *Sin*, as it is displayed in the Stuck Villa, conjures up psychological complexities that we attempt to understand today. While her expression is implicitly yielding to an audience, she is compliant to the serpent, a symbol of sin. If this is the case, then in *Sin*, there seems to be no possibility of returning to something good and decent, whatever that might be. But if Stuck's painting satirizes sin, then its definition alludes to a transformative stage, crossing the threshold between innocence and experience, and the softness and subtlety of the woman's facial features suggests little other than accepting her fate without sorrow or regret. The theme in the portrait causes the spectator to question the degree to which sin transforms who we are, whether sin is inevitable and already indicative of our character, the very content of who we are.

Phallic shapes dominate Stuck's work, which could also be meant as trivializing sexuality, more specifically, gendered differences. The phallus at least as a representation of power and male authority plays a central role in mythology, contributing to conventions of male superiority / feminine inferiority. But the phallus relates to an idea, a symbol or power which neither men nor women really possess. The conflict of power that exists between men and women more often has to do with controlling or dominating the opposite sex. In Stuck's paintings it does not appear that the woman is powerless despite the snake being wrapped around her torso, her pubic area, and appearing much larger compared to the size of the woman's body. The size of the snake, the suggestion that it physically overpowers the woman in both *Sin* and *Sensuality*, alludes to the phallus, represented by the serpent, as a symbol of dominance and power. So the male—represented by the snake—not the woman—is still the powerful threat. But because the paintings are so surreal, the snake disturbing and central to the picture, the dark shadows contrasted with the luminous light of the woman's body, it might be argued that Stuck satirizes this power struggle since he makes it so obvious in the paintings. Sexual inequality between men and women is more a Westernized fact, especially in the late nineteenth century

when these images were painted. Does Stuck satirize the silliness of male and female dichotomies by arranging each figure, animal and human, independently of one another? Korner suggests that they are less linked and more allied together (157). He goes on to explain that the positioning of the woman and snake demonstrate "the specific formulations and configurations we believe to represent phallic symbols" (157). In different ways, we assimilate and recognize these symbols from art into modern life. But in order to understand this, the pose of the woman, the gaze and positioning of the snake, need more discussion.

The penis as a representation of power is based on the erection and procreation, and of the potential misuse of this power, leading to concepts of sexual desire and independence where women are forced to depend on men, submitting to their needs. In the expression of the models for both *Sin* and *Sensuality*, yielding obedience to the phallus and spectator can be identified in her subtle yet determined gaze, the settling of the lips, the position of the head, the snake dominating the body, having power over her sexuality, even her female organs, guarding the pubic area. Perhaps it should be no surprise that, by erecting an altar to *Sin* in the Villa Stuck, the artist figuratively shows praise, even worship, of the phallus, its sexual dominance. The woman's face recedes into shadowy darkness, while the snake is the phallus. Korner explains that there are three motifs in the painting: the snake, human torso, and human head, features representing the phallus (158). To begin with, the human head possesses unique powers alluding to definitions of the phallus; it represents knowledge, intelligence, the ability to construct ideas; it is a gatekeeper or even a guide. But the human head is also a sacred symbol in religious societies, representing super natural power, wisdom, and fertility—that for Stuck manifests as a symbol of worship before a specially built altar in his home.

The human torso in *Sin* immediately captures the attention of the spectator because it is so luminous, light, even with half the width of the snake's body curled around the model. The snake is specially arranged right next to the torso so that the spectator cannot help but measure its length and width. The female's body might tantalize or excite the spectator, but its nakedness is in possession of the snake which contrastingly intimidates the viewer, possibly making the woman even more desirable due to the threat of the serpent. Yet a male spectator might also be encouraged to identify with the snake, the phallus, to excite not only his pleasure in viewing the portrait, but excitement in vicariously experiencing similar power and dominance over the female body. Power and craving are not permissible to women, so they just rely on more cunning and creative alternatives. During the late nineteenth century, and realistically even today, women are objectified for male fantasy. The identity of the woman is that she is incomplete without the phallus, forced to submit to her social and sexual inferiority. So if the portrait is banal, obvious, or trivial, this might be by the fact that Stuck takes more conventional ideas and exposes them in such a direct and conspicuous arrangement, that one cannot help but find these cultural

differences between men and women as totally ridiculous, or at the very least, surreal. Yet Hermann Broch argues that

> the symbol develops from an inter-flux of life and dream, and all poetic knowledge about world reality is ignited by symbols ... If human beings did not possess dreams that are open to reality, they would stand "speechless" as animals before the phenomena of reality.
>
> (103)

In short, creating fantasy is dependent on everyday reality, and symbols that reappear in a constructed fantasy emerge from everyday life. The combination of life and dream alludes to Nietzsche's distinctions between Apollonian and Dionysian dualities. Broch explains that symbols help express a greater awareness of truth that has not yet been perceived, but can be understood through "symbolic capabilities" more thoroughly explained by Nietzsche. These symbols awaken an awareness that previously had never been understood. The dream state allows one to perceive a new truth, but one's own individuality gets in the way of discovering such truth. Only through the act of self-forgetfulness, what Nietzsche describes as the Dionysian state, can one be open to reality, standing speechless as Broch puts it. A symbol flows throughout life, and our dreams which involve symbolism lead to some kind of continuous change. Symbolist artists like Stuck are looking for the highest reality which they seek in their methodologies used to create art, and by the symbols identified in their work. While Korner argues that Stuck's imagery is far removed from Broch's insight (158), I disagree. The mind uses symbols in an attempt to make logical meaning about the world. Those symbols often evoke certain emotions, and we therefore question why and how we are impacted by these representations of symbols. The snake is the most obvious symbol, which for many people conjures up a terrible phobia, especially in *The Red Book* where Jung, who had a terrible fear of snakes, describes a large black serpent winding itself around his body. He imagines being helpless and with the only alternative to endure this torture (252). Their very shape and movement cause much anxiety, even quickness of breath, the spectator fearing the loss of his ability to defend himself against these creatures, but for what reason? Serpents are provocative, and this effect leads to the sublime aroused by Stuck's paintings of women with snakes coiled around them. Imagine the unimaginable; see the invisible, and perceive the imperceptible. The arts and what they come to mean individually become an escape from the burdens of life while constructing an understanding of yet a different reality rooted in self-awareness.

Dreams work on the subconscious mind as a collage of symbols and meaning that in some extraordinary way reflect the events taking place throughout our day when we are perfectly conscious. In this way dreams can be a relief from psychic components that we attempt to either repress or project onto others. The unconscious mind works out these psychic components through dreaming,

leaving the dreamer more refreshed upon waking. Jung argues that we can never divorce ourselves from the shadow, and while it cannot be eliminated, it must be accommodated or assimilated. If Stuck's *Sin* conjures up dream-images, we can gain new insight in our worldly reality. In an attempt to try and eliminate the shadow, this leads to a doubling effect by splitting ourselves off from an undesirable part of ourselves, even a particular group such as family or friends, and then we begin to project the trait onto other people, condemning them for having it while we ourselves possess it. Stuck's paintings, especially *Sin*, allude to the complex paradigm of the psyche. First, the portrait is a frequent representation of how women are paradoxically portrayed in Western culture: innocent yet experienced, beautiful and vulgar, desirable and fearful. While women are characterized as the weaker sex, culture at that time and in the several decades to follow suggests that women require the strength of a man represented by the phallus. By considering these attitudes, the image of the woman stands for the shadowy, liminal figure, a representation of sin that is in transition. As a result, she becomes the scapegoat among both men and women. She is the source of all sin and blame. But this does not lead to new understanding. In fact, it leads to regression. So instead one must embrace and even integrate all these strange polarities of the self in order to develop a healthy psyche. It leaves the spectator standing in between two opposites between the ego and the repressed other. Such acceptance of the self leads to wholeness, maturity, and full development.

In Stuck's art, the role of the woman is clear to the viewer and, at the same time, blurred by the way she is constructed through the use of both light and symbolism. Throughout art and literature, women are portrayed to transgress more culturally distinct binary oppositions between acceptable moral behavior and unacceptable vice. These problems that result in making a distinction of the role of the woman in Stuck's painting occur in both *Sin* and *Sensuality* and might best be further explained in a discussion of *Coldness and Cruelty*, where Gilles Deleuze claims that there is "a struggle of woman against man" (61) who either puts up a fight to assert her own subjectivity, or recoils in defeat, by being objectified within the culture of which she lives. This struggle is more clearly defined by the dichotomy of masochism and sadism, which negates the woman and exalts the male who creates laws, the power structure, and enforces them. The woman is the masochist who has no influence over how these rules might be generated and established, but regardless, she must obey them, much like that of Medusa who quite literally puts up no fight when she is cursed—or beheaded. The sadistic man seems to be always triumphant, which exists within this fantasy—the flux between reality and dreams. This example is clearly executed by the male-hero, Perseus. In *Sin* the sadist is represented by the snake and shapes the meaning of the woman. The masochist woman does not act by her own will, for her will is that of the sadist. Masoch, according to Deleuze, persuades the woman to look for lovers (62), which leads the masochist woman to produce disorder when she uses her sensuality to attract men, living only for the moment and exhibiting a fleeting nature of love. One representation of this is defined as a hermaphrodite, represented in *Sensuality* with the snake

coming in between the woman's thighs and resembling a giant penis in place of the pubic area. It is where her body ends and the snake begins, submissiveness combined with aggression and force.

Returning to an earlier point when Korner names the expression of the model in *Sensuality* as being "whorish," prostituting a woman is a technique of masochism—not sadism. But the woman as a masochist willingly transitions into the prostitute role as a means of being controlled by the sadist. Though it might seem that neither of these female images in both Stuck's paintings intend to do harm, they are taunting the male spectator who is excited by the woman's nakedness. The image also perpetuates his desire to identify with the snake that dominates the woman. He is attracted to her submissiveness, and yet she is not real. He can only enjoy the fantasy of her, not the reality. This causes him to stare without restraint, to gaze at the impenetrable expression of the woman, to gape at her body. There is pleasure in looking without pain. But again, she only provokes the imagination. Love itself has no place in these matters, only sexual desire. The conditions of a powerless woman who submits willingly to the sadist might be humiliated and cursed, but hypothetically she obeys because it also heightens her sensual pleasure from which she does not want to free herself. It becomes an inescapable cycle.

Violence is associated with sadism. The sadist uses torture to make the masochist feel something. To shame and torture the masochist, the torturer uses humiliating language to dominate his victim. He must hold absolute power over the woman in order to fashion her into a likeness of himself, where she learns how to use power to control other men (the male spectator in the case of the paintings). She must dominate his gaze and his fantasy life. Her technique is cruel and oppressive, where he reaches for her and attempts to have her while she pushes him aside, even torturing him by submitting so completely to the phallus (snake). The woman's naked body can be contemplated in a mystical frame of mind; he has a need to observe, to see. But the model in Stuck's paintings is only a work of art, an idea that the male spectator obsessively desires to become real, something more than a visual experience of her nakedness. The phallus has all power. When the sadist man has succeeded in training the masochistic woman into an image of himself, she can now be a sadist to another man, by threatening him, demoralizing him, exploiting her power over him, and ridiculing his impotency since he can do nothing with her, to touch or feel her, let alone dominate her. However, the woman objectified as a sexual fantasy having power over the man is only imaginary. It is still the male spectator who forms this woman, who creates his own torturer to satisfy his needs. She still has no power, even if she becomes a sadist to other men. Deleuze explains that

the masochistic hero appears to be educated and fashioned by the authoritarian woman whereas basically it is he who forms her, dresses her for the part and prompts the harsh words she addresses to him. It is the victim who speaks through the mouth of his torturer.

(22)

As noted earlier, the woman in the portrait is dominated by the snake wrapped around her body, guarding her genitals, threateningly looking at the spectator, while the woman poses in a submissive way. But Stuck staged each pose meticulously, from her expression, to her hands or what she held, to her gaze at the spectator. So if the male spectator finds her desirable, if the woman projects his own licentious sexual fantasies onto her, then the image of the woman / object has moved into the imaginary realm of being contained and restrained by the male artist who controls the gaze of the male onlooker.

This imaginary realm is created in the dual relation between the ego and the specular image, an illusion that has powerful effects in everyday reality. For one, that imaginary realm cannot simply be dispensed or overcome. But there is a very specific process that, for example, can be demonstrated by the way we view art, and in this case, it is the image of a sensual, naked woman provocatively posed. To begin with, the ego identifies first with the counterpart, in this case the spectator with the woman and snake, the double gaze. By first identifying with the counterpart (or specular image), the ego forms a relation to it. This dual relationship between the snake and the woman tends to be narcissistic, generating a new imaginary realm that is both alluring yet deceptive. The principle illusions give the male spectator the feeling of wholeness, the woman in the painting making that illusion complete; however, this feeling of being whole or more autonomous is dependent still upon the ego identifying a similarity with the other (the woman). He sees that she is yielding to the snake, which suggests she will obey and be compliant to his wishes. Because the male spectator identifies with the phallic snake image, he associates his figurative power with that of controlling the woman and making her obey him. But this is only an illusion of the imagination created by the artist. Figuratively identifying with this source of power of the snake gives the onlooker the impression of being whole. But that appearance exists only on the surface, making this association with power deceptive. The painting must have some kind of structured order to it. To begin with, the imaginary realm asserts a captivating power over the subject, seeming to control and actually dominate the subject / spectator. But it is a mistake to assume so. The most obvious feature in the painting is that the snake represents the phallus, and the woman signifies the other. So her meaning might come to be a variety of things depending upon what the spectator might be seeking. The woman is passive, and seems to portray her role willingly. She is naked, and available, yet restrained by the phallus, the snake, which makes her unavailable. If the subject identifies with the dominating power of the phallus, he sustains the illusion, the means by which he can figuratively control her and satisfy his own needs. According to French psychoanalytic theorist, Jacques Lacan, who discusses this realm, the imaginary is rooted in the subject's relationship to his own body or rather the image of his body. This captivating / capturing power of dominating the object, of using her at his own will, is both seductive and disabling; in one way, it affects his perception of himself and his relation to his own world as he constructs it, making him more aware of his sexual desires. But at the same time, the imaginary imprisons the subject in a series of fixations, or fetishes that continue to develop over time. Stuck's art exalts this relationship between the phallus

and the other, the imaginary and the ego by creating an altar where this duality can be venerated. Moreover, the translation of a life drawing and a studio situation into the painting give the scene a drastically natural appearance and an historic aspect of how the image was structured and created.

In *Sensuality* the heaviness and width of the phallus, the snake, seems to engorge her, showing enough of her nakedness to provoke a reaction from anyone in the nineteenth century viewing this portrait. But there are also questions to the degree in which the snake is touching the female genitals, though it seems tightly enclosed around her. It neutralizes a sense of reality, clearly demonstrating that this is a dream vision, a projection of dominance and submission, the idea of total control, and total passivity. The form of the woman, the snake, and motifs centered on our understanding of the power of the phallus generates an imperfect reflection of a divine original. So everything in the material world is symbolic of the ideal form in eternal reality.

Immanuel Kant explains that we experience the sublime when the imagination transgresses the boundaries separating it from logical experience and knowledge from it. Unlike Nietzsche, Kant argues that the imagination cannot meet the demand of logic; it cannot present ideas of reason lying outside the boundary of experience. Therefore, by applying Kant's use of logic, when a painting evokes sexual desire, we realize it only appeals to the imagination that cannot realistically be acted upon. Despite Kant's theory that the imagination poses insufferable limitations, Nietzsche provides a different understanding of the use and purpose of the creative mind by presenting the dual nature of reason combined with imagination. Symbolically, the portrait represents male and female relations that are acceptable and commonplace within modern culture: the male is dominant while the female is submissive. Based on how those symbols are interpreted, Kant insists that the spectator is limited to act on them; he cannot necessarily physically or realistically experience that realm in which the imagination creates new meaning. But according to Nietzsche, the use of symbols in art allows one to escape consciousness, and in this case, to transcend beyond limited binary oppositions between men and women, which is necessary to arrive at a new truth from which the spectator has been blind. Consciousness conceals the world from us by limiting our perception of reality. Art is meant to penetrate the conscious by embracing the Dionysian world.

The key influence is in Stuck's art, the dichotomy between Apollo and Dionysus. Dionysus represents that of *Sin*, standing for sensuality, expressiveness, spontaneity, and erraticism. Licentious excess and wild disorganization, dissolution of the individual are major themes revealed in *Sin*, inspired by the myth of Dionysus, a life beyond rules. Dionysus emerges from the dark cave of the imagination. There is a significant link between the Dionysian perspective observed in Stuck's art and how Dionysus can be identified in the mythical creature, Medusa, and later personified in Symbolist painting. According to the classicist Jean-Pierre Vernant,

> one constant feature dominates all [of Medusa's] representations: the frontal view of her face, which bears a similarity to Dionysus, the only Olympian

god represented in full face; full frontal view of the face implicitly signifies both a unique proximity to mortals, that they are physically alike—that mortals have been modeled after the gods, yet juxtaposed with the particular power that the gods have over mortals. Medusa specifically bears this force like that of Dionysus, a force that also figures into the monstrous blurring of all categories: in literature and art, she is both young and old, beautiful and ugly, mortal and immortal, celestial and infernal, and sometimes with her snaky hair, leonine head, bovine ears, and boarish tusks, she appears both bestial and human as well.

(qtd. in Foster 182)

In "Medusa and the Real," Hal Foster observes that Medusa embodies "a fusion of genders": in which case she is sometimes described as bearded, her tongue a phallic symbol, dangling like a penis, her hair hissing serpents, metaphorically penises, both male and female, that help shape into her mask. In Medusa, a disquieting mixture takes place, analogous to the one Dionysus achieves through joy and liberation toward a communion with a golden age. While Dionysus primarily evokes licentious pleasure, the Gorgon, a figure of disorder produces horror, the fear of looking, and pleasure coupled with looking, the effect produced by the act of gazing at her, the death wish, the thrill experienced in the drive toward death and destruction. Medusa, I argue, produces this effect on the spectator experiencing both pleasure and pain, simultaneously. As human beings, we suffer pain whenever we are out of balance or out of harmony. The Freudian pleasure principle allows one to maintain this feeling of harmony, while facing the unpredictabilities of everyday life. The death wish is also natural to each human being because it helps meet the ideal of dynamic harmony. There is a function to everything: the death wish in opposition to the pleasure principle, peeking—looking at Medusa, though it is forbidden and punishable. But there is also pleasure in breaking rules, challenging conventionality, rebelling against the gods who have cursed Medusa. We want to see, and by doing so, maybe we are looking at ourselves, and seeing for the first the very thing about ourselves that frightens us. Medusa is our shadow in the glass.

The life drive, that can be attributed to Apollo, a god of truth and of healing, is meant to create cohesion and unity. But the death drive produces the opposite, yet must exist, fused together with the life drive. Lacan describes the death drive as "a nostalgia for a lost harmony" (Evans 32). It can also be linked to the suicidal tendency of narcissism. In this case, Lacan declares that the "death instinct is only the mask of the symbolic order" (qtd. in Evans 32), which means that the death drive has more to do with culture, not with our innate biology. In other words, it is not human nature that someone would be self-destructive. But our environment, our culture, produces this effect of the death drive. Lacan also argues that the death drive is not separate from the sexual drive or life drive, but it is an aspect that exists within all these other human needs. Our drives can never be satisfied, aiming not at a particular object, but always around it. It would arguably be the death drive that causes one to gaze at Medusa, to see her.

We might all agree that we look at her because we are curious. So gazing at a sculpture or drawing of Medusa determines the impact that her image has on the spectator, though, the effect is likely to be different for each of us. Are we repulsed, saddened, fearful? So every drive—the sex drive, life drive—is "virtually a death drive because each drive pursues its own extinction" (Evans 33). The emphasis here is on "pursuit," the action of following someone or something; it is a specified kind of activity, but suggested here is that the pursuit of this object or thing will never be reached. We follow it to extinction, but also we become extinct before our own drive, or that drive ends when our life ends. The pursuit can never be fulfilled.

Bibliography

Broch, Hermann. *Hofmannsthal und seine Zeit*. Eine Studie, 1974.

Danzker, Jo-Anne Birnie. *Franz von Stuck*. Frye Art Museum, 2014.

Deleuze, Gilles. *Coldness and Cruelty*. Zone Books, 1989.

Ehrenpreis, David. "The Figure of the Backfisch: Representing Puberty in Wilhelmine Germany." *Zeitschrift Für Kunstgeschichte*, 67(4), 2004, pp. 479–508. www.jstor.org/stable/20474266.

Evans, Dylan. *An Introductory Dictionary of Lacanian Psychoanalysis*. Routledge, 1996.

Foster, Hal. "Medusa and the Real." *RES: Anthropology and Aesthetics* 44, 2003, pp. 181–190. www.jstor.org/stable/20167613.

"German Art Show at Metropolitan: Entire Field of Modern Painting from Lenbach to Menzel on Exhibition." *New York Times*, January 4, 1909.

Jung, C. G. *Four Archetypes: Mother, Rebirth, Spirit, Trickster*. Trans. by R. F. C. Hull. Princeton University Press, 1970.

Jung, C. G. *The Red Book*, ed. Sonu Shamdasani. Trans. by Mark Kyburz, John Peck, and Sonu Sham-dasani. W. W. Norton, 2009.

Kandinsky, Wassily, and Rebay, Hilla. *On the Spiritual in Art*. The Solomon R. Guggenheim Foundation, for the Museum of Non-objective Painting, 1946.

Kurtz, Charles M. "The German Paintings at the Albright Art Gallery." *Academy Notes*, 2(3), August 1906, pp. 46–47.

Nietzsche, Friedrich Wilhelm, and Smith, Douglas. *The Birth of Tragedy*. Oxford University Press, 2000.

Reynolds, Simon. *Kingdom of the Soul: Symbolist Art in Germany, 1870–1920*. Prestel, 2000.

Rilke, Rainer Maria. *The Selected Poetry of Rainer Maria Rilke*, ed. and trans. by Stephen Mitchell. Vintage International, 1982.

Schmoll, J. A. "Josef Albers under Franz von Stuck: An Interview in Das Phanomen Franz von Stuck: Critical Essays and Interviews 1968–1972." Villa Stuck, 1972.

Wilder, Henry. "Art in Saint Louis." Saint Louis Annual Exposition for Arts for America, 1896.

6 Edvard Munch and the fatal woman of Medusa

Appeals to Edvard Munch's darker needs were never far away. One such example is that Munch never recovered from his relationship with Tulla Larsen, the 30-year-old unmarried daughter of a rich wine merchant. Tulla's strength of passion shocked and frightened Munch, who later lamented that his sporadic love affair robbed him of three years of creative work and the use of his left hand that was wounded when his pistol accidentally discharged during his final argument with Tulla. Bereft and traumatized, he threw himself into excesses of work, drink and gambling. By 1908, he became ill, paranoid, hallucinatory, and, having a break down, admitted himself to Dr. Jacobsen's clinic in Copenhagen. Munch ended up staying throughout the winter and spring months in 1909 while still showing his paintings. In time, he recovered and carried on working until his death in 1944, though some critics observed that the life and intensity had gone out of his work.

In *The Sin (Woman with Red Hair and Green Eyes)*, critics concluded that the drawing was of Munch's ex-fiancée, Tulla Larsen, an image evoking their tumultuous relationship. However, the emerald-eyed temptress of this dramatic lithograph has been identified instead as a professional model who posed regularly for the artist in his Berlin studio. Like many artists of Munch's time, his female subjects follow the popular fin de siècle trope of the femme fatale with her long tresses, blank stare, and full breasts enticing the male gaze, while connoting the potential for danger. For Munch, this depiction was more personal, presenting the women in his life, who appear in his paintings, fatal to himself, to his health, and to his art. While the portrait of *The Sin (Woman with Red Hair and Green Eyes)* bears reference to Symbolist painter Franz von Stuck's celebrated 1893 painting *The Sin*, the two paintings communicate paradoxical impressions. Munch depicts a figure in the same position and state of undress, though von Stuck's female figure has dark hair and a large serpent coiled around her neck; she is submissive to the male gaze and can be constructed at will, while Munch's green-eyed woman dominates the male gaze as the spectator attempts to objectify her. Stuck's woman in *Sin* is more complicit whereas Larsen's flowing red hair suggests an exhaustive power over the painter. In "Women in the Art of Edvard Munch," Carol Ravenal explains that Munch transforms threatening events from his life into works of art. Art is his muse "who never abandoned

him, remained the single most important factor in his final achievement of equilibrium and peace" (Ravenal and Wylie 6). An undisputed master of the print medium, Munch made no fewer than 800 prints during his prolific career. Yet his subject matter of women was limited to a smaller number of powerful images that he continually reworked in etching, lithography, and woodcut. His keen interest in technical experimentation, coupled with his use of simplified forms and expressionistic color, position him as an important progenitor of modernism. It is a fortunate yet unusual pairing that Munch was named the leading painter alongside Pablo Picasso at the Cologne Sonderbund exhibition in 1912 as having sparked the significance of the modern movement in art.

Any scholar of Munch's art knows of his ambivalence towards women. Like his other Symbolist contemporaries whose collective work contributed to "The Earthly Chimera" exhibition at the University of Chicago in 1981, sexual insecurity and fear of the emancipated, sometimes promiscuous, female are reflected most succinctly in the image of a devouring femme fatale. Munch's art, according to Ravenal, is built on paradox; his themes concerned "union and separation; death and regeneration; lust and guilt; love and loss; and especially women, envisioned alternately as virgins and vampires, Madonnas and Medusas" (3). The 54 prints presented thematically at the exhibit accurately illustrate her thesis. They are all reproduced in the catalogue with six in color. "The Earthly Chimera" conveys the central motif of women as the femme fatale, siren, or aggressive seducer of men that emphasizes these intensified anxieties among men at the end of the nineteenth century. While these paintings attempt to define the nature of women, they do not produce realistic renderings of women's actual experience. Symbolist male artists subconsciously perceive them, according to Reinhold Heller, as "an evil or destructive force" (*The Earthly Chimera* 12). The paintings revisit and personify the old conventionalized myth of Medusa. But this study of their work helps to understand how and why Medusa is persistently vilified, the main symbol of all men's fears, especially in art though she transforms into so many other images, the significance of her hair, her gaze, and her beauty. As a destructive force, she appears to be inescapable, but had she been reduced to just a victim, perhaps her image would have faded into obscurity. Men almost need to identify with Medusa as a threat rather than a victim so they can make some kind of sense of her. Otherwise she becomes too liminal a subject. To view her as a combination of both victim and seducer requires one to understand her humanity where she would become less a source of obsession to the inspiration of the artist.

Early influences on the artist

Growing up in Norway, Edvard Munch was beleaguered by life-threatening illnesses, and the premature deaths of his mother and sister were explained by his Christian fundamentalist father as acts of divine punishment. So by the time Munch was five years old, he was left without his mother, a loss that eventually led to unresolved problems concerning love and affection. These tragic events

shaped a visionary, yet troubled artist, whose fatalistic interpretation of life contributed decisively to a preoccupation with themes of anxiety, emotional suffering, and human vulnerability. He is brought up to believe that women cannot be trusted, stemming from his father finding it hard to cope without Munch's mother. Moreover, he is most concerned with human mortality such as chronic illness, sexual liberation, and religious aspiration. These aspects of human life seemed best answered for Munch in the works by Frederick Nietzsche. In fact, much of Munch's library consisted of books by the nineteenth-century philosopher. He identified with Nietzsche's parable of the madman, and he felt compelled to embrace life, to say "yes" to life (Heller 96). While Munch may have felt trapped and powerless, much of his work also demonstrates these limitless struggles of mankind that move towards life-affirming qualities. He appreciates both the joys and sorrows that come with living. After his mental breakdown in 1909, he abstained from alcohol, became more reclusive, but leant toward more positive aspects of life. His attitude can be identified in his work where Munch intended for his intense colors, semi-abstraction, and mysterious, often open-ended themes to function as symbols of universal significance. Thus his drawings, paintings, and prints take on the quality of psychological talismans, similar to the way Harrison describes the purpose to which Medusa symbols are represented and put to use, as explained earlier in Chapter 2. But in this case, these "symbols" are ideas made real through an expression of contradictions coming from his own painful life. Having originated as a source of ambivalence in Munch's personal experiences, images of women are meant to convey, and perhaps alleviate, the painter's own emotional or psychological condition. The frequent preoccupation in Munch's work with sexual subject matter derive from both the artist's bohemian valuation of sex as a tool for emotional and physical liberation from social conformity as well as his contemporaries' fascination with sexual experience as a window into the subliminal, sometimes darker facets of human psychology. Munch strove to record a kind of marriage between the subject as observed in the world around him and his own psychological, emotional and spiritual perception. By struggling to find meaning in his frustration with these issues, he also tries to understand the cause of his troubled relationships with women.

The most famous of his paintings, *The Scream*, is no exception. In fact, it portrays the deadly effect women have on Munch, the scream that comes from within him, and cannot be shut out or turned off. For his inspiration of *The Scream*, Munch recalls in his diary entry on January 22, 1892:

> I was out walking along the road with two friends. The sun set. I felt a tinge of melancholy. Suddenly the sky became a bloody red.
> I stopped, leaned against the railing, dead tired, and I looked at the flaming clouds that hung like blood and a sword over the blue-black fjord and the city.
> My friends walked on. I stood there, trembling with fright. And I felt a loud, unending scream piercing nature.

In the painting, an alien-like figure stands at the center of a bridge overlooking Oslo. The expression is one of paralyzing fear, the eyes wide, hands covering his ears, his mouth gaping open in terror. Given Munch's explanation, we might expect that this image is Munch himself, dressed in black, crossing that bridge to the middle, but crossing over to what exactly, the spectator can only assume: it might be of death, of sexual fear, of inhibition, a remembrance of brief moments lost forever. In this we see how both fear and sadness are combined together in color and imagery, leading to some form of regret. The sky is a variety of colors, blue, green, red, in long brushstrokes. Though Munch may have been in the company of other friends, the spectator still senses his intense isolation, where only the artist can recognize something more impeding in nature, while his friends carry on into town, hardly noticing a thing. In sharp contrast, Munch sees himself separated from everything around him, desperate to make sense while he surrenders to his fear and looks for an answer to these human problems that are esoteric and can only be addressed in his art. For Munch, the answer exists somewhere in that blinding-red intensity of the sky. The brightness of the setting sun gives the impression that the clouds are red flames, the heavens on fire, a physically exhausting and daunting experience. *The Scream* is a potent symbol of terror, an existential loneliness, the death of God. The artist is sensitive to all his surroundings and to his relationships that torture him, and that are expressed by a physical and mental breakdown.

Throughout his art, Munch projects an unbearable dread and isolation into this painting. He produces images of isolation and loss. The horror reflected in his work is associated with Medusa, his fear emblematic of her image where she becomes a reflection of his loneliness, rejection and abandonment. Munch applies symbols throughout his work to signify his mental state, and Medusa is a repetitive motif. *The Scream* also marks Munch's artistic attempts to experiment with psychological tension and elimination of static detail. The rhythmic sky is a concentrated image for the rhythms passing through the brain. The long, slightly undulating brushstrokes create a sky of different color that moves in a sequenced pattern. He conveys heightened moments of a dramatic human experience, an ordeal of which he struggles to face; it is part of the performance of life where he feels forced to act.

Traces of Medusa are thematically identified in many of Munch's paintings, expressing his obsession with women and his failed relationships with them, especially in isolated, rustic settings of the forest, fjords, or coastal shorelines. Medusa, more to the point, also signifies nature. In fact, she *is* nature, enveloping all of it. The snake, as a primary example, defines Medusa as nature, and it is also a symbol of worship. As Jane Harrison explains, "they are uncanny-looking beasts" (327). The Greeks associate the snake with a ghost of the dead man. The Medusean woman in Munch's paintings usually signals a profound emotional epiphany of the artist. He is the dead man lurking about the room, the isolated figure in an open and vast world. The woman from his past is someone whom he worshipped and now disparagingly tries to forget. According to Dr. Stanley Steinberg and Joseph Weiss, the first physicians to examine Munch's art in

relation to his mental state, Munch purportedly feared nature. This seems to be a bit of conjecture since in his later years when he resided in the rural farm setting of Ekely, Munch often painted outdoors. Many of the scenes in his paintings take place in natural landscapes. He certainly does not appear to be afraid of it. It can be argued that Munch might feel a loss of connection to nature if he believes that the fatal woman is one with it. But evidence in his work contradicts the claim that he fears the rural outdoors, though Munch seems to fear a loss of control over nature. In fact, according to German studies and cultural critic, Reinhold Heller, "Munch told one of his patrons that at the time he heard the scream in nature he felt a great fear of open places, found it difficult to cross a street and felt great dizziness at the slightest height" (67). His fear of heights and open spaces infers his fear of death, a motif also associated with women in his art. Soren Kierkegaard, whose work had a profound impact on Munch, states that:

> We can compare anxiety to dizziness. He whose eyes look down into a yawning abyss becomes dizzy. But the reason for this is as much his eyes as it is the abyss itself. For we can easily suppose him not having looked down. Therefore anxiety is the dizziness resulting from freedom.
>
> (1298)

Freedom comes from looking directly at the abyss, to overcome one's own fear of death, to triumph over the disorienting aspects of individual life. Heller further explains that Munch's anxiety of these external surroundings is actually "rooted in the same cause, in the self" (68). In other words, Munch's mood is affected by these surroundings, that trigger internalized feelings of desperation while perhaps watching a sunset, where the artist is suddenly overwhelmed by fear, abandonment, and loneliness. Similar to the awe he might experience by looking at a sunset of bright colors and open spaces is analogous to gazing at a beautiful woman where he feels isolated and small compared to the vastness around him, its beauty sublime. These external elements develop into symbols in Munch's art that come to represent his anxieties. Though Heller notes ideas counter to the Symbolist artists of the late nineteenth century, he notes that they did agree that

> The thought of woman has for him the power of an "obsession." He feels that he cannot resist the exciting influences proceeding from the woman that he is her helpless slave, and would commit any folly, any madness, any crime, at her beck and call.
>
> (*The Earthly Chimera* 9)

Medusa embodies that effect described by nineteenth-century social critic Max Nordau who notes in his critique of heroines in Henrik Ibsen's dramas that some women "are not fit for marriage" (413). In Greek mythology, Medusa turns away all of her suitors before she is cursed. While Nordau notes that nineteenth-century ideologues agree that "Promiscuous sexual intercourse and

prostitution are their most deeply seated instincts," Ibsen instead shows "The struggle of woman for moral independence" (Nordeau 168–169).

The turn of the century marks the first sexual revolution where women are gaining more freedom and less dependence on men. But once again, a woman's value is determined by men, not by women themselves. Nordeau finally concludes that women are only interesting for brief moments, but otherwise men are apathetic towards them. Once his "erotic pleasure is appeased" (168), men's attitude is cold. From Munch's studies he goes through a series of moments such as these with women. They are desirable so long as they are out of reach, and he often pursues women who are unattainable even though it causes him so much pain. Once a woman starts making demands on the artist, he seeks a way out of the relationship. In a more general understanding, when women attempt to assert themselves by the end of the century, they resist adapting to dominant male perceptions of their nature by reacting against their subordination to men. Women's demand for equality becomes most pivotal during the World's Fair in 1900 which featured for the first time a publicly funded International Congress on the Condition and Rights of Women (*The Earthly Chimera* 8). Regardless of these early demonstrations, men still have more power over the social relations between themselves and women. Though Munch is seemingly tortured by failed relationships, it appears to be he who rejects women in his life, finally defining them as a distraction from his work and giving them up altogether after his convalescence in 1909. Still, women feature as a central theme in his art while Munch explores the meaning of his anxieties perpetuated by the external world and how they come to affect him differently over time.

Eighteenth-century dramatist and critic, Gotthold Ephraim Lessing, whose work parallels Munch's artistic vision, believed that there is an important distinction between literature and art (in *Scream* Heller 28). Painting cannot work with a single description of an image. In other words, Munch's paintings of women are not about reproducing the features of his female model. But instead a painting concerns a moment that must be characterized as a single action in which the artist attempts to produce meaning. As a result, Munch's sketches and paintings of landscapes are less literal and more expressionistic. In these works, Munch paints from his own experience, which is crucial to understanding his portrayal of women and his reproduction of the Medusa image. Open spaces envelop the solitary figure as if swallowed up by it. Heller claims that Munch "[concentrates] on an autobiographical narration of the nature of love and death" (28). The painter makes discoveries from his emotional life that he produces in art. In a description of Edvard Munch at the Berlin Secession Exhibition in 1902, art critic Karl Scheffler notes that

> There never existed a painter with a greater desire for a lyrical emotional life; but his un-happy intellect never lets him forget the worm concealed in every bud, the grimacing skull beneath every face, the beast lurking behind every passion, Nature's arbitrary whims in every painful sensation.

Munch featured twenty-two paintings titled "pictures of life"—*Frieze of Life*. He wanted to paint what was human, rather than settling on landscapes. But in the paintings where he captures nature, there is a human intensity that displays the painter's deepest emotions such as that which is depicted in *The Scream*. Otherwise a painting of a natural setting is lifeless for Munch. In Munch's paintings of a moonlit landscape or curving road in a forest, a solitary figure is depicted at the very center to project loneliness and isolation in nature. In these landscapes he makes human emotions visible to the spectator. Therefore, nature serves a specific purpose to characterizing human experience, and Munch overcomes the limitations of landscape painting. He distorts the features of nature to meet his purpose that expresses his psychological and spiritual mood.

Fru Heiberg

In his painting that depicts himself with Fru Heiberg, *Self Portrait Under the Mask of a Woman*, Munch explains in his diary dated February 1890 that "Is it because she lied, deceived, that one day she finally took the blinders from my eyes and I saw her Medusa head, saw life as a great puzzle?" Munch alludes to his first failed love affair with Fru Heiberg, a fictitious name according to Trygve Nergaard who discovered her real name, Emilie (Millie) Ihlen Thaulow. Even though he knew she was married, Munch feels betrayed, deceived, and attempts to reconcile himself to this realization. The relationship was clearly never ideal considering that Millie Thaulow had a reputation for being unfaithful to her husband, Dr. Carl Thaulow. Munch met her in 1885 which coincided with dramatic social changes among women and Munch's introduction to the bohemian counterculture that had a more unorthodox view about sexuality, alleging that sex should be widely accepted as experimental. Presumably Munch met Millie at one of these bohemian gatherings that she often attended. Being rather idealistic, Munch had a much higher expectation of his relationship with Millie. But physical appearance of the woman who he once loved transforms over the course of his relationship as he sees her far differently from a young man in love to a disillusioned artist. Medusa epitomizes the physical transformation of women and therefore becomes an appropriate motif through which the artist identifies how his feelings for Heiberg change based on how he now sees her. Though he may not be angry, she baffles him, not in a mysterious way, but in a threatening way that might have caused him to stop loving her. In the painting, there is no real expression on his face besides solemnity, that he is pensive, humorless, still in the process of accepting this new certainty about his former lover. His expression is stony, figuratively seeing "her Medusa head" for the first time. Above him is a head, with large dark eyes, painted rose-colored cheeks, and black liner marking the outside ridges of the eyes deep-set and penetrating. The rouged skin purposely cheapens the image of the head, alluding to the inauthenticity of her character, that she cannot be trusted. The eyes of the head stare outward, while Munch, standing below the head, stares onward, transfixed, seeing nothing, as if paralyzed in time. In her thesis, *Edvard*

Munch's Fatal Women: A Critical Approach, art scholar Barbara Susan Travitz Bimer explains that, the Medusa head "star[es] mocking[ly] challenges and entices the viewer," seeking out her next victim, having "drained [Munch] of all his energy" (40). His eyes are luminously blue, vacant, as if he is in shock, though the expression is grave. Because the image of Munch is very central to the portrait, it also suggests that the head hanging from above, floating in space, unharnessed, haunts the unconscious mind, possibly leading to fear of women, or anxiety of his future lover. Bimer argues that "By juxtaposing his weakened self beneath the mask of this woman, Munch implores the spectator to partake of his psychic trauma ... he hopes to gain the viewer's sympathy and understanding" (40).

In *Edvard Munch: Behind the Scream*, biographer Sue Prideaux concludes that the conditions under which Munch developed a sexual affair with Millie laid the foundations for a relationship "associated with melancholy, remorse, fear and even death" (64). Prideaux also links the fatality of the woman with landscape scenes that similarly depict isolation and loneliness in the features of Aasgardstrand where Munch lived. To develop the theme articulated in the title of his Berlin exhibition, *Frieze of Life*, Munch paints his first kiss from Millie in the forest, the loss of his virginity in *The Voice* when Millie surrenders herself to him. Because Munch has his first sexual experience with Millie, she was his first love, and he is more vulnerable to her. These are the most important scenes from his life, indicating "the worm concealed within the bud" (qtd. in Heller, *Scream* 14) because Munch is forever changed by these events. Similar to Nietzsche's attitudes of women, Munch finds women fascinating, but most commonly, portrays them as a temptress, a distraction from the great work that can be achieved by men.

But Munch must also come to terms with his own desires that led him to Millie in order to be free from her. There must be some kind of internalized process in which it is not only the woman to blame. He accepts her lies. Turning her into a Medusa figure is Munch's attempt to destroy his memory of her. Perhaps it is only natural that in order to get over the disappointment of a love relationship that has failed, the lover must demonize the memory of the beloved in order to get on with his life. But he is at battle with himself—not with her. Therefore, to compare her to a Medusa image is a manifestation of his love turned to distrust, but not literally of her, but maybe of himself and his choices that drive him into seclusion. In reference to the effect of the Medusa curse, the Gorgon head represents his emotional paralysis resulting from their failed romance. Because he is also unable to forget his former beloved, the woman is symbolized by the Medusa figure that becomes a recurring motif in his art. He can try to destroy his tenderness for her, but she largely remains unaffected, though, likewise, perhaps disappointed that the relationship ended. Eventually Munch perceives his relationship with Millie Thaulow as another "episodic conquest" (Bimer 33). By forgetting her, he can also forget the suffering and pain that she caused him, a demon dwelling within him long after she is gone. His art frequently returns to the memory of her. In reflecting upon his relationship with her, he compares it to helpless victimization. He needs to continue

this process of forgetting her, of exorcising her memory from his mind, in order to validate his own individual existence which can be achieved by returning to his art, by focusing on the one aspect of his life that provides meaning to him.

There are important historical facts of that relationship that need to be brought to light. Munch is infatuated with a married woman who is unavailable to him from the very start. Given this circumstance, he cannot help but feel rejected by her. This feeling of rejection was punctuated a few times. He is the young, struggling artist, following her around Oslo, namely on *Karl Johan Street* where he had been seen anxiously searching for her. In his writings about Millie where he fictitiously names her as Fru Heiberg and himself as Brandt. He eventually catches sight of her driving down the road in a carriage towards him, and when she stops to talk to him, the meeting causes him to feel nervous, as if he wants to escape. Instead they greet each other, and she holds out her hand, laughing and showing him yellow flowers on her lap, handing him one for each hand, then says good-bye, leaving him there standing in the street, helplessly staring after her while she rides away. The scene becomes indicative of their relationship where he can never make out what she is thinking, and he vulnerably does not know how to act around her. His hands and arms are burdened with things that he does not want, meant more for a woman than a man. While she is free to come and go as she likes, his helplessness emasculates him. Indeed, Millie takes on a more traditionally defined male role, pursuing the artist and seeing him when she wills for it to happen. The love affair becomes torturous to him, where he at times is fascinated by her beauty and within the same moment as the landscape begins to change, "the evening heavy clouds [drawing] in," so does his mood when he suddenly decides "he didn't like her now" (T 2781).

These chance meetings inspired him to paint *Evening on Karl Johan Street* in which a few provincial buildings and one lone cypress tree mark the famous promenade. A man, who the viewer presumes is Munch himself, walks into the distance along the street, his back turned to the viewer, his image dark and shadowy, easy to miss. But on the left, a group of intensely illuminated faces advance toward the viewer, immediately catching our eye. At the center is a tall man wearing a black top hat. In a ghoulish expression of bewilderment, he looks directly at us, his eyebrows thick, and his face rather gaunt. He is Millie's husband, Carl Thaulow. Fru Heiberg (Millie) stands next to him on his left. Her features are somewhat homely, almost nondescript. But she evokes a feeling of anxiousness, hiding her lover who presumably she sees in passing. Her intention is to elude from her husband the discovery that she has a lover. She prefers to keep her other life secret, captured by the shadowy figure that suggests their casual romance which she will eventually forget. She is three years older than the artist and much wiser than he is on the pragmatics of feelings associated with love, and this ostensible immaturity on the artist's part was also vital to his capacity for irreconcilable feelings over his affair with married women. It may have led to obsessive behavior that indicates boyish jealousy as he follows her around the city, but he also becomes acutely aware of the dissolution of one person into another that he would then go on brilliantly to capture in his paintings. These feelings

of despair develop and haunt Munch throughout his life, repeating the same habit of falling in love with married women. He experiences destructive feelings by entering into this illicit love affair with married Heiberg, overwhelmed by his burden of guilt. Believing that her husband also suffers equally in this game of marital deception, Munch empathizes with the man. He is even compelled to write a secret confession to him in which he identifies himself as her lover, confessing his pain and suffering, and thinking the man suspiciously waits for his wife's return home after illicit meetings with the artist. In short, Munch deceives himself into believing that the husband felt the same as he did.

Throughout his intimacies with women, Munch only allowed women to come within a certain distance of him; his art always came first. Among his own writings, he contends: "I have always put my art before everything else. Often, I felt that Woman would stand in the way of my art. I decided at an early age never to marry" (qtd. in Heller 187). While Munch expresses suffering caused by loneliness, much of it appears to be self-determined, rejecting the possibilities of intimacy or courtship. It can be argued that these otherwise casual sexual relationships do not last because he becomes jealous when he sees these women with their husbands or other men. To vilify women in his artistic interpretations, the Medusa figure demonstrates his belief that women corrupt and spoil his devotion to his art. So his attitudes about women and prioritization over his work conflict with one another. He fails to develop a spiritual kinship and trust with another woman, the consequence of his loneliness.

Munch's "cropping" techniques emphasize the subject matter in the painting *Evening on Karl Johan Street* by removing details that would otherwise be more distracting. This method intimates threat and unease, as the vacant, pitiless gaze of the bourgeois strollers bear down on the viewer in Karl Johan Street. The mood of nocturnal consciousness comes from Munch's experience as he waited for his mistress to meet him: she appears to greet him with a soft smile, continues to walk on. The blurred figure, which is Munch, causes his surroundings to be so visibly empty. The strangeness of the people in town passing by him allude to his awkwardness, as if they are looking at him, drawing attention to his isolation. This painting is still more symbolist than expressionist, the raw power of the latter hidden under the great beauty of the blue night sky and the glowing lamps, a velvet surface disguising the terror of isolation, rejection, and loss. Furthermore, the solitary figure moving against the crowd and walking in the middle of the street, evokes Munch's own situation as a "bohemian" and radical artist, hounded by the middle-class authorities in the stifling parochialism of Kristiania (Oslo), in contrast with the larger world of Berlin, Paris and beyond for which he was yearning. Munch's mastery of symbolism, however, ensures that these personal interpretations do not intrude on the vision of universal anguish and every individual's fear of the mindless crowd, their grim faces united as a pretense of respectability and conformity. Carol Ravenal explains that:

> with the potential development of intimacy, he [Munch] is again terrified by conflicts. For the woman to be separate, to recognize her otherness, is to

expose him again to the dangers of separation and abandonment; and his aggression is projected—the life giving Madonna becomes the demonic Medusa head and the "good" woman is lost. Only complete merger with the woman, complete control on his art would prevent a Madonna from becoming a Medusa.

(6)

To be mesmerized by a woman's beauty and charm is to be ensnared in the all too familiar trap which he wants to avoid. He fears the time when the relationship cannot overcome conflict between himself and the woman he has come to love, that he will be consumed by her, threatened by her, made helpless by her. Subliminally in his art, he exorcises these feelings by dividing women into the Madonna or Medusa figure. While the love and nurturance he experiences from these women give him hope and comfort, conflict eventually rises and forces him to entirely change his perception of her. At the same time, he demands from them more than what they can give. Therefore, their inadequacies are fatal to him. But the circumstances under which Munch concludes that women are dangerous to his artistic endeavors and cause him so much suffering demands a close look. Munch's attitudes largely have to do with the type of women with whom he was introduced among the bohemian society to which he belonged in Kristiania (Oslo) beginning in 1882. The two most eminent women of that circle were Millie Thaulow and Oda whom Munch described as "vampire women" (Prideaux 98). Both of them were beautiful young women who came from respectable families and married men of education and wealth. They enjoyed a certain degree of prominence and were celebrated for their fashionable taste featured often in the society pages of the newspaper. Yet they also exemplified the insatiable sexual encounters enjoyed by other young women belonging to this bohemian group started by Hans Jaeger who Oda voraciously followed. While the emancipated woman at the beginning of the twentieth century stood for women's independence and equal rights to men, Millie and Oda have no interest in pursuing these revolutionary changes to their status. In fact, they wanted to keep up conventional appearances and benefit from the economic advantages of their husbands, while carrying on a double life. So they cheated on their husbands and pursued a variety of sexual partners.

Given the earlier description of the Medusa archetype in Chapters 1 and 2, these adventures among the two Norwegian women inaccurately represent the Medusa myth. Moreover, while they may consider themselves libertines, they really are not such examples. A woman using her sexuality to exploit the insecurities or weaknesses of men is not an example of being free from an otherwise restrictive and parochial society. Rather they calculate opportunities at the expense of other people, namely men. So Munch is correct to distrust these women, but they certainly are not representative of other women who seek emancipation from the dominance of patriarchy. In a closer look at Millie and Oda, it is equally demoralizing to abuse the vulnerabilities of men; such behavior only continues this cycle of trying to dominate the opposite sex. These

behaviors do not fall within the feminist perspective that seeks independence, but is otherwise misrepresented by examples of women who, as Munch had put it, reduces men to soup once they marry them (Prideaux 99).

The outcome produces a stereotype of a woman who lacks subjectivity in relation to the artist. But I argue that his art is not limited to this paradox. It is an introspective journey towards his own inadequacies expressed through the image of the woman, one whom he loves and demonizes at the same time, feeling limited by living completely in his first failed relationship with Millie Thaulow that repeats itself throughout his life. He consequently refuses to surrender these categories of women because after his second tumultuous relationship with Dagny Juell, he is convinced that he can never love again, that his spirit is broken. Symbolism in Munch's work is powerfully representative of disappointments in his personal affairs. Ravenal goes on to observe that

> Munch's use of symbolism of the Medusa head is a particularly fitting representation of his intense ambivalence. He is to witness the transformation of the beautiful maiden, into a frightening monster, the sight of which turned the spectator into stone. As with Perseus, he then must slay her and eliminate her tyranny of him.
>
> (12)

But women are not just maidens or monsters because they fail to meet the needs of men. Often, however, this representation has been the case. By attempting to escape through other means, such as gambling, alcoholism, and sex, the artist finds that he alone is meant to suffer, and the woman is the cause of all his grief. Munch repeats the same themes about women throughout his art because he fails to understand them truly as human beings with experiences and personal struggles of their own right.

The opposite is true for women. In fact, according to Gubar and Gilbert, "women must kill the aesthetic ideal through which they themselves have been 'killed' into art" (17). But this belief conflicts with the attitudes and behavior demonstrated by women among the Kristiania bohemian society of the 1880s. Ravenal suggests that Munch's distrust of women's loyalty started with the "terrible bereavement of his cherished mother" and his father's continued criticism against women (4). But his romantic liaisons with Millie Thaulow and later on, Dagny are not good examples of women seeking love and offering affection since they are both married women having extramarital affairs. The process of a woman becoming liberated can lead to some confusion, and a woman cheating on her husband or carrying on with a number of male lovers clearly does not lead to female emancipation. Trying to be more like men does not lead to women's liberation from male patriarchy: she must also kill the monster, which Gilbert and Gubar explain involves a process of women eradicating the shadow self-defined by men and has led to self-loathing. Gilbert and Gubar refer more literally to women loathing their own bodies, the aging process, criticizing themselves as too thin or too fat, their fear of being freakish—too sexualized

or too unfeminine. So a woman must come to terms with the natural changes of her body, and the progression of her intellectual and emotional development. Therefore, when a woman looks in the mirror, she must first "come to terms with the images on the surface of the glass" and accept herself as she is (16–17). This requires more self-introspection completely separate from how society might judge women. As Gillian M. Alban explains in *The Medusa Gaze in Contemporary Women's Fiction: Petrifying, Maternal and Redemptive*, "mirror-gazing" is "a female activity" encouraging women "to parade themselves as lovely objects in order to win male approval and love" (61–62). But somehow women must seek their own identity that is not influenced by the social world that defines a woman's value based on physical appearances. Male artists, on the other hand, "fasten … mythic masks … over her human face" (Gilbert and Gubar 17). Gilbert and Gubar argue that male artists determine the social identity of women by attributing specific tropes to them, which are identified in Munch's work as either Madonna or Medusa. In other words, these masks have been invented *for* women, not *by* women. In order for women to be truly liberated, they must figuratively "kill" the mask—annihilate "her Medusa-face [that] also kills female creativity" (17). Women must examine and then deconstruct the myth in order to destroy the mask. Christina Rossetti similarly observes that "the male artist often 'feeds' upon his female subject's face 'not as she is but as she fills his dreams'" (114).

While Munch creates great art that becomes an emotional journey toward self-discovery, he and his other contemporaries objectify women, but not women as themselves. To represent women's subjectivity requires developing meaning from the woman's perspective, to understand why Millie and Oda, for example, sought sexual intimacy outside of their marriages. Oda seemed to be looking for adventure and excitement by first having an affair with Christian Krohg, her art teacher, and eventually with Hans Jaeger who believed that "women derived as much pleasure from sex as men" (Prideaux 50). As for the male artist, Munch is not seeking inspiration from them, though he depicts his unhappy relationships leading to specific categories in which they are placed that alleviates his disappointment and suffering, interpreting the mystery of women. But it is not meant to trivialize a woman's subjectivity. To characterize both Dagny or Millie as being monstrous helps to lessen his dread of their inconstancy. I argue that the Medusa-face described by Gilbert and Gubar is the central male narrative about the snake-haired woman that symbolically portrays her as monstrous. While there is much to be gained in understanding how male and female relationships are portrayed, the male artistic interpretation of Medusa is not accurate. Munch relies on this mythic figure to express specific experiences of falling in and out of love. But the image of Medusa poses a limited perspective.

The "killing" of both the male-defined angel and Medusa figures as Gilbert and Gubar argue is a necessary step to starting over and developing a more accurate understanding of these myths and of women in general. It is admittedly difficult to kill the male myth that constructs women. For example, it is possible to make the argument that Medusa is not a femme fatale, which

is rooted in patriarchy because of the deadly effect she has on men. Turning men to stone is not of her own will. I argue that the threatening aspect of Medusa has to do with the fact that she wants to be independent. Her side of the story is told from a male perspective up until the time Ann Stanford writes the poem "Medusa" in 1977. In her collection of poetry, *Mediterranean Air*, Stanford writes from the perspective of a rape victim to show how a woman's anger transforms her physically and emotionally. This is the first time that Medusa's story has been portrayed in a woman's voice, and especially emphasizing the rape rather than Perseus' victory over the Gorgon. In the poem, the feminist narrator describes in sordid detail the brutality that she suffers. Stanford's poem humanizes Medusa and eradicates beliefs that the feminine gaze is lethal, that Medusa is an evil instrument of Hades as she is portrayed by Homer in *The Odyssey*, as the Underworld's guardian / monster (XI, 633–635). Though rape and powerlessness are familiar to other women of all generations, from youth to old age, that ravaged place of the female hero is transformed by emotional and intellectual curiosity. The Medusa that more accurately speaks for women does not renounce where she has been; she is not ashamed of her past. She is both darkness and the other side of darkness, light and healing.

While Munch is portraying his emotional experience, both male and female artists must create from the perspective of women in order to overcome narrow categories or labels under which society indoctrinates them. In other words, the motivations of both Oda and Millie among the bohemian group in Oslo are complex. It could be argued that while they are respectable within Kristiania (Oslo), they rebel against the conventionalized motif of good women by promiscuously carrying on affairs with men who they find exciting compared to the wealthy and industrious men to whom they are married. But rebellion or becoming what society might believe is wicked does not weaken these patriarchally defined categories, but rather justifies these categorizations of women. To protect themselves, or to hide themselves, women might be more prone to follow the angel of the house representation. However, they fail to find their own voice, and rather internalize their experiences and suffer quietly.

The creative quality of women fails to emerge when a woman cannot say "I am" because she does not yet know who "I" am. The knowledge that a woman has of herself is private and introspective, separate from the means by which society convinces her and manipulates her into believing what she should be or wants to be. In other words, when women look at themselves in the mirror, they visualize a socially accepted construction of themselves, and if the expectation does not meet their reflection in the mirror, then society bullies women into believing that they have in some way failed. But this is superficial. Pain and anger are often repressed emotions that come with a woman trying to define herself, her values, and ideas by the strict paradigm constructed in a dominant male world. Within these narrowly prescribed standards she is otherness, an object of desire, hate, or glorification. Men can force women to act in a role that is socially more acceptable, where patriarchy creates the world of women, where she has no authority over her own thoughts or creativity of her own life.

The faces upon which male artists feed become masks that women are forced to wear. Women simply want to be included within that creative realm. Gilbert and Gubar explain the effects women endure by being excluded from contributing to the shape and form of culture, a visionary action. By leaving them out, Woman becomes an embodiment of clichéd images that emerge from Otherness, where she is feared, loved, loathed, worshipped, exiled. According to interpretations of artists applying Medusa images in their paintings, the woman either teaches men purity (the Madonna trope) or degradation (the monster). Joan Didion notes that writing or art is "an imposition ... an invasion of someone else's most private space" (Gilbert and Gubar 20). Male constructions of women invade that private space of women. Munch blames women, with whom he has been in love, for breaking his spirit, depleting his capacity to give or show love. While Munch has feelings of suffering relating to love, his past lovers have also been affected. Munch promoted his belief in the necessity of using private, subjective experience to create "universal" statements and imagery. This was the ambience in which Munch's originality and personal convictions flourished. His art celebrates the life of the individual artist rather than of community or society, a contrast emphasized in his work where images of him are pictured alone and waiting. However, his ambivalence and distrust of women is inescapable. Though Munch very accurately portrays passion that comes with human relationships and suffering caused by incompatibility of men and women, the obstacles that forever prevent a harmonious union, Munch retreats into the same pattern of either worshipping or demonizing women.

But this also requires a careful consideration of Munch's style which develops more innovatively by 1892 in *Frieze of Life*, described by Christian Krogh as "a gaping gulf between" his own works and other paintings (193). Frederick Deknatel, who helped run the first Edvard Munch exhibition in the United States, explains that Munch's emphasis on contours and colors demonstrates a harmony in his subject matter that "has a prominent place in [his] art" (21). The painter's subjects are in direct relationship to his themes of death and love. He signifies his forms for expressiveness of mood. These differences set his paintings apart from Parisian artists as Deknatel explains. While, for example, Gaugin may have influenced Munch, the Norwegian artist puts to use the principles of Gaugin's style to his own purpose. Gaugin's influence becomes apparent in Munch's paintings of 1891, some of which are shown in the *Frieze of Life*. Meandering lines, for example in *The Yellow Boat*, are features in Gaugin's art. However, "the deep recession of the lines into the distance" are Munch's own technique (Deknatel 21). As a result, Munch's use of color and "elimination of depth" present a deeper contrast of the moody figure in the foreground contrasted with the tranquility of the setting in the background. The dark figure constructs the central tone of the painting by the use of these contrasts that is not characteristic of Gaugin. This method of Munch's painting demonstrated in *The Yellow Boat* are emphasized in his *Frieze of Life* exhibition in Berlin.

After Munch painted *Ashes* in 1894, he left Aasgardstrand and returned to Berlin where his then lover Dagny and her husband, Stanislaw Przybyszewski,

had gone back. While Munch was having an affair with his wife, he battled with fits of jealousy of Przybyszewski, and though Dagny increasingly showed her affection for Munch, he often perceived it as false, and tortured himself even more by convincing himself of her duplicity. He put himself in this situation, pursuing women that were never available, yet falling desperately in love with them. So he portrays Dagny as evil. He tried to leave Berlin because of the effect his relationship with Dagny had on him, but it took him at least 16 months to tear himself away. Similar to his treatment of Millie in his art, he does the same with Dagny in the painting titled *Jealousy*, typecasting her in the role of a faithless and evil temptress. Przybyszewski is portrayed as the jealous, cuckolded husband, while Munch is the married woman's lover. In the painting, Przybyszewski is at the forefront, his face illuminated brightly, emphasizing the features of his face. His expression is ominous and vacant, the point at which he realizes his wife and friend have been deceiving him. The woman is depicted as a Medusa figure, a seducer of men, unavailable and evil. Munch cannot pull himself away from this archetype of Medusa which projects his feelings of abandonment, his constant insecurity with women. He rewrites the myth of Medusa by conveying his feelings onto her image. She becomes sexualized, taunting, and emasculating.

Jealousy expresses a strong likeness to Przybyszewski, his full beard groomed in pointed style, his mustache overgrown, his eyes gazing directly at the spectator while his wife and the artist are in the background to the far left, in a private moment, prurient because they are so near to Dagny's husband. She wears a scarlet-colored dress that is open in the front while she parades herself for the viewing pleasure of Munch. Though we cannot make out the details of their faces, they appear to look at each other while Dagny offers her lover an apple to portray the image of Eve, tempting her lover, promising pleasure though it comes at the expense of her husband's suffering and eventually the jealous pain she will cause her lover. Her hair is long and wild, flowing over her shoulders and behind her back. The two lovers are in a verdant garden, the implications of fertility and seduction, while to the right where Przybyszewski faces the viewer, the setting is dark, representing the conscience of the lover, as if he comes out of the shadows to face this reality. With raised eyebrows, Przybyszewski does not appear startled or surprised by the tryst that goes on literally behind his back. Rather, he surrenders while the affair between his wife and friend carry on.

In true life, Przybyszewski had a number of affairs himself. After visiting the poet and playwright, Jan Kasprowicz, Przybyszewski started an affair with Kasprowicz's wife, Jadwiga Gąsowska. Shortly abandoning Dagny thereafter, he set up house with Jadwiga. Though he left his wife for the wife of one of his friends, Przybyszewski was also involved with Aniela Pajakowna, who already had a daughter with Przybyszewski. Needless to say, though Munch's painting may have portrayed Przybyszewski as jealous, it is unlikely that Dagny's husband actually experienced these emotions, even if he did know about the affair Dagny had with Munch. It could also be that Dagny initiated this affair with Munch to find some kind of comfort and relief from the torment she may have

felt while Przybyszewski had affairs with other women before he finally left her. He also believed that it was good for his wife to carry on liaisons of her own. On the contrary, Munch was adamantly jealous of Dagny being with any man other than himself. The image he portrays of Przybyszewski is actually a projection of his own feelings, of being an outsider, unable to understand or accept the loose sexual attitudes of his lover and her husband. This is a repetition of Munch's earlier experience and his perceptions of Millie's husband, Thaulow, who was not at all begrudging of his wife's affair with Munch. Years later in Berlin, the artist shared his feelings about his affair with Dagny, and how he felt tortured by her. He confessed his jealous outrage of the affair:

> I don't understand that my nerves didn't cave in back in my Berlin days. I sat at the table with these people and couldn't say a word. Strindberg talked and talked. All the time I kept thinking, doesn't her husband understand a thing? First he ought become green with jealousy, then blow his top.
>
> (Przybyszewski 7)

Munch references Strindberg who had also been one of Dagny's lovers. The artist is agitated that Przybyszewski does not speak up against Strindberg and throw him out, as Munch himself apparently felt like doing. It is clearly Munch—not Przybyszewski—who feels cheated and cuckolded. Przybyszewski in contrast had no feelings on the subject. Much of Munch's pain was caused by the expectation of his friends and lovers to conform to his beliefs, rather than to accept that their ideas about relationships were simply different from his own. It appears that Munch's relationships with women may have been complicated by the fact that he demanded complete submissiveness whereas they enjoyed sexual liberation, which as explained earlier, is not to be confused with women's emancipation. Their desire to be more sexually liberated in a culture of which Munch found himself among friends and other artists should not have been surprising, nor does it match his artistic portrayal of them as evil or deceptive. The affairs and relationships carried on by this bohemian group was, on the contrary, very open and forthright. Munch expresses idealistic views of women that contradict the beliefs of Kristiania Bohème led by Hans Jaeger of whom the artist became cynical. But the archetype is still inaccurate of Medusa since her intention is to be autonomous and does not involve exploring aspects of her sexuality or power over men. She simply desires emancipation from male dominance and an escape from society that is structured by male power. Therefore, to seek such advantages, Medusa must be exiled and cast out of patriarchal society.

In his correspondence with Rolf Stenersen, Munch blames Dagny for ruining his chances at a more prolific career as a painter in Paris rather than Germany. He had planned to exhibit his work in Paris, but was so disturbed by what went on in Berlin that he called it off. The real reason he may have decided to cancel his plans in Paris is that the paintings revealed too much about his feelings for Dagny, his resentment toward both she and Przybyszewski. To show his paintings such as *Jealousy* becomes a most obvious narrative of his suffering

that is documented while he was in Berlin with these friends. The paintings show the artist in an unflattering image, that he is really Przybyszewski, jealous, and emasculated by the naked and seductive image of Dagny beguiling another man. Though Munch may have felt this way about his friends, Przybyszewski understood how destructive jealousy can be, but nevertheless empathized with Munch by also accepting that jealousy is very much a part of the human condition. Przybyszewski makes the following observations in his review of *Jealousy*, identifying how these insecurities subverts one's ability to think clearly and rationally:

> Within this painting lies the entire stupid, inflexible brooding of a passion which has been reversed into the insane idiocy of despair. The painting appears almost like a pictorial presentation of Cicisbeo's physiological experience of light and color sensations; it is nothing more than the painted philosophy of a suffering feeling of natural selection … It is in this manner that a landscape is pictured in the mind of a male who loses a female of his natural selection to someone else: the wild, prehistorical battle for the female has been transformed into a cultural triste, cowardly, stupid, resigned brooding.
>
> (32–33)

There is no cause to despair; jealousy is simply an illusion generated by the imagination. Przybyszewski suggests that Munch attempts to portray himself as the gallant lover Cicisbeo of the eighteenth century, who had exclusive access to a married woman, attending public events with her. According to Przybyszewski, there are physical resemblances between Munch and Cicisbeo. But his criticism alludes to Munch's effort to hide his wretchedness in this disguise, and Przybyszewski is really commenting on Munch's self-delusional belief that he has won the affection of Dagny. The landscape in Jealousy is a metaphor of the mind, its untamed beauty, fertile green, red associated with aggression, vitality, and love. But the Garden of Eden, the snake, and the apple are symbols of temptation. While the apple is associated with the enticements of sin, it is also the gift of Eve, mother of all living, to Adam. Yet on the contrary, the skeleton of death often holds an apple, symbolizing the price for original sin, death.

If the woman in *Jealousy* can be compared to a femme fatale, then the inevitable threat she poses is unmistakable. Jealousy in this case has the destructive power to impotently paralyze all men falling within this tryst, the actual cause being that they are incapable of acting on their own behalf by using their sensibilities. Instead their desire and weakness for a woman destructively changes their perception of themselves because they cannot accept rejection. The shadowy darkness pertains to the chaos lurking in the unconscious, manifested into feelings of jealousy, yearning, and fear of loneliness. The cultural triste in which Przybyszewski refers is the way men handle jealousy in what is designed to be more reserved and conventional, whereas feelings of jealous rage cause

men to naturally regress into prehistoric and unsophisticated beings. But despite how much society has advanced from a prehistoric age of survival, men cannot help but be moved by their feelings, and Przybyszewski recognizes this, and has compassion for his friend, the artist.

Possessive behavior that Munch expresses toward Przybyszewski's wife is perceived as debilitating to the artist, and Przybyszewski seems to try to pull him out of it, as if Munch is in a deep trance from which there is no escape, trapped in the image of which Munch metaphorically hides behind in his depiction of Przybyszewski. Munch also wishes to perceive himself as being victorious over his friend for his wife, that she has in fact chosen Munch. But the painting here reveals Munch's own delusion that he has won something, taken off with the woman, that she has finally chosen him, and therefore he is no longer the man lurking despairingly within dark shadows, desiring a woman who chooses a different man. Since Munch works exclusively with this dichotomy of good women versus bad women, we see how being stuck within this polarity only affects and hurts him. He forces himself into this deep morbidity by relying on the love and affection of a woman that will somehow conform to his needs. But in the end, she always fails, and because of this failure, he can only see her as good or bad.

Munch in Paris

Though Munch preferred a certain type of woman, wealthy, respectable, and prominent in society, all of them possess a rebellious and independent spirit, enjoying a bohemian existence. Munch is drawn close to these women as a result of their shared interests in art and philosophical ideas that originate within their bohemian shared culture. But sexual obsessions, insecurities, and for the very reasons that he becomes infatuated with them, their independence, each relationship is doomed to fail. His meeting with Judith Molard was no exception. After having settled in Paris in 1896, Munch met Judith, the stepdaughter of William Molard who was the French Ministry of Agriculture. As a teenager who entertained the family's more bohemian guests, writers, and artists at the time, Judith eventually became an artist in her own right, preferring older men who mentored her interest in art. She became attached to her first lover, her teacher, Monsieur Floquet. She certainly was not a demure young lady, but instead witty and outspoken. She could also be very possessive, having demonstrated this in her later affection for Gaugin, threatening anyone who interfered, particularly his friends. But Gaugin tired of Parisian life, and he left for Tahiti, never to return, leaving Judith heart-broken. At this time, both Judith and Munch were recovering from broken relationships. He was still in love with Dagny and struggling to accept that they would not be together. Judith on the other hand still carried a torch for Gaugin, and while there was a void in her life, just waiting to find a suitable lover to fill it, none of the artists visiting the Molard home interested her. However, Munch was a well-cultured, sophisticated man, distinguished and

handsome, as evidenced by photographs of him. This was the preferred taste of Judith. Because Judith was high spirited, it was also natural that Munch would be attracted to her. Munch decided on living in Paris for an extended period which was unusual since he traveled frequently. Oftentimes he visited the Molard home, at which point it is suggested that there was some kind of involvement between Judith and Munch, while she was still getting over Gaugin (Bimer 97). Though neither Judith nor Munch ever specified an affair between the two, there is implicit evidence that such an acquaintance began shortly after he moved to Paris. At the time, Munch was 32 and Judith was 15. When he finally left Paris and returned to Norway, this was the time in which Judith became engaged to Edouard Gerard. Munch returned to Paris briefly in 1898, but there is no evidence that he visited the Molards.

The cat and Medusa motifs

During that summer in 1896, Munch did not return to Norway as he usually did, but stayed in Paris to work on lithographs and woodcuts. According to Bente Torjusen, a friend had given him a white cat, which the artist kept as a constant companion. Prideaux explains more at length that Munch's cat had actually come from the street and made a home for itself in Munch's studio. Though the cat clawed at Munch's paintings, driving him frantic, rather than admonishing its behavior, Munch allowed for the creature to roam around at will, deciding that they were both independent creatures. Yet between the paintings, the cat, and the artist, this scene played itself out into a constant drama of love and hate. Despite earlier insinuations that he did not like these feline creatures, especially during his relationship with Millie Thaulow, he kept the cat and eventually house trained it. Given the territorial power struggle that Munch suffered, there is an analogy that the artist makes between women and cats, implied in a letter that Munch wrote to his aunt: "One day I was working with a female model—a little Parisienne, very lithe and supple—when suddenly I see the cat steal up to her white body, purring and affectionate—they were like two people or two cats" (*Familien* 156). The cat belonged to Munch, but the young woman could have been Judith Molard. By likening the cat to the woman and the woman to the cat, Munch suggests that the cat makes him nervous, and he struggles to tame the animal, but without success. The cat became even more central to the portrait than the woman, dominating his thoughts. Munch notes that the animal is disruptive to his work, the cat's gaze penetrating, causing him to feel nervous and distracted from painting. But despite this ongoing conflict, this cat figuratively steals its way into Munch's soul, similar to the women in the painter's life who preoccupy his mind, drive him to despairing periods of intoxication. Cats in general fascinate and terrorize the artist, comparable to women who also captivate and frighten him, though no woman can be dominated or mastered. He notes: "It had anxious, questioning eyes—the eyes of a human being—and I was almost afraid of its gaze," and on another occasion with a woman, he mentions "the white cat ... gazed at

us—as if it were, straight into our souls" (*Familien* 156). Symbolically, the eye of the cat appears to change as the light strikes it from different angles, and is considered deceptive. The animal's ability to hunt even in virtual darkness led to the belief that it was in league with the forces of darkness. The animal is associated with lasciviousness and cruelty and was considered, above all, the familiar, the spirit guardian of a witch. Moreover, in comparison to women in Munch's paintings, the cat is typically the feminine animal, and woman is more deeply rooted in the dark, representing the more intuitive side of life than man, compared to man's simpler psyche. Perhaps this is what makes Munch so nervous, that similar to women in his life, he lacks the ability to tame the cat; the animal is beyond his control. Furthermore, feline metaphors are often used for misogynistic expressions, such as "a cat in heat." The use of cat metaphors signifies an aggressive attitude toward that which is female. Cats are also difficult to catch or confine, thriving on their liberty, yet tirelessly cunning when they chase their prey. Ironically, the women in Munch's life are likened to these feline characteristics, attracting free-spirited and sexually assertive women who pursue the artist. At the same time, he also falls hopelessly in love with them; his feelings assuredly dominate his psyche and even his art, appearing in so many different versions, but always alluding to the same idea, the cruel and inescapable mistress.

It is revealed in a letter that Munch wrote to his friend Bente Torjusen of the woman that the cat actually represents in Munch's life, and that would be Judith Molard. But he also mentions in his letter Tulla Larsen and Eva Mudocci. According to Torjusen:

> Since the white cat is mentioned in the same breath as Tulla Larsen and Eva Mudocci, it seems natural to suppose that [Molard] was a woman to whom Munch had been very close, a woman from the Paris milieu where Munch and Delius had friends in common.
>
> (197–198)

When Munch suffered a mental breakdown in 1908 brought on by excessive drinking, it is presumed that it was caused by his argument with Tulla Larsen that led to Munch firing a gun and injuring his finger. The event surely changed his life. But his painting *The Tiger* suggests that he recalls the memory of Judith Molard who may have played a part in his suffering when he was in France in 1896. On a chance meeting in Stockholm before Munch checked himself into Dr. Jacobson's clinic in Copenhagen, he and his friend Albert Stockenstrom presumably met by chance and spent an evening reminiscing about the Paris years, much of which were spent at the Molard home. It is suggested that the subject focused even more exclusively on Judith. A few days later in a complete state of intoxication he wrote an unsent letter to his lawyer Harold Norregaard, in which Judith's name is mentioned, possibly the source of this

recent emotional crisis. Whatever pain Judith may have caused Munch is never mentioned. Instead he wrote:

> I sit here burning out my nerves with whiskey, postponing this ghastly half suicide of committing myself to the sanatorium in Hornbaek—which I feel is my duty—since I must either do so or burn my nerves entirely—out … (I stand outside) looking deliri-ous and miserable and say Judith—Judith her fault—she was Molard's daughter—whom you know—And then there was the Goat Canal—and finally—But in actual fact I was thrown out.
>
> (Torjusen 101)

It is clear from the letter that Judith did something to hurt him that now he does not forgive her. But moreover, this point seems to have a dramatic toll on Munch's health rather suddenly after his conversation with Stockenstrom. Something about Judith must have been revealed in that conversation that Munch previously did not know. It can easily be assumed that some kind of relationship existed between Munch and Judith though it is never recorded by Munch or his friends who knew the Molards. Second, she may have done something that caused him to return to Norway. But finally, the cause of Munch leaving Paris may have been something far more simple, even though the unsent letter to Norregaard suggests that he departed under bad terms with Molard. Needless to say, his relationship with Molard is serious enough to pre-sumably send him into mental confusion, a suicidal drinking binge from which he cannot stop without help. Once more, he eventually processes his mental anguish in his art. Also important to note is that much of his work produced during his time in Paris portrays Judith as unpredictable and unrelenting, which would have caused Munch a great deal of anguish.

In *The Cat*, a drypoint sketching, Munch depicts a nude figure of Judith Molard, her small, lithe body laying on her side, her hair splayed out behind her head, her hands holding the decapitated head of Munch, his head laying close to her thighs, figuratively, as if she has given birth to him. In his journal, Munch refers to the model as being the white cat, a predator that victimizes Munch. Falling in line with Munch's paintings of women, this drypoint shows a young, nude female figure as destructive, "an ego-devouring force in the artist's life" alluding to Freud's theory of Medusa, the decapitated head representing male castration (*The Earthly Chimera* 44). Since the woman represents the "cat," the translation shows the cat as predatory, unpredict-able, playing with and tormenting its victim. The cat is the companion to the goddess Freya in Norse myth. She is mystifying yet dangerous. Freya is famous for her fondness of love, fertility, beauty, and fine material possessions—and, because of these predilections, she's considered to be something of the "party girl," a seeker of pleasure and thrills. This corresponds to the personality of Judith, young, intelligent, easily bored, frightfully plain spoken. She could have a viciously sharp tongue when she did not like someone. Moreover, it

is thought that the goddess Freya slept with all of the gods, which seemingly correlates to Judith's appetite for love and older men, sometimes insatiable with perhaps only Gauguin as the one satisfying her needs until he leaves her. Whatever further details that Munch learned on that night he spoke to Stockenstrom were undoubtedly previously unknown. But judging from this much earlier painting of Judith, it is apparent that he is well familiar with her character. Similar to Munch, Symbolist painters often viewed cats as part woman. In ancient Egypt, the short-tailed cat is known in *The Book of the Dead* as slicing up the evil snake Apepi. The cat is fearless, turning the world upside down. Returning to images of women whose bodies are enshrouded by snakes, namely Stuck's paintings, this suggests that if the woman represents the cat, then really while the snake alludes to a domineering and threatening presence, it is really the "cat" that symbolizes the castrating female who has all the power. The cat's way of playing is harmful and destructive. Love becomes a form of play for the cat, leaving the man beaten up, defeated, and emasculated, while the cat is victorious. Art cathartically attempts to master some form of control by objectifying women and cats in relation to the artist himself. The cat, a symbol of women, is charming and seductive, but at the same time, deceptive.

The companion to *The Cat* is the drypoint sketch, *The Maiden with the Heart*. A nude woman sits with her arms outstretched, legs slightly bent, while she holds a heart in her hands and squeezes out the blood. She has stolen Munch's heart, letting the blood coagulate around her feet and her wet hands. Her body is passive, yet playful in this activity, having pounced on the head. Bimer insists that Munch is depicting his "heartfelt grief for Judith Molard" (106). Other men similarly had found Molard equally vicious by her demanding and unrelenting criticism of them. Without much provocation, she cruelly and viciously attacks men who attempt to court and tame her. Examples of this torment are likened to a game that might be played between a mouse and cat, striking at will, perceiving this sadism as a game, painful though it is for her victims.

Yet Munch creates women in his own image, as they relate to his experience and therefore tries to understand the relationships and conflict that goes on between men and women. The signals of women are conflicting, while the male figure looks passively onward, or as in *Ashes II*, buries his head completely. The man sits on the bed off to the far-right corner with his hand covering his head, while the woman stands at the very center of the portrait, untroubled and indifferent, her loose hair enveloping her shoulders as she gazes directly forward at the spectator. It is a couple right after lovemaking where the two appear completely isolated from one another as if they are not even in the same room, where the man cowers while the woman is more conspicuous. This lithograph is of Munch and Dagny. It illustrates Munch's attitude about lovemaking, that it is "ego destructive" (*The Earthly Chimera* 39) because there is no spiritual kinship. The "euphoria of orgasm" is short-lived, and he just as quickly loses his passion after sex. Furthermore, he depicts his belief in the intellectual connection that might possibly be experienced with women. But his desire for

such a harmonious kinship is quickly extinguished by his introduction to the free love society of Kristiania Bohème, shown in art where sexual relationships can drive men and women apart. The women in Munch's paintings have a more dominant presence while the men are usually blurred images. The woman's hair is always long, wild, ensnaring. She is a combination of vulnerability and tenderness, yet ambiguous and evil, both a saint and whore. On the contrary, this becomes a moment of reckoning with himself, that he can only visualize her as domineering, and this perception is destructive to Munch. It also suggests that for too long he has idealized her beauty, and using her physical attributes to construct her character, he insinuates that he was blind to her duplicity. From his very first sexual encounter with Millie Thaulow, women in Munch's art transform into a metamorphosis of Medusa. Yet it is not so much Millie Thaulow who changes, but the artist himself without anger or even depression, just a sudden realization upon which he must act by leaving her. Though that separation might be gradual, he has accepted that it is inevitable. This is one way of portraying the Medusa, that while this application to construct the character of other women might be cloying, duplicitous, and threatening, I again argue Munch's artistic interpretation of Medusa produces an inadequate impression of the real Medusa who does not depend upon men, nor does she seek to have relationships with them. Munch relies on the Medusa image as a lens to negotiate the meaning of his own loss and to try and understand how he has changed in relation to women in his life. If he can perceive a woman with Medusean-like qualities, this makes it easier for him to quit the relationship.

In Munch's *Self-Portrait Under the Mask of a Woman*, Bimer concludes that Munch portrays himself as Perseus and Fru Heiberg (Thaulow) as Medusa (40), though this analogy has some complications. Munch may very well have had this intention, depicting greater heroic qualities of the lover who prevails over his beloved's inadequacies. While Munch may want to see himself from this heroic perspective, in relation to the women in his other self-portraits, he is undemonstrative and internalizes all psychological conflicts and emotional suffering by his facade of self-constraint. Perseus is very physical in his murderous pursuit of the Gorgon, driven by urgency to free his mother Danaë from marrying Polydectes. But in contrast the painter's heroics are demonstrated by inaction, by not showing emotion, a passive onlooker compared to the fatale woman. The male protagonist's heroic feat (Munch) is to remain unmoved by her. Yet, in his other paintings that I have discussed here such as *Jealousy* and *Ashes II*, usually after love making, he shows that the male protagonist lacks the ability to hide his disappointment. Symbols such as the woman's hair, her unabashed expression, or other men featured in his paintings suggest the degree to which she has actually defeated him. The Medusa face is figuratively an immoveable mask floating above his head, and the body must be unattached in order for her to have no power. Perseus, on the other hand, needs the head of Medusa to have any power or protection to achieve his personal ambitions. In this case, the hero's goal does not involve undermining the power of the woman he once loved. Rather than figuratively losing his own head over a woman, he

has no passionate feeling for her that might otherwise distract him from killing the Gorgon. Based on his diary entry, it may have been Munch's intention to prove that he feels no emotional attachment to Millie Thaulow, that they are no longer lovers. But subliminally she still hovers above him, haunting his imagination. Consequently, Munch also needs to objectify her as the femme fatale so that he can begin to see her differently rather than being blinded by her sexuality. All too often, Munch expresses feelings of persecution in relation to these women, not victorious over them.

The use of the mask

Another important feature in Munch's painting of *Self Portrait Under the Mask* is the physiognomy of the mask, which is extremely manipulable. With the aid of a mask, all the human traits of their face can be filtered out to the point where only indifference or impassivity remains. At the same time, the person wearing the mask can feel internally transformed and takes on temporarily the qualities of the god or demon represented by the mask. Masks are not only disguises for the face, but also used as independent cult and art objects. Moreover, the mask can heighten a particular mental state or emotion. Harrison explains that ancient Greeks use the masks as an "apparatus of a religion" to cause terror (188). By applying this meaning to Munch's art, the mask warns against certain actions, behaviors, or obsessions. Harrison discusses "a goddess Praxidike, Exactness of Vengeance, whose images were heads only, and her sacrifices the like" (188). In comparison the mask in Munch's work not only cautions the spectator against wrongdoings, but identifies the destructive consequences of love affairs, physical intimacy leading to jealousy and martyrdom. But he also demonstrates that the woman is at risk of being victimized, which leads to his sympathy (*The Earthly Chimera* 44). Munch suggests that women are in the guise of many masks: "Woman in her many-sidedness is a mystery to man—Woman who is at one and the same time a saint, a whore, and an unhappy person abandoned" (Munch Museet ms. N30). While Munch suggests that there are so many complexities to women that they are perhaps not meant to be understood, he also implies that the female subject in his work reflects the complicated feelings that the artist tries to understand about himself.

Once the expression on a mask has been determined, it is unchangeable. Wooden masks have great ritual importance in rites and alliances. In this case, the mask might signify all women, or at least that collective group with whom Munch had love affairs or whom he desired. Because Munch suffered failed relationships with women, a figurative alliance of women represented by the mask in the painting might be independent, unmarried, strong-willed women in the nineteenth century, women who rebel against convention and come off as controlling, antagonistic and hostile. The mask therefore constructs this collective, subversive group. Medusa represents duality, feminine beauty, desirable object or cursed, exiled woman. She can freeze her male victim with terror or transfix them with desire, but Medusa must first capture the male gaze. The intent may not be so much to kill her spectators but to startle them. The man

watching must contemplate the scene in which she appears. In *Self Portrait Under the Mask*, the spectator follows the mask's gaze which is on that of the man in the portrait, Munch. Therefore, identification is not with the mask but with the male subject. The male image reveals hidden truths about the woman who mirrors his existential condition. The mask hovers above him, gazing out at the spectator. His powers are depleted, characterized by his withdrawn expression, his lifeless body. Yet the room is painted red, alluding to their passion that has exhausted itself. The painting of the Medusa mask is a symbol for the artist himself, an agent of self-deception, of finding satisfaction in women that inevitably leads to disappointment, women attached to someone else, whether they are already married or separated from a previous lover.

The Medusa head in art

In *The Severed Head: Capital Visions*, Julia Kristeva describes:

> Without showing us Medusa, Edvard Munch nonetheless presents her effect on the artist: his retina is stricken. Blinded, but only partially, the artist sees only the horror of an eye. A necessary precaution? A trick of the disease so as not to succumb to an abject truth?
>
> (35)

Munch makes several allusions to Medusa without the image becoming quite so literal to the spectator. The effect she has on Munch is loaded with conflict, his impulse to sympathize with the Medusean woman as a victim of abuse and abandonment, the very emotions that he experiences, or the mental burdens that result from the same image of the woman who has abused and abandoned him. The eye, to which Kristeva refers, "brings misfortune, an evil eye, it kills" (29). The eye itself is soulless and threatens the destruction of Munch, moreover, his work as an artist. The threat to Munch's art is the greatest source of destruction that the Medusean woman perpetuates, which renders him impotent without the ability to create. Yet woman is creation incarnate, and her ability to bear children represents, according to Gilbert and Gubar, "the contingency of life, life that is made to be destroyed" (35). Men become insecure about the conditions of their own life and death, since they do not have control over this natural process that women otherwise represent. In "The Syphilitic Woman," literary historian, Sander Gilman, asks whether hidden truths, or the true nature of women be discovered in their bodies (197). The question is facetious since all women are different and complex; female experience is difficult to determine a woman's subjectivity which continues to evolve with age. Because men do not trust the nature of women since women are so very different from men, they attempt to delineate a woman's charm by monstrous female tropes, that has throughout generations caused "real women" to feel ashamed of their own bodies. Women force themselves to conform to the angel of the house stereotype which certainly is not an authentic or realistic version of themselves.

Gilman explores the image of the vampiric woman, with "spider-like hair" represented as seductive, diseased women who threaten to destroy men. "'Medusa' masks the infection hidden within the female" explains Gilman (197–198). At the same time, a woman uses her "vampiric power" to undermine men's ability to reason when they easily succumb to her seduction despite all the warning signs suggesting that she is a femme fatale. Munch describes both Oda and Millie as "vampiric women" because while they are certainly chasing after something, it has nothing to do with early protests for women's rights where they pursue great ambitions to use their intellect to discover their own truth, to determine the value of their life experience. Rather Oda and Millie who are not characterized as liberated women by Munch are pursuing lovers because they are dissatisfied with bourgeois life, exploiting their husbands for their wealth while trying to create an independent life on their own terms, leading to excitement and distraction. They expect financial support while they pursue free love (Prideaux 99). These women are also not good examples of progressive women.

Gilman cites a 1916 Belgian poster that features a cartoonish woman similar to descriptions of Medusa, which represents the desirable woman "as the source of syphilis" (198). So Medusa is portrayed as an exotic, sexualized temptress, a femme fatale. The more beautiful, the deadlier she is. Kristeva and other postmodern feminists demystify these attitudes, by naming her as a reflection of men's own unconscious desire manifested in her image. Kristeva concludes that artists are concerned that they risk being victimized by her. But they avoid this threat by instead reflecting her in the same way Perseus falls meditatively into a trance when he gazes at the reflection of the severed head that becomes a permanent emblem on Athena's shield. The hero and the monster become a reflection of each other. The spectator of artistic images of Medusa somehow becomes obsessed with her repeated image in art, in mirrors, in reflections of her, that he cannot take his eyes off her. The Medusa that hovers over the self-portrait of Munch suggests that in spite of the woman deceiving him, of disappointing him, he cannot be free of his feeling for her. Though he is more aware, he still appears to be under her spell, suggested by his trance-like gaze. Kristeva even goes onto suggest that we, the spectator, have consecrated Medusa, making her body sacred, by commemorating her in art. The reflection of Medusa in art is what remains of her in death, of her body and blood. Kristeva, in this context, analogizes Medusa as Christ. In Munch's painting, the mask that we see is of the grotesque, the eyes and lips dramatically exaggerated. In comparison, Munch appears somber, having accepted this truth though it seems uncanny and dream-like. Ironically, the two are reflections of one another, ego and alter-ego, the mask mirroring Munch's psychological state of mind which becomes more literally portrayed in *The Scream*, a transition from this state of the abandoned lover to the artist who suffers a complete breakdown as a result of reckless relationships with women whom he tries to dominate or finds equally oppressive.

In spite of rejection in both his personal and professional life, Munch refused to compromise his ideals that are so forcefully demonstrated in his art. Love and death dominate his work, appearing to be never joyous, but also demonstrating his pleasure in portraying himself and other people in different guises and changes of mood to show how we struggle to eventually accept our destination in life, though it may be of loneliness and unreciprocated love.

Bibliography

Alban, Gillian. *The Medusa Gaze in Contemporary Women's Fiction: Petrifying, Maternal and Redemptive.* Cambridge Scholars, 2017.

Bimer, Barbara. "Edvard Munch's Fatal Women." Master's of Arts Thesis, North Texas State University, 1985.

Boe, Roy A. "Edvard Munch: His Life and Work from 1880–1920." Ph.D. Dissertation, *New York University*, 1970.

Deknatel, Frederick Brockway. *Edvard Munch.* Museum of Modern Art, in collaboration with Institute of Contemporary Art, Boston, 1950. Print.

Gilbert, Sandra M., and Gubar, Susan. *The Madwoman in the Attic: The Woman Writer and the Nineteenth Century Literary Imagination.* 2nd ed. Yale University Press, 2000.

Gilman, Sander L. *The Jew's Body.* Routledge, 1991.

Harrison, Jane Ellen. *Prolegomena to the Study of Greek Religion.* 3rd ed. Meridian Books, 1908.

Heller, Reinhold. *Edvard Munch: The Scream.* Viking Press, 1974. Print.

Heller, Reinhold. *The Earthly Chimera and the Femme Fatale: Fear of Woman in Nineteenth Century Art.* David and Alfred Smart Gallery, University of Chicago, May 20–June 21, 1981.

Kierkegaard, Soren. *The Concept of Anxiety: A Simple Psychologically Oriented Deliberation in View of the Dogmatic Problem of Hereditary Sin.* Liverlight, 2015.

Krohg, Christian. "Notes on *Evening*." 1891.

Munch, Edvard. Diary. February 1890. Munch Museum. June 5, 2019.

Munch, Edvard. Diary. January 22, 1892. Munch Museum. June 5, 2019.

Munch, Edvard. T 2781. Munch Museum. Saint-Cloud, 1889.

Munch, Edvard. N30 ms. Munch Museum, 1889.

Munch, Inger. OKK T 2782. "Letter to Tante Karen." *Edvard Munchs Brev, Familien.* Munch Museum. Tanum, 1949.

Nergaard, Trygve. "Refleksjon og Visjon. Naturalismens delimma i Edvard Munch Kunst, 1889–94" (1968), note 163 and pp. 72–72, as cited in Reinhold Heller, "Munch's 'Night,' the Aesthetics of Decadence and the Content of Biography," *Arts Magazine* 53, October 1978, p. 105, note 149.

Nordau, Max. *Degeneration.* University of Nebraska Press, 1993.

Prideaux, Sue. *Edvard Munch: Behind the Scream.* Yale University Press, 2005.

Przybyszewski, Stanislaw. *Totenmesse Requiem Mass.* S. Fischer, 1893, pp. 32–33.

Ravenal, Carol, and Wylie, Jr., Harold W. "Women in the Art of Edvard Munch: The Madonna-Medusa Complex" (unpublished). Washington, DC, 1979.

Ravenal, Carol, and Wylie, Jr., Harold W. "Women in the Art of Edvard Munch (1863–1944). Edvard Munch: *Paradox of Woman*." Exhibition catalogue, New York Public Library, 1981.

Rossetti, Christina. "In An Artist's Studio." *New Poems*. Ed. Michael Rossetti. Macmillan, 1896.

Scheffler, Karl. "Berliner Sezession." *Die Zukunft*, xxxix (June 14, 1902), pp. 419–430.

Steinberg, Stanley, and Weiss, Joseph. "The Art of Edvard Munch and Its Function in His Mental Life." *Psychoanalytic Quarterly*, 23(3), 1954, pp. 409–423. doi:10.1080/21674086.195411925955.

Torjusen, Bente. "The Mirror." *Edvard Munch: Symbols and Images*. Exhibition catalogue, National Gallery of Art, 1978.

Part III

Medusa in the twenty-first century

Identifying the woman in the mirror

7 Nan Goldin and a new vision of Medusa

At Cookie Mueller's funeral in 1989, Nan Goldin took a haunting photograph. The picture is grainy, burnished orange. The woman lying in the casket is a voguish Cleopatra, an ancient pharaoh. Thick black liner extends beyond the corners of her closed eyes, a personal trademark when she was alive. The rigid expression around her mouth reluctantly gives in to death. Arranged on both sides of her temples are white lotus flowers, a symbol of resurrection, immorality, and evolution—the Heart of Being. It is a flower rooted in soil that floats above muddy waters of attachment and desire. Her necklaces spread into a beaded collar, similar to Egyptian dress. Though the casket is lined in white satin, a strong red glow in the background defies the condition under which she lies there after having succumbed to the AIDS virus. A number of bracelets line her left wrist with only one on her right, rings on each finger, her hands folded together in final repose. A deep melancholy, combined with a decadent setting arranged in flowers and flashy jewelry, mark the remains of Cookie Mueller's past archived in photographs and memory.

Yet these were the 1980s and AIDS was at the time killing many, and few knew why. In "All Yesterday's Parties" Luc Sante explains that among the young, lost, artistic, energetic, and tragic generation of the late 1970s and early 1980s in Manhattan's lower East side, "AIDS began taking out the very ones who seemed most alive to the moment ... [but] Nan's slides made us aware, however subliminally, of the fragility of our eggshell bodies, the transience of our fun, the vulnerability of our bonds" (Sussman 102). One of the most eclectic and unpredictable personalities of that group was Cookie Mueller, described by photographer Nan Goldin as "a cross between a Tobacco Road outlaw and a Hollywood B-Girl, the most fabulous woman I'd ever seen" (Sussman 256).

This is the world that Nan Goldin documented. At that time Goldin photographed drag queens who were her close friends and not really allowed in public; it was too dangerous. In bars and night clubs owned by the mafia where she filmed their lives, she realized that the conventional American lifestyle portrayed on television in the 1950s and 1960s had nothing to do with large parts of society, and she wanted to capture the real life of her friends.

Cookie, the diva, the sweater superstar, was one of Goldin's best friends, both of them bisexual. In that time, their whole family that they formed lived in

New York City and rotated around Cookie, the eccentric of the clan, serving opium and turkey for Thanksgiving. Her girlfriend Sharon lived with Cookie for many years, but went through a personal crisis when Cookie began a relationship with Goldin. Eventually Cookie met Vittorio Scarpati, and they got married when they were both HIV positive. Though she rigorously fought the virus, Cookie seemed to give up the fight after her husband died, and she became fatally addicted to heroin and cocaine.

Cookie and Vittorio visited Peter Koper in California after they found out they had AIDS. Koper recalls Cookie as high-spirited, smart, and a lot of laughs. But given her adventurous ways, strange things always happened to Cookie, such as when she and Sharon rented a car in Positano and got stuck on a train crossing, or when she crawled the fire escape to get into Studio 54. Cookie died shortly after Vittorio passed away from AIDS. By the time she succumbed to the virus, she was paralyzed on one side of her body, blind in one eye. Her speech was fading, making it difficult for her to speak, and, overall, she became more helpless. Naturally at this time, things that she wanted to talk about were not coming from her usual self. Then out of the blue, she called Sharon and wanted to spend a weekend with her, who ended up staying and taking care of Cookie. But after that, Cookie went quickly downhill.

Why mention Cookie Mueller here, the John Waters' film actress diva? Goldin's work was influenced by their relationship, and their relationship became a way of looking at life. I first saw *The Ballad of Sexual Dependency* at the MOMA in New York City, August 2016. By accident, I came across the exhibit, and it produced that same anxious feeling I experienced six years ago at the D'Orsay's Ange du Bizarre exhibition in a room filled with Medusa paintings and sculptures. It was uncanny, and, similarly, I thought some kind of answer could be produced here. *The Ballad of Sexual Dependency* is the defining work of Nan Goldin's life, a 48-minute slide show, with 40 different songs; the songs provide a different narrative to each image on the screen. Though a book followed based on these photographs, the slideshow has a much deeper intensity. The Modern Museum of Art in New York refers to the slideshow as "a downtown opera." It covers a scope of social and cultural issues that are pervasive even today such as drug use, domestic violence, sexual relationships, parenting, while also marking the historical AIDS epidemic when both men and women suffered through the devastating later phases of the virus. Goldin records friends cavorting at East Village bars, a self-portrait of Goldin beaten up by her then boyfriend Brian, a close-up of someone shooting heroin, a young couple straddling each other, while music connects the spectator's emotions to each scene, which is either penetratingly sorrowful echoed by the operatic voice of Maria Callas, or exhilarating and nostalgic of a life in rhythm to the harmony of "Small Town Boy" by Bronski Beat.

When I left the exhibit, I felt beaten, exhausted, and haunted by my own memories that Goldin's slideshow recalled for me. I heard that some critics had claimed that Goldin's work is self-indulgent or narcissistic. After the exhibit, my impression was that either these critics had a very low bar for what counted

as narcissistic, so that any representation of aberrant experiences counted, or they just applied such pejorative terms inconsistently to anything they were already disposed to dismiss. My experience of Goldin's show, rather, was contrary to reviews from critics who claimed that it was self-indulgent or narcissistic. Instead I took her work as an awakening, and as a new reckoning.

Goldin's intimate portraits of young lovers, addicts, and so much else reminded me of my own experiences. I was not alone in this. By design, Goldin produces meaning in memories, in what Sarah Ruddy describes as a liquid form where her slide shows and the people in them are "anything but still" (350). It becomes a new way of acquiring knowledge by making observations, not through empiricism, but through *affect*. The photographs make me feel how transient life is, while I desperately want it to slow down. Instead the vastness of everyday life collapses into irretrievable moments, a memory, a relationship, a person—gone. As Ruddy points out, Goldin's work "enacts a moment rather than depict a scene" (351). Photographs mourn the loss of a moment; we capture that point in time as it disappears. In that moment of loss, the subject (the spectator) feels like she belongs to that object. Aching for the memory, to be reality again, we disproportionately invest it with value, and so feel the loss of the people it is about even more. Goldin even writes that "I used to think I couldn't lose anyone if I photographed them enough" (Goldin 27), only to realize the hopelessness of such an attempt.

The physical expression of loss is described by French feminist Julia Kristeva in *The Black Sun*: "In the tension of their affects, muscles, mucous membranes, and skin, they experience both their belonging to and distance from an archaic other that still eludes representation or naming" (14). Kristeva describes crying as a process of grief for which that loss cannot be "represented," depicted by language. These corporeal emissions belong to that loss and yet we are distanced from it, from some remote moment of our past. The reason we cannot represent such loss, though, is that affect causes our bodies to be flooded with painful memories, each of which is frustrated by the next. We cannot help but talk to ourselves about loss, but the feelings remain. Given that the effect of loss is independent of language in this way, the process of recovery is always in flux, fluid and unstable. And such affect can easily be reactivated, given the right trigger. However, this theory of affect does not just apply to loss. Actually, the power of affect cannot really represent such emotions in language. Goldin's work, therefore, can be thought of as an emotional documentary that is coupled by political and social elements.

Goldin illustrates this in her photos of Cookie Mueller. Let us briefly consider two of these. I have already described the first of these at the beginning of this chapter, taken on November 15, 1989. This was Mueller's funeral. In this photograph, she is a voguish Cleopatra, seemingly regal even in death. In the second photograph, from 1985, Mueller stands on our left, but to her right is blank, unencumbered space. She is dressed in a black, short sleeved shirt, black leather belt, six silver bracelets lining her left wrist, rings on her right fingers, her right hand holding her chest right below her neck, laughing as if she cannot

stop, the viewer wanting to get in on the joke, Cookie's mouth wide open and eyes squinting. She is pure vibrancy, energy, alive, and we feel alive with her. Mueller's laughter is guiltless, unimpeachable pleasure, her left hand pressed against the wall, her right hand holding her chest as if to hold herself up. Her uncontrolled laughter in ancient cultures suggests a challenge to the gods, a triumph over the impediments of life. These were the good times, with only the excitement of existing, and the mystery of what will happen next without fear of the future. In other photographs, Cookie is at once exuberant, and suddenly pensive where she sits beside herself, her head and eyes turned downward in a private moment of contemplation.

As if describing herself, Cookie memorializes her generation of young men and women who died from AIDS as

> the kind of people who lifted the quality of all our lives, their war was against ignorance, the bankruptcy of beauty, and the truancy of culture. They were people who hated and scorned pettiness, intolerance, bigotry, mediocrity, ugliness, and spiritual myopia; the blind that makes life hollow and insipid was unacceptable. They tried to make us see.
>
> (Sussman 274)

Goldin provides a new way of presenting our histories, and when I viewed her work, I also thought immediately of Medusa. To be more specific, ancient Greek and Roman poets silence her voice, writing from a patriarchal bias that repeats the same stereotype about a monstrous, mortal woman defeated by a man. The absence of a voice is what largely caused that anxious feeling I had at the D'Orsay. Instead, artistic images of her body present her history. Medusa's transformed body fills in for the absence of her voice. The art that I saw at the Ange du Bizarre told a different story compared to ancient myth about Medusa, not one that I had ever heard, and yet it was not entirely a different story compared to myth. Instead, these artistic interpretations filled enlarged gaps of her myth with a more complete tale of the Gorgon woman. It was also to see how the Gorgon transforms over time into other women such as Eve or Lilith. When I considered Medusa like this, I wasn't afraid of Medusa anymore.

This new realization of Medusa shocked and compelled me to do something with it. In *The Laugh of the Medusa*, Hélène Cixous offers an ultimatum for women, which I see manifested by the rhetorical and social implications of Medusa's body: that women can either remain trapped in their own bodies by language that does not allow them to express themselves, or they can use their body as a means to communicate by moving outside the patriarchal rules of discourse. Sure, this is simplistic. Not all bodily traps are of the same kind (or could be escaped in the same way), and not all rules of discourse are patriarchal or are rules we would want to escape at all. But my realization here was that women's bodies in their various transformative stages can indeed become a source of power that relies on their own modes of communication, whether they be in art or writing. Just envisioning that there can be this mode of expression that

is unlike any form of communication that I have observed is completely liberating yet daunting at the same time.

Women who create certain kinds of art or write for themselves can indeed lay claim to themselves, for it can form their identities, and can be a private source of expression independent of the expectations of others. However, before Goldin's work is theoretically relevant to Medusa, I will summarize some of her main points.

First, as a voyeuristic exploration of universal concerns, Goldin's photography figuratively transcribes women. Women terrorize men, and men react to women, but in different ways. However, women also terrorize women, and men terrorize men, again in all sorts of ways. But Goldin's lens freezes her subjects, leaving their emotions frozen in time. While she captures her subjects in a moment, the moment itself is immobilized. Although our perception of that scene can and does change over time, it evokes certain memories that fade. After all, our perceptions are still tightly bound to a particular period of history.

Second, because Goldin's photographs are illustrations of affect as it is without meditation, they also reveal that our responses to it cannot be represented linguistically. Of course, we often seem to use logic and reason to interpret the images, guided by universal values, as well as any experiences we had prior to making these observations. But much of this logic in our responses hides what is really important. From a second alternative perspective in experiencing Goldin's documentation of her subjects, our emotions are awakened, and for these there is no language. So she specifically means to reveal an undeniable truth—affect by itself—that cannot be revised as something that it is not. As spectators looking at the photograph, we powerfully identify with the emotional exchanges among Goldin's friends, which in turn provokes our memories of shared activities, love, intimacy, even death. Such emotional experiences, moreover, make us empathize or even reject persons or groups, although we often do not know why we are doing so. Such experiences, Goldin insists, require acuity, and self-knowledge. But the real question is: when we observe such images, what emotion registers with us?

Third, Goldin intends for her photographs to convey affect independently of any cultural norms or values. But that does not mean that we have enough self-knowledge to see them. Abjection, as this has been called, does not play by cultural, ideological rules of understanding that guide meaning. To show this affect, Goldin's photographs are of men and women that many in society had previously rejected (even if the participants do not care). Abjection investigates the fears and horrors one might have by facing objects or images that may threaten one's identity. Equally, confronting such fears can make one realize that one's rebellious identity is just as fragile. Either way, abjection theory means to break down what we took to be either part of who we are, as opposed to alien (and opposed) to us. Such distinctions can be entirely arbitrary. So Goldin confronts her audience with their potentially discriminatory attitudes of all kinds, and reveals that such inherited attitudes are in our power to change.

Fourth, part of Goldin's project is to reject what she calls "revisionism." We can revise some event for good (e.g. when we are incorrect), or we can lie to ourselves about reality, creating a false perception in its place. Goldin opposes the latter, saying that revisionist thinking is to decide that what happened, never happened. According to Goldin, the problem is that "the wrong things are kept secret," and this is therefore dangerous. Our individual histories should never be revised—they should never be changed to reflect how we want to see ourselves. We must tell the truth about ourselves, to ourselves. Goldin's refusal to go along with revisionism, revising where we have been or what has happened to us, was critical during the height of the AIDS epidemic. By observing people coming and going, and disappearing, that was the result of AIDS in the early 1980s. Everything in a photograph has to be exactly as it is. Scars and open sores, physically muscled men suddenly reduced to emaciated bodies by AIDS, this is all important to see. Therefore, spectators of Goldin's photographs become intimately familiar with the names of her friends she pictured, and recognize their faces as if they are part of *our* tribe. By photographing indoors and thus producing a claustrophobic awareness of such closeness taking place in the moment, Goldin corners us with the truth.

In the introduction, I explained that this project focuses on a revisionist myth of Medusa, and distinguished the parameters within the use of that term that I have applied throughout this project. My use of a revisionist myth is to examine the story of Medusa, to understand how her face figuratively changes over time with a body that becomes attached to her. Again, I hoped to show how Medusa is reborn into many different versions of women over the centuries from Eve to Salome. Yet throughout Medusa's history, it has been her body that has given her agency. Unlike other revisionist myths, however, the Medusa story has been fragmented from the very first story of her, from her birth and parentage, leading up to the curse. Bits and pieces of her story, though, add up to a more fully developed narrative. She is still a mystery to us, incomplete. But in a modern expression, and as a symbol of feminine power, women use that image of Medusa to empower themselves, to give themselves agency. So as long as women continue to change, and refuse to be victims, then this study of Medusa's subjectivity begins with an analysis of how she becomes a protector of women who should not be afraid to speak up, to tell their own stories about their lives.

Medusa is the other side, an alternative to the mainstream, a rejection of conventional attitudes, emblematic of people struggling to be heard, to be looked at, to be taken seriously, not to be stereotyped or feared because they are different compared to what society has determined is socially acceptable behavior. Because the border between the inside and the outside ceases to exist, desire is no longer repressed. In Goldin's photography we see intimate human relationships, the space called "The Other Side." Whether that be more iconoclastic, radical, or nonconformist, it does not matter. These images connect the spectator to human emotion that is expressed in this interaction between looking at (the spectator) and being looked at (the image in the photograph).

We do not need to know the person in the portrait in order for them to register with us. Ruddy explains that "Goldin documents her world, her own history, not with 'empirical positivism,' but with what Dianne Chisholm, in her study of the constellations that make up queer memory, called 'emotional, if not abject, acuity'" (349).

Empirical positivism would seriously limit the emotional impact of Goldin's work for the following reasons. First, empirical evidence can only be established by our sensory awareness, data that we collect from observation. When empirical evidence is coupled with positivism then society operates according to general laws, or what we recognize as acceptable cultural behavior. So if what one sees does not concur with acceptable social behavior, then it is deviant. Society is governed by conventionalized laws of human behavior, and the spectator faces the challenge of transcending the border that protects these two realms between a socially acceptable construct and unconventional desire. The reason why empirical positivism is too limited of a perspective is because our keenness of thought is often dominated by general or universal laws, which can leave us out of tune with the emotional impact that art should have on the spectator. Empirical evidence comes only from sensory experience that requires an object. We draw upon a conclusion about the object based on our sensory awareness, which can be influenced by universal laws of socially acceptable convention. Photography, however, is a synthesis of the object that can work as a symbol or signifier coupled with emotion, and because emotion cannot be objectified it cannot be signified. An object, however, can represent our emotions. Furthermore, Ruddy explains that the world revealed to us in Goldin's photography is not empirical positivism, but can be abject, which leads to the claim that there is no definable object.

Kristeva expounds upon this point in *Powers of Horror: An Essay on Abjection*, defining abjection by what it is not. It is not otherness, nor the object, nor a systematic chain of signifiers. A feeling that leads to abjection is an immediate revulsion, though we do not know the cause. We identify that there is part of oneself that we have rejected, and that part is therefore abject. Whether it be a fetish that does not fit within the strict parameters of social behavior, one will try to hide that obsession because they fear rejection. Therefore, they reject that behavior or obsession or desire in order to assimilate within their ideas of what society expects from them. However, looking at one of Nan's photographs can liberate the spectator from this fear of rejection by identifying with the emotion expressed by the image. So if one is completely in acceptance of the self, they do not see the distinction between gay or straight, male or female dichotomies. Instead that spectator will respond to and identify with the emotions of that couple in the photograph in a moment of intense intimacy, whether it is a prolonged embrace, a kiss, or sexual intercourse. This is the visual world of Nan Goldin. Methods such as otherness, identifying the various representations of the object, cannot be used to determine a single interpretation of a photograph. The moment captured in a photograph comes to represent many different things, feelings, and emotions that constantly change over time. But if the

spectator fears something about himself that he has rejected, and decidedly finds that previous quality of himself as repulsive, then he cannot respond to that moment of intimacy expressed by the couple in the photograph; instead he repudiates the image in an effort to repress desire that he is afraid to experience. He fears the possibility of unrestrained physical intimacy that overpowers the couple. If he had no fear, then it would not matter.

The Medusa myth embodies the idea of confronting the unknown and facing that of which we fear. Ovid suggests Medusa's touch is powerful and terrifying, while other myths purport it is her gaze that petrifies. The touch and the gaze of a woman are powerful, having the ability to transform her surroundings. She is inaccessible to view, paralyzing to the touch. Her "slimy head" as Kristeva describes its severed head, and serpent hair conjure "the female sex organ … the vulva" that terrifies the young boy who sees it (29). So much like Athena as a figurative warrior goddess, Medusa survives throughout the centuries, meeting us here in the twenty-first century. In order to be free from the cultural ideology that shapes our beliefs and attitudes, the border that divides repressed desire from rational and social behavior must be eradicated. In other words, the border, separating the inside (repressed desire) from the outside (socially acceptable behavior), disappears. The collapsed border applies to images in Goldin's photography that allows for a deeper understanding of the Medusa figure when internalized emotions and repressed experience of women become indistinguishable from the physical transformation of Medusa's body, the way that the body can tell a story, the very things of which we see, but do not see. Photography captures it all, the essence of the moment.

For these spectators, Goldin's photography specially confronts their fears. Abjection as a theory appropriately applies to Goldin's photographic work because it does not play by cultural ideological rules of understanding or producing meaning, since Goldin's photographs are of men and women that society has previously cast off or rejected, and refuse to accept as mainstream. Abjection investigates the reactions that one might have concerning fears and horrors that they have experienced by facing objects or images that threaten their own identity. Confronting such fear can lead to subverting a conventionally defined identity. In other words, abjection theory means to break down both the subject and object, no longer defining the two based on cultural ideology. Looking at Medusa produces the fear of death, fear of punishment, fear of alienation. To look requires a recognition of the thing that threatens identity and subjectivity. Similarly, Nan Goldin confronts her viewer with discriminatory attitudes such as misogyny and homophobia, showing that these are cultural fears. American society of the 1970s and 1980s, when Goldin's work becomes so prolific, still wants to cast aside homosexuality. These attitudes were most apparent during the 1980s during the start of the AIDS crisis, when conservative ideologues argued that gay men in particular were being punished. But on the contrary Goldin documents private moments among men and women physically on the brink of death from AIDS, who evoke compassion, and the feeling of emptiness that comes with loss, compared to earlier photographs of these men

and women pictured at the height of youth, ecstasy, invincibility. She shows that love, hope, and death transcend far beyond simplified social constructions of gender or sexual orientation. We feel inseparable from the moment, from human suffering, from the longing for intimacy.

There are two different points to note here. First, we look at art and try to determine the effect that it has on us. So when we study a work of art, a photograph by Nan Goldin, we take details from the imagery derived from our sensory experience, and use logic and reason to make an interpretation, part of which is influenced by universal values that are determined by our socialized environment. This forms a minor conclusion about the effect that art has on us. It reveals a certain truth that can only be found, first, by sensory observations, and, second, by our experience that we have had prior to making these observations. From a second, alternative perspective, Goldin's documentation of her subjects is different: we engage in a different experience; our observations of those images awaken our emotions, affect, for which there is no language. As a spectator looking at the photograph, we powerfully identify with the emotional exchanges among Goldin's friends whom she documented, which constructs the spectator's perception of shared activities, love, intimacy, even death. We therefore objectify affiliations or social groups based on emotions. Such observation and discovery require acuity, visual sharpness. But the question here is what emotion from that image registers with us? The emotion that Ruddy identifies is one of loss leading to melancholy. So to look at an image, a photograph, taken during a certain period of time, records a moment, conveys a specific mood projected by that person, by Goldin who captures that mood through her lens, but it is also lost as soon as the shutter clicks. We get to observe the original recording, and it is our emotions that enable that image to register with us, whether it is, for us, a lost part of our past, a lost lover, a lost part of ourselves.

When Goldin finally checked into rehab in 1988, she wanted to find out what she looked like without drugs, and started photographing herself to get back into herself. For a long time, even as an artist who quickly became well-known in New York City, she still experienced a crisis of identity and fear, never going outside during the day, and all of a sudden being sober and living in light. Her honesty embodies the struggle for identity that all women experience periodically throughout their lives. Light affects the result of photography, coming out of darkness and into light. Goldin confides that photography is a form of love-making that tests how close she could get to someone without drugs, to know the feeling of intimacy between two people.

Sharing her experience at the Tate Museum during a lecture she gave in 2014, Goldin asked how many people believe that a photograph can be true. Only two people raised their hand. It was distressing to her. Art and photography have to tell some kind of truth. She points out that photography needs to be less coldly objective and more subjective because when it is, in my opinion, the work changes the perception of the spectator whose view of the world might be too dogmatically rooted in social norms. Photography presents

the possibility of escaping those norms and therefore discovering in art some-
thing deeply personal. Unfortunately, photography in the twenty-first century,
according to Goldin, has become a medium of revisionism, where we are cre-
ating a specific kind of truth, and ironically it becomes more objective where
each image attempts to frame a certain reality that is completely fabricated. From
my observation in the twenty-first century, narrative is invented through social
media, which rarely portrays people and scenes as they are really happening—as
they really are. Goldin states that "The whole social media is a disaster for man-
kind" (Lecture Tate Museum).

By making a connection between Goldin's warning against revisionism and
my intent to provide a better understanding of the Medusa myth, the combin-
ation provides an empowering perspective of women in the twenty-first cen-
tury. My goal has been to tell Medusa's story, and Goldin's work suggests to me
that I could go by what first inspired me, this new, provocative, erotic, and abso-
lute melancholic emotion that I attached to these images of Medusa. I wanted
to write that story about Medusa. Goldin presents a voyeuristic exploration
of universal concerns that figuratively transcribe women into the Medusa
myth. Viewing one of Goldin's most photographed subjects, Cookie Mueller,
compels the gaze which metaphorically involves danger, and in the case of
Mueller, physical deterioration. But more importantly beauty is profoundly
redefined after death. As Cookie Mueller lies in her casket, grace and wholeness
are revealed in this transition from life to death. Even after such destruction,
rape, exile, Medusa is portrayed in Archaic, Classical, and Hellenistic periods of
ancient Greek art and sculpture as beautiful. After she is mythologized, a body
is attached to the head of Medusa, and only with a body can Medusa have a
story, a history. When she is decapitated, is might be an easy deduction that there
is something irresolvable and deeply personal. Then again, before her head is
severed, she is the sleeping Medusa, a woman who dreams and perhaps savors
something that this world cannot satisfy.

As mentioned earlier, Goldin is aware that critics misunderstand her work,
and they assume that her pictures are about marginalized people. In *The History
of Sexuality*, Michel Foucault describes those attitudes as "a policing of sex"
which is "not the rigor of taboo, but the necessity of regulating sex through
useful and public discourses" of which, I observe, popular American televi-
sion and media have been a central influence in contemporary culture (25).
Goldin explains, however, that her friends who she photographed were never
marginalized because they *were the world*, and they did not care what straight
people thought of them; they did not interact with straight people; they had
no time for conventional, straight people who played no part in their com-
munity or life; therefore, straight people did not matter. Goldin corrects this
attitude, that her art is "not about being outcasts". By eradicating these anti-
quated behaviors about sexuality, she takes up this problem within our cul-
ture that Foucault names as "the policing of sex" in his 1978 publication, *The
History of Sexuality*. Goldin experiences the liberating intoxication of real life,
and real people through photography, thus recognizing that only the most

straight people can see her work as being marginalized. Hélène Cixous and Catherine Clement show that women in particular who live by their own rules, or become malleable—not to social norms—but to the playfulness and therefore unpredictability of everyday life, are not strange or marginalized.

Cixous makes an analogy between the so-called hysterical women and sorceresses that Freud claims to be "unfortunate … victims" to women who easily adapt to playfulness of life itself in which the rules are often unpredictable. We simply learn as we go along. Cixous in particular observes how the so-called spectacles of women, namely shamans or witches, absorb into the mainstream when the spectacle of these women become fodder for entertainment, when they can be filmed, the center of storytelling and myth created on the big screen, or performed in television series. Now suddenly the rebellious, savage, unconventional woman has transitioned into the mainstream, but only so long as she, as a spectacle, makes money in which dominant, wealthy industries benefit from the profits earned by these spectacles.

Especially today, there are many women who resist and refuse to back down. Goldin questions social conditions from only five decades ago, in which some young women and men in the 1950s and early 1960s refuse to conform to a so-called mundane sensibility. At this time in American culture, they are punished by their families, locked up in asylums, safe from being viewed or judged by society; these women and men are told that they are crazy for believing in and living a different way of life. As a result of these social constraints, the family member with whom Goldin was closest, her older sister Barbara, committed suicide by throwing herself under a moving train. Losing Barbara affected Goldin's whole life. Yet her parents wanted to tell a different story about how their daughter lived and died because the truth of her life appeared socially unacceptable. In *Sisters, Saints, and Sibyls*, Goldin makes a tribute not only to Saint Barbara, but to all women who had the gumption to stand up for themselves and rebel in spite of the consequences that many suffered or endured by society's harsh reprisals.

The analogy between Saint Barbara and Goldin's sister is uncanny. The ancient Greek martyr is beheaded by her father, Dioscorus, for finding spirituality. In comparison, Goldin's sister Barbara is forced into an asylum because she did not want to behave by family rules. Saint Barbara's wealthy pagan father keeps her locked up in a tower because she refuses to marry, having secretly become a Christian. When he builds a bathhouse, she erects three windows instead of two, to acknowledge the trinity, finally admitting to her father that she is Christian. Withdrawing his sword to kill her, his effort is foiled when a hole opens in the tower wall, leading her to safety in a mountain gorge. In search of his daughter, Dioscorus comes across two shepherds, the first who protects her and the second who betrays Barbara. Eventually the second shepherd is punished and turned to stone just like Medusa's victims who gaze at the Gorgon, as they once did, but longingly, before she was cursed by Athena.

It is ironic that Medusa must be sacrificed to serve as a protector. Because both Medusa's immortal sisters Stheno and Euryale are indestructible, it would have been impossible for Perseus to destroy them. In both Greek art

and literature, these immortal Gorgons could either seize the assassin with their own hands or petrify Perseus by gazing into his eyes. Stheno has killed more enemies than both her sisters combined. There is a greater tenderness to Euryale, who is later the dolefully mourning sister who bellows after Medusa is beheaded by Perseus. According to fourth-century Greek writer, Palaphatus, like Medusa, Stheno and Euryale have no desire to marry and instead keep their father's wealth among themselves, each of the three sisters ruling over one of the three islands, regions that are rich in gold. They are powerful women, and Perseus wishes to usurp their wealth. By bloodthirsty means, he accomplishes his task. Yet, sixteenth-century Italian mythographer, Vincenzo Cartari, claims that Medusa is killed because the world could not tolerate such a terrible monster. The young, cursed, beautiful woman put to death, for whatever reason is always immortalized by the circumstances of her death. She is more legendary in death compared to how she lived.

Though Goldin's parents have attempted to rewrite or make alterations to fit within the strict boundaries of standard conventional thinking, Goldin's book is proof that Barbara lived this life and this death, and no one could change it. Free-spirited women growing up in the 1950s and 1960s who do not want to be held down by old-fashioned ideas feel like they have no way out. In order live as they choose, Goldin observes that a woman needs to have a tribe, a family of her own choosing. By having no tribe, no people like her, were circumstances that Goldin believes killed her sister, Barbara. It is a tribute to all the women who rebel against a crippling cultural example that forces women to adjust or suffer. Hélène Cixous argues that women need to stop accepting being trapped and make it a point to liberate themselves. But, unfortunately, not all women survive this resistance towards an axiomatic patriarchal ideology.

Nan had said that Barbara was born at the wrong time, ironically only three years after my own parents were born. At the age of 14, Barbara was institutionalized after kissing boys at movie theaters and having a black boyfriend. After several institutionalizations, on April 12, 1965, Barbara obtained a day pass, and having walked several miles from the National Institute of Health, she laid down on train tracks and was beheaded by a passing train. The 2006 slideshow *Sisters, Saints and Sybils* was dedicated to "all our sisters who have committed suicide or who have been institutionalized for their rebellion" (Goldin). But what about the rebels who lived? Anatole Broyard writes that illness and suffering are "not a disaster or an accession for depression or panic, but a narrative, a story." Goldin began her 2006 show with images of illuminated manuscripts and Goldin reciting the legend of the third-century St. Barbara, whose well-off father imprisoned his daughter in a tower because he was afraid that she would be corrupted by a man. After Barbara surreptitiously received a Christian lover and was converted, her father turned her over to the authorities, who tortured her and then allowed the father to behead her himself, a near perfect allegory of what happened to Goldin's sister Barbara. In Nan's own words she explains that

My sister's psychiatrist said that I would end up just like her. I thought that I would commit suicide when I was 18. I left home at 14 and found a new family. Drugs set me free. And then they became my prison.

Life is a series of tiny deaths when the thing that liberates us can also turn into a trap. Transcending the confines of such a prison metaphorically requires us to transform ourselves in order to change our lives and live again.

Goldin explains that her career was not an uphill trajectory, especially having a hard time between 1978 and 1988 when people jeered at Goldin's prolific work. But the genius of her work is finally realized in *Saints, Sisters, Sibyls*, the triptych at the core of the exhibit, heartbreaking in its renditions of women. The first segment illustrates the story of St. Barbara with footage of medieval drawings and paintings. A neutral voice introduces the theme of the rebellious, persecuted woman, explaining her imprisonment in a white-turreted castle and subsequent torture and execution for her conversion to Christianity. In the stories of these ancient women, Medusa, medieval women, Saint Barbara, and the modern women who rebel are all martyrs for simply living a life of their own choosing and at the same time wish to be left alone. They hurt, but in different ways from men, and in different ways from each other.

In particular, the loss of a sister, especially under tragic conditions, leads to an identity crisis for the sibling left behind because it is to lose one half of a whole. By somehow finding her through glimpses of other people or objects becomes a figurative search for the self. There is a great need to preserve the original narrative of the person, to humanize them. By sticking to the facts of that lost person's history, one can accept the history of their own life. Otherwise it is difficult to know what we really are or what our purpose for being here really means. The process requires time to look at things, to document and share one's life. A survivor watching the life of her sister play itself out analogously operates as a camera recording time, the eye is metaphorically the lens of the camera. The camera cannot lie but instead reveals to the spectator both the resiliency and fragility of life. These moments caught on camera are critical to shaping our identities as they develop and transform over time. What we also identify in Goldin's work is a struggle in our intimate relationships that conflicts and eventually grows into dependency by seeking satisfaction and wholeness that another person simply cannot give. Dependency on another person, especially where it happens frequently in intimate relationships, is counterproductive to developing a more authentic self. That is why, according to Goldin, male / female relationships often do not work. But by discovering truth in loss, without becoming dependent on another person to form our identity, by becoming active rather than reactive, leads to newness and wholeness. On the contrary, dependency results in deep melancholy. Kristeva explains that loss in the case of relationships leads to depression because it is combined with loving the lost object, mourning the loss, while also hating the object for having loved them (11). As a result, one dislikes herself for having loved the lost object, which results not only in loathing for that object, but hatred toward the self. In other

words, it becomes demeaning to love something that is gone, that no longer belongs to us.

The picture of Sharon, Cookie's former lover, sitting on Cookie's bed during the last two months in 1989 when Cookie was dying from AIDS is, according to Goldin, the most important picture she ever took. Vittorio, Cookie's husband, was in hospice care in New York. Cookie died the day the Berlin Wall came down. During the AIDS epidemic, society stigmatizes both homosexuality and bisexuality as a curse. Their reaction shows how emotions, intellectuality, and spirituality are confused with the body—or maybe the body is just not accurately represented in terms of how we use it. In *Gender Trouble: Feminism and the Subversion of Identity*, Judith Butler notes that according to Foucault, "the body is figured as a surface and a scene of a cultural inscription" (129). In other words, the body is always under siege, suffering destruction by the very terms of history. This certainly was the case for Foucault who died of AIDS in 1983 when very little was known about the virus, when many men and women also yielded to the disease in the 1980s and early 1990s. Butler points out that "history is the creation of values and meanings by a signifying practice that requires the subjection of the body" (130). In the case of Nan Goldin's generation, her tribe, her friends, and teenagers like myself growing in the early 1980s suffered the new AIDS epidemic. It redefined the generation with greater impact. The AIDS society changed what it meant to come of age, making people aware of their bodies in new ways. Though the spirit is more robust than the body, we come to ask how might the body and spirit function together? Our personal history is marked all over our bodies—the scars remain, even though the moment might be gone. The body reminds us of where we have been.

Bibliography

Butler, Judith. *Gender Trouble: Feminism and the Subversion of Identity*. Routledge, 1990.

Foucault, Michel. *The History of Sexuality, An Introduction*, Vol. 1. Vintage Books, 1990.

Goldin, Nan. *Fantastic Tales: The Photography of Nan Goldin*. Palmer Museum of Art in association with Pennsylvania State University Press, 2005.

Grist, Anna. "And I Stop, and I Turn, and I Go for a Ride." Interview, 2017.

Kristeva, Julia. *Black Sun: Depression and Melancholia*. Trans. by Leon S. Roudiez. Routledge, 1999.

Ruddy, Sarah. "'A Radiant Eye Yearns from Me': Figuring Documentary in Photography of Nan Goldin." *Feminist Studies*. College Park 35(12) (Summer 2009), pp. 347–380.

Sussman, Elisabeth. *Nan Goldin: I'll Be Your Mirror*. Whitney Museum of American Art, 1996.

8 Liz Craft and the all knowing "I"

During the second week of June 2017, the Museum of Modern Art in Paris featured an exhibition of contemporary sculpture, fashion, and jewelry inspired by Medusa and taboos dating back to ancient Greek mythology. I was most awestruck, however, by the artist Liz Craft who reproduces sexual parts of the body, the lips, the breasts, the tongue, and even the testicles to present the obscure nature of gender and sexuality. Craft portrays both the ambiguity of gender and even cultural stereotypes to show how media images work within strict paradigms of male and female that undermine individuality. Overall Craft's artistic vision implicitly argues that one's identity is limited by standardized conventions of gender. The Medusean myth is insinuated in this presentation to suggest that the eye turning men to stone operates as an instrument that is not limited to the protection against a potent danger or threat, but it also becomes the all knowing "I," an eye that reflects the truth of the world in which we live, its fears and hypocrisies. In this case of gender, Craft's sculpture namely demonstrates and deconstructs cultural views about women: cultural perceptions of women, impressions that women have of other women, and apprehensions that women have about themselves. The all knowing "eye" seeks something beneath the surface of these prescribed definitions of gender, and particularly of women.

To begin with, the sun is often associated with looking, understood to be the "omniscient" eye. The highest order of angels have eyes on their wings as signs of their pervasive wisdom. The whites of the eyes symbolize the purity of the ether, their brightness its brilliance, the pupils are the stars above. Moisture from the tear ducts are likened to the upper waters sprinkling this same ether, lest it be damaged by the higher celestial fires. The tears of the gods are rain putting out those fires; in fact, the deity's tears are a response to human sorrow. But from great sorrow, all life can proceed. Every function of the eyes completes a most complex structure that collects data about the world in which we live, and generates our attitudes and our reactions of what qualifies as a moral life. The symbolic power of the eye is further explained by Jungian scholar, Bettina Knapp, who compares Medusa to the *Hawk Woman*:

> Such power does this Hawk Woman wield that anyone who gazes into her "unmoistened" eyes is cursed. Just as Medusa in Greek mythology—who

had serpents for hair, brazen claws, and enormous teeth—turned the beholder into stone, the Hawk Woman's personality is wholly destructive. Perseus was saved from annihilation because he carried a mirror with him and did not look directly at her. Psychologically no one may peer into a God's domain: the Self. To experience the absolute, either in its horrific or beauteous aspects, is to invite the destruction of the ego, to welcome its fragmentation.

(258)

First, an unmoistened eye into which one might peer is an eye with no soul, whereas gazing into a moistened eye is analogous to looking into the mirror of one's soul.

Second, looking into Medusa's eyes allows the collective unconscious to take over. Medusa, like the Hawk Woman, is an archetype that emerges from the deepest layers of the unconscious. An archetype is therefore contained within the collective unconscious, which exists at the deepest level of the hidden realm, that of which is not within our reach or knowable to us. The Self of which we do not know is concealed within the collective unconscious. This knowledge is out of reach because it is dangerous to peer inside that realm, to look inside the cave of the unconscious. To be more specific, secret aspects of ourselves are discovered within the unconscious. Since that realm is usually inaccessible, it instead manifests within archetypes, or what is otherwise called universal motifs, like the Terrible Mother or Spiritual Father (God). Medusa is such an archetype.

While an archetype emerges from the collective unconscious, to know those hidden secrets that reside within our own psyche is almost impossible to face. It is the Absolute Truth of what we are. To see something of ourselves that we are afraid to see would, at the very least, cause panic or cause us to turn away in shame, or to stare back in confusion and fear. Moreover, Knapp claims that this realm leads to a universe "without time or space" (258). In Knapp's assessment of the Hawk Woman, she is an archetype that allows one to see truth revealed to us, but it proves to be too overpowering, even having the capacity to drive the spectator insane. He cannot handle what he sees—in Medusa—for what he discovers for the first time is actually himself, leaving him paralyzed by what he comes to realize about himself. Knapp equates the Self to that of looking directly at God, and "no one may peer into God's domain: the Self" (258). Therefore, the eyes of the Hawk Woman are "not of this world" (259).

The "eye" also signifies the intellect; for example, theft of the Graiae sisters' eye leads to the discovery of the Gorgon's secret dwelling and the acquisition of Medusa's head. Capturing both the eye and the head emphasize that defeating the enemy requires seeking knowledge. Perseus, in other words, must render his enemies blind. The eye and head are powerful tools that guide Perseus throughout his quest. Otherwise he is figuratively impotent without them. In all cases, he vanquishes his enemies through knowledge of the omniscient eye and the talismanic power of the head.

These devices of the head and eye, however, carry with them a destruc-
tive force symbolized by the archetype, such as Medusa, that possesses these
resources. Likewise, the Hawk Woman is wholly destructive to spectators. Her
power questions that of an Absolute Truth, that is to recognize that reality is
inflexible and fixed. Individual societies are dominated by Absolute Truth such
as God or morality, which allows them to function. In this case, universally
accepted truths are necessary. However, while the spectator believes he knows
the truth absolutely, by gazing at Medusa in the reflection of the mirror (the
shield), truth is apparently quite relative. Positing an absolute is to suppose that
the statement was true, and yet "truth is relative." Everything including that
statement would be correlative. Therefore, if a statement is relative, it is not
always true. If "truth is relative" then what we see may be reliable informa-
tion, but experiences over time change a perception of what is true, leading
to truth relativism, that there are no absolute truths. So what does the Hawk
Woman see? She identifies that which we cannot see for ourselves, to which
we are previously blind. That vision of ourselves is reflected back to us when
the Hawk Woman returns our gaze, which is dangerous. Because our percep-
tion of the truth is always changing, there are no absolutes. Medusa challenges
all absolutes in a society that dogmatically believes that all standards enforced
by patriarchy are true and moral. A new way of thinking about Medusa might
reveal for the first time that these standards of thinking are incredibly flawed
and not trustworthy.

Craft's sculpture of *The Spider Woman* with the four eyes lined across the
forehead figuratively suggests the "all-seeing eye," and that all secrets can be
penetrated. In modern psychology, the eye functions symbolically as the organ
of light and consciousness. It permits us to perceive the world and makes it real
to us. Dreams that include eye symbols have to do with this act by which we
grasp existence. In some cases, people have dreamt of eye ailments. The "eye"
not only communicates the world in which we see, but our visual sharpness
constructs psychological awareness. So, for example, a dream about an eye
ailment alludes to the limitations of something psychological that we cannot
grasp or understand. In other words, our visual acuity of the psyche is limited.
This conclusively means that our inability "to see" in this state does not allow
one to understand or visualize life properly. When consciousness is in danger,
hence the ability to distinguish between reality and the imagination, then fig-
uratively from a psychological perspective, many eyes gaze upon the critically
ill person. In other words, the eye of the mind alludes to the inner truths within
the depths of the intellect. But that world of truth must be translated into a
viable form that produces something that can be understood by the intellect.

In greater detail of Craft's sculpture, *Spider Woman* displays eyes that are
dramatically enlarged, looking sideways rather than right at us, which could
suggest evading the truth by avoiding direct eye contact. The four eyes over her
forehead suggest a symbol of knowing and seeing all that the spectator attempts
to hide, that the hidden world can only be viewed by the third eye. In Craft's
sculpture, the face is shaped and formed from newspaper mâché; her gaze looks

to the right, away from the spectator's view. Her eyes are unusually large and blue, glassy. Dotted across her forehead are four blue eyes staring into space, that psychic knowledge of who and what we might be. The eye is the most important organ of the senses, symbolically associated with light and intellectual perspicacity. The eye is not only a receptive organ, but also the transmitter of beams, the image of spiritual expressivity. Evil creatures or those with great magical powers were thought to have eyes whose gaze rendered others powerless, similarly associated with Medusa. The supposed emanations of the evil eye led to the production of countless amulets. Craft's artistic expression figuratively demonstrates that the act of looking into Medusa's eyes allows the collective unconscious to take over.

The skin below the eyes of Craft's sculpture is more flesh-toned, but the newspaper mâché appears almost a sickly green. The Spider Woman's hair is a white gauze, reaching her shoulders. The expression of the lips is openmouthed, bright pink, as if she is pausing at something, aware that she is on display. Her shoulders are a wooden pants hanger with an off-white, long-sleeved sweater attached to make up the top half of her body, her torso. The legs are made from fishnet leggings with ballerina flats for feet. The hands are also made from papier mâché, the left hand resting on her hip while the right hand hangs at her right side. The legs give the appearance of the ultra-skinny look, popular in fashion magazines, but works with the grotesque, embellishing a look that appears comic. In an interview with Nicolas Trembley, Craft explains the influences that classic art has had on her style in sculpture:

> I guess if you think the main thrust of classical sculpture is a reflection of the natural world, then yes. But I'm including the mind, rationality, psychological subtexts and dream states, which I think are also part of the natural world.
>
> (6)

Her attitude about the function of art largely reflects the philosophical views of Delville, that one is searching for a connection to the dream state, the unconscious and how that might be accessed through art. Similarly, she suggests that the natural world cannot be understood without being coupled by the unconscious mind, the intellect. This point about experiencing all worlds, including the transcendental, is critical to understanding different means by which an artist can interpret the meaning of Medusa. On a literal context, she is monstrous, at least this is how she has been portrayed, inspiring fear. But artists and poets alike who grapple with the meaning of Medusa, seeking a greater understanding of her, must move beyond these readings that are better revealed in art and literature. It is the dream state, the rational mind that leads to new ways of viewing her.

Medusa is always characterized as having the evil eye turning men to stone. Perseus fears the evil eye, not giving even the slightest risk to look at it. At the same time, a woman gazing at Craft's sculpture cannot help but identify with

its features. Returning back to an earlier point, the *Spider Woman* is not gazing right at us; instead she looks away. But there is yet an alternative interpretation, that something more remote and distant captures her attention. By using a number of different materials to construct her sculpture, Liz Craft shows that while living in the twenty-first century, our culture still implicitly suggests that women's sexuality and biological experience are rejected in favor of an idealized female image that distorts a woman's true character. Craft purposefully subverts this idealized image by exaggerating these very ideals such as weight and youth into their grotesque form and thereby presenting something horrifying. The body is so thin and anorexic in *Spider Woman* that it appears misshapen. The head is disproportionate to the body, enlarged compared to a body balancing the weight of the head. The shoulders of the sculpture are simply a clothes hanger, meant for the purpose of displaying fashion purposely, giving the woman no subjectivity. The head is made from newspaper mâché, tinted by flesh-colored paint around the eyes meant to emphasize their awkwardly large dimension. Finally, the head is loosely attached, as if it is ready to fall off.

Postmodern artwork of Liz Craft, I argue, generates yet another interpretation of Medusa that applies to women, their bodies, and their perception of themselves through their bodies. Craft's work gives the spectator yet a new insight on the power of women and how this continues to evolve. In Crafts' art, this develops as an uncanny new image of women. The modern Medusa comes together in a whole different style, while still retaining themes and motifs derived from Greek and Roman mythology. Largely influenced by growing up in California, Craft shares the source of her inspiration for her art: "I gather images from things I see around, collect at thrift stores, or have as memories, or from fantasizing or dreaming. Sometimes they're art historical or formal references. Then I collage them together" (Grist 226). Medusa is reinvented as a California icon, metamorphosed into a counterculture hippie, 1960s flower child embodying the adventures of a postmodern woman, a collection of memories, representative of different historical periods, while she trail-blazes her way to the West Coast. The Medusa archetype transitions into a liberated culture. She is gazing at a dysfunctional world of satire and farce.

Craft furthermore applies her voodoo mythology in *Venice Witch* (2002), a construction of a Cleopatra imitation with beaded, shoulder-length hair, bulging eyes, puckered mouth, and claws for hands reaching out and grabbing at something. With hair and dress made of amber beads imported from Venice, Italy, she is the mocking, unperturbed old hippie emerging from an outdated culture of coolness. On chrome roller-skates, she surreptitiously progresses forward with a chrome portable boom box on the ground beside her that imaginatively blasts music from behind in rhythm to her movement. Zigzag shaped panels on the floor mark where she has already traveled and continues ahead into the future. Two more chrome zigzags complete the piece. She is the fearless modern old woman, unencumbered by age. The inspiration for *Venice Witch* came when Craft visited Italy and had seen a woman with long, beautiful blond hair, who suddenly turned around and looked ironically like she was

90 years old. It shows how our expectations are contrasted suddenly and shockingly with reality. Our expectations are inevitably contrary to the truth, because our perception of beautiful women is that they are trained and modeled after cultural ideals in the modern world. She is the Medusa turning around and catching our gaze, laughing at us because the viewer really is the butt of the joke, repulsed by her old woman's face. But the other part of the joke concerns women who really are old and attempt to be young and glamorous, women who still attempt to meet the ideal. These are the examples that Craft claims come out of everyday life.

One of Craft's more iconoclastic art sculptures is *Mountain Mamas*, that portrays life-size, grotesquely obese female figures with pointy, featureless heads, who sit with their legs outstretched, arms melting into the folds of their stomachs. Here is where Anna Gritz observes the connection between Craft's work and a point made by French feminist theorist Julia Kristeva, that Craft's art

> bring[s] together Julia Kristeva's idea of abjection as something fluid and formless, neither object nor subject, with a type of social abjection—bodies that do not function in a societally accepted way, deemed unproductive and cast away as disgusting.
>
> (226)

This point challenges society's view that women undermine, today anyway, patriarchy by physically failing to achieve the ideal standard of beauty, youthful, and slim-figured with large breasts and tiny waists. In ancient Greece women didn't reject social rules like Medusa. By retaliating against a society ruled by men, Medusa is the castrating woman, disempowering men by finally returning their gaze, objectifying them, literally, into stone.

Historically, American culture has, to a much lesser degree, retraced these steps. The post-nuclear mother figure acquiesced to hegemonic authority. By the twenty-first century, the complacent mother is replaced by the nubile, youthful, and ditzy West Coast blonde, popular in television sitcoms and blockbuster films. Craft parodies this stereotype because women are too often judged by their physical assets; they are objects of worship so long as they fit within these unrealistic stereotypes of feminine beauty, and those who resist are defeminized. Women who cannot achieve the ideal body or face are redefined as outcasts. But judging women based on their bodies and youth is another form of "women-hating," whereas Craft suggests resisting these pressures. Society now creates our culture's aesthetic sensory activity by dominating our choices over what we find pleasing or desirable or seductive. It suggests there is only one appropriate answer, an unrealistic standard of which we are constantly bombarded within the media. Liz Craft describes the setting that led to *Mountain Mamas*:

> That piece was actually inspired by a person I saw while driving. She was sitting on the sidewalk under a freeway bridge, maybe homeless. I thought

she looked beautiful and amazing sitting there like a mountain, but I also felt sad for her. She reminded me of the mountains on the way to my parents' house. And I like the idea of mixing a figure and a background. I didn't really think of this piece as funny; it was more about a person in a landscape. Or person as landscape. Or the sublime.

(227)

Referring for a moment to theories of dark romanticism explored earlier in Chapter 1, the sublime is discovered and experienced in what might be conventionally defined as ugly. But true art is not created based on any conventional standard, and beauty is found in the unconscious state, such as the sublime. The setting in which Craft discovers the woman sitting alone in isolation under the bridge becomes ironic, surrounded by the modern world, freeway structures where one is unlikely to be noticed, where a woman who chooses to sit under a freeway wishes not to be observed. This is not a comic scene given its solitude. The solitary figure of the woman remains invisible but can only be spotted by an artist, and the image of that solitary figure, epic in size, immediately evokes feeling. The *Mamas* are snow-capped mountains, a figure of nature. The image of the sculpture sustains the mystery of beauty and of the physical world. This combination of nature and the feminine form allude to this mysterious relation between the spirit and physical matter. The mountain scenery that Liz Craft passes is reminiscent of her childhood that was spent growing up in Mammoth, California, while driving as an adult woman in that same direction to visit family. For Craft this symbolically comes to represent the proximity of God, the mountain rising above the ordinary level of humanity and extending close to the heavens. To find beauty in objects and women that is antithetical to a superficial standard of beauty is to experience the sublime, to be at the peak, our imagination stimulated and awe-inspired with the contact of a superhuman realm, the mountain being above everyday life.

Part of Craft's humor depends on the fact that her sculptures, such as *Mountain Mamma, Spider Woman,* and *Venice Witch,* are scary in an oddly distanced way. To explain more on this point, her imagination is three-quarters California funky and one-quarter horror story. Ironically, it might be hard to take the situation she constructs seriously since she consistently references West Coast banality. At the same time, Craft emphasizes its darker side, cheap thrills and a folksy aesthetic, combined with violent transgressions: her witch is genuinely frightful, but in the anything-goes atmosphere of the Golden State, the comical plays a central function in order to understand her art. Influenced by her parents' generation of the 1960s counterculture, Craft's work covers a variety of popular California trends from hippies, outlaw bikers, to New Age followers. But throughout each of these images, she evokes a mood of nostalgia and loss, a younger generation's disappointment at the failure of the 1960s to deliver a more steady, liberated progression of change. Instead it ends in a nightmare of violence, such as the gory and brutal murders of Sharon Tate and her friends leaving a stigma attached to the 1960s generation.

Sharply observant of her surroundings, Craft perceives the woman sitting on the sidewalk alone as indeed a manifestation of that landscape, that in fact transcends contemporary definitions of femininity and feminine beauty. For too long now, popular culture depicts conventionalized beauty as an ideal form that Craft negates. Instead she chooses a solitary larger-than-life, epic figure, and therefore it accurately becomes the proximity of something higher than us. But the fact is, we look toward the wrong things, the banality of things in order to experience beauty, which inevitably becomes dissatisfying. The fact is, at least from Craft's point of view, that we can find beauty in anything. René Girard, Professor of French Language, Literature and Civilization, explains that "the romantic is always falling on his knees before the wrong altar; he thinks he is sacrificing the world on the altar of his Self, whereas the real object of his worship is the Other" (87). This is the fatal mistake the individual, man or woman, makes by falling for "the physical" which as Girard goes onto explain, "diminishes in importance" (85). Conventional attitudes suggest that physical attraction defines love or even compatibility for the Other. But clearly our aesthetic sensibility is very limited from this perspective if we become convinced that beauty lies within narrowly prescribed definitions, especially of idealized feminine beauty. This means to fall for the "wrong altar," to worship that which is "physical" rather than "metaphysical." Craft's work parodies these human foibles through the images of the grotesque. But an appreciation for the metaphysical allows for desire of the Other to continue to grow and develop over time while our bodies transform from youth to old age. The body communicates experience and life events over which we triumph. These life stories are sublime, a thing of pure beauty reflected even in our physical transformation over time. The consequence, however, of relying on false aesthetics leads to questions about how we deal with everyday life.

Craft observes: "I think everyday life is complicated, and I try and show this. I feel like with language we try and tidy things up and put them in categories or simple forms so we can deal with them" (226). In general, making sense of our everyday life requires a process that is uncomplicated. Social pressure, relationships, the unknowable future can bring about so much discord that it renders a feeling of helplessness. We find a place where the problem is conveniently filed away, determining where it should go, and later apply a textbook method to resolve the matter. But this does not help one to achieve a sense of autonomy, to see how the natural world affects our current thinking or living conditions, to understand our connection to the world. In fact, we are largely desensitized to it. For Craft, she believes that in "the arts I think it's possible to show the multidimensional qualities of life" (226). In our ordinary existence, we might find it difficult to deal simultaneously with all the pressure and struggles we must face in contemporary life. We tend to put things aside, and deal with them later because we would rather remain at the wrong altar, worshipping the wrong things, be it the physical, as Girard puts it, instead of the metaphysical. Such false worship can also develop into a form of escape. Art, however, speaks to the unconscious where we must eventually engage in some kind of personal reckoning.

Craft alludes to a method in which we can see how ancient Greek and Roman myths of Medusa apply today through a different artistic lens, shifting our perspective through which we see and understand women, so we can gain some new discovery. Craft likes to "loosen up structures" which allows that different lens to change shape and color (227). The spectator can be disturbed, scared, or threatened, but in the process of moving past a first reaction, the observer of Craft's art can relate, understand, and even empathize with the various new shapes that Craft, along with other artists and writers, make of the Medusa figure. This new awareness develops through a process that begins when all prior meaning falls apart, and everything fails that the onlooker previously thinks he knows or believes. A necessary reality enables us to identify new theories, new ideas, to realize a different ideal that is in fact more metaphysical than physical. Such engagement with art demonstrates that the form is always shifting. Our previous understanding of Medusa continually falls apart and transforms into a different realization. An artist's vision constructs a fresh and imaginative way to speak for yet a new generation. It is a puzzle, a strategy that begins with conscious, rational thought and reaches completion through what is discovered by the unconscious. These disparate parts eventually fit together, taking new shape, and allow for both men and women to see, to understand, to identify with Medusa as the world frenetically continues to change. But men always remain at a distance from her, regardless of whatever age in which we live. Today, there is still a potent fear among men that they cannot match her in strength or wisdom, that they cannot master her. At the same time, many women are now identifying with the dark power Medusa possesses, and through this archetype, connect with their own creative energy. A woman is a dangerous process, picking and choosing from disparate parts that might seem so isolated from her own character, but, in the end, are very much of what she possessed from the start.

Women are not victims and refuse to be subjected to this otherwise stereotypical role. Yet they are also not driven by revenge against men. Perseus kills Medusa, but in one reading, it is suggested that metaphorically he is killing the thing that he loves. Chapter 2 asserts that both Perseus and Medusa are doubles, side by side. Perseus holding up Medusa's head in victory is similarly described as holding a mirror to his own face. She is that which the hero desires to become over the course of his journey. Medusa is independent, powerful, a great ruler, feared by men. These are the very things that Perseus pursues. But upon closer study, he really does not possess these qualities when he begins his journey. In order to defeat Medusa, he relies on Athena, and likewise in order to defeat his other enemies, he must depend on showing them Medusa's head which still has the power to turn enemies to stone.

In *Violence and the Sacred* Girard argues that "Society is seeking to deflect upon a relatively indifferent victim, a 'sacrificeable' victim, the violence that would otherwise be vented on its own members, the people it most desires to protect" (4). Medusa is that "sacrificeable victim," meeting this criterion because of her intense female eroticism, her self-determination, her willfulness to disobey. Therefore, patriarchy in the form of Athena must defend its position

against her, seeing her only as a threat to their status and their authority. Today Medusa shares these characteristics with millions of women executed as figurative witches. But no society, especially our culture, can be named as woman-hating. Rather, we live in a more sophisticated culture that intends to dominate the most private and desirous proclivities of both men and women, maneuvering their judgment into choices that contradict their true nature. A contemporary interpretation of the Medusa myth transcends all limited definitions of women to represent the experience of women today, to reveal their shadow meaning behind the mask of Medusa's mythical personage.

Bibliography

Burke, Edmund. *A Philosophical Inquiry*. Oxford University Press, 1990.

Girard, René. *Deceit, Desire, and the Novel: Self and Other in Literary Structure*. Johns Hopkins University Press, 1966.

Knapp, Bettina L. *A Jungian Approach to Literature*. Southern Illinois University Press, 1984.

Kristeva, Julia. *Black Sun: Depression and Melancholia*. Trans. by Leon S. Roudiez. Routledge, 1999.

Trembley, Nicolas. "Artist of the Month: Liz Craft." Michael Underwood. Courtesy of the Artist and Jenny's, Los Angles, 2015. http://jennys.us/wp-content/uploads/2015/11/NUMM0168_ANGLAIS_LIZCRAFT-2015.pdf.

Index

.

Printed in Great Britain
by Amazon

12380809R00108